Double Duty

Sketches and Diaries
of Molly Lamb Bobak
Canadian War Artist

With the enthusiastic co-operation of the
National Archives of Canada and
the Canadian War Museum,
Canadian Museum of Civilization.

Double Duty

Sketches and Diaries of Molly Lamb Bobak Canadian War Artist

edited by Carolyn Gossage

DUNDURN PRESS
Toronto & Oxford
1992

Published by Dundurn Press in co-operation with the National Archives of Canada and under licence from the Canada Communication Group – Publishing, Supply and Services Canada.

Cover Design: Ron & Ron Design Photography
Copy Editor: Judith Turnbull
Printing and Binding: Gagné Printing Ltd., Louiseville, Quebec, Canada

Dundurn Press wishes to acknowledge the generous assistance and ongoing support of **The Canada Council, The Book Publishing Industry Development Program** of the **Department of Communications, The Ontario Arts Council,** the **Ontario Publishing Centre** of the **Ministry of Culture and Communications** and **The Ontario Heritage Foundation.**
Care has been taken to trace the ownership of copyright material used in the text (including the illustrations). Credit for each quotation is given at the end of the selection. The author and publisher welcome any information enabling them to rectify any reference or credit in subsequent editions.

J. Kirk Howard, Publisher

Canadian Cataloguing in Publication Data

Bobak, Molly Lamb, 1922-
 Double duty: sketches and diaries of Molly
Lamb Bobak, Canadian war artist

ISBN 1-55002-166-4

1. Bobak, Molly Lamb, 1922- - Diaries.
2. World War, 1939-1945 - personal narratives,
Canadian. 3. World War, 1939-1945 - Art and the
war. 4. Canada. Canadian Army. Canadian Women's
Army Corps - Biography. 5. World War, 1939-1945 -
Participation, Female. 6. Women painters -
Canada - Diaries. 7. Painters - Canada - Diaries -
I. Gossage, Carolyn, 1933- . II. Title

ND249.B554A2 1992 759.11 C92-095291-7

Dundurn Press Limited
2181 Queen Street East
Suite 301
Toronto, Canada
M4E 1E5

Dundurn Distribution Limited
73 Lime Walk
Headington, Oxford
England
OX3 7AD

CONTENTS

This published edition of " 'W110278' — The Diary of a C.W.A.C." is lovingly dedicated to my friend, Claude Bouchard.

Molly Bobak, August 1992

FOREWORD

◆

Those fortunate readers who experienced the delights of Molly Bobak's *Wildflowers of Canada* will have happy memories of the spirited account of her colourful and fascinating life, so aptly accompanied by her sensitive watercolour drawings of wildflowers she has known."W110278" is yet another example of her fertile and discerning mind. Her war diary combines a hand-written account of the day-to-day events of her army life with drawings that graphically reproduce these events in her own inimitable manner.

Molly joined the services in 1942 as a private in the Canadian Women's Army Corps. Her abilities were channelled in a variety of directions, from serving in canteens to designing sets for the Army Show, before she was eventually promoted, in 1945, to lieutenant in the Canadian Army Historical Section, thus becoming the only woman to be appointed an official war artist in World War II. Sent overseas after the ceasefire, she made drawings in England, Holland, Belgium and Germany. She "even got to Paris," as she puts it.

I first saw this unique diary in its original form and was much impressed by its unorthodox format. The essence of the diary and the events, the humour and the reality it conveys bring us Molly's zest for life and her special way of looking at things.

For those of us directly involved in World War II, the experience remains an unforgettable "time out of time" even today, when that great conflict recedes into ever-deepening perspective. Molly Lamb's diary will awaken memories for many who were there, as well as stimulate interest among those in the generations that have followed.

Charles Comfort, OC, RCA
(Major, retired)

ACKNOWLEDGEMENTS

———————◆———————

Initially, I want to thank Molly Bobak, not only for creating her illustrated war diaries of World War II, but also for having preserved them for the past fifty years. What a gift! Her enthusiasm and support for my efforts towards this publication have added enormously to the pleasure I found in working with the original material.

To Terresa McIntosh and her colleagues in the Documentary Art and Photography Division of the National Archives of Canada, my sincere thanks for their co-operation and assistance. I offer the same to Jim Burrant for his patience with my ineptitude at the photocopier, to Françoise Bouvier for her imaginative approach to the solution of technical difficulties and to Joan Schwartz for moral support along the way.

My sincere thanks as well to Bill Kent, Karen Graham and Cameron Pulsifer of the Canadian War Museum for their time and efforts — often on rather short notice, I'm afraid.

I am also indebted to Mary McTavish of the Robarts Library for her assistance relating to this project and to Everett and Ray Staples for resurrecting and restoring their vintage Bobak pen and ink sketch for reproduction.

To my two computer gurus, Caird Wilson and David Wood, I extend accolades for their expertise and understanding. Their willingness to drop everything and come to the rescue on a moment's notice is truly appreciated. As well, the unabated and generous hospitality of Helen Murphy et al. contributed greatly to the preservation of the remains of my sanity (if not my waistline!) during my frequent visits in the nation's capital.

To Kirk Howard and all the Dundurn Press gang, my thanks for the sense of well-being that comes over me whenever I cross their threshold.

As for the esteemed members of the VW Society — Kemerer, Prentice and Wright — along with Valerie, Derrick, Graeme and MBG, a toast to one and all ! Over and out.

Carolyn Gossage
Toronto, August 1992

PREFACE
A NATIONAL TREASURE

—————— ◆ ——————

On September 10, 1939, Canada became involved in World War II, an involvement that would drag on for six long years, until August 1945. While many records documenting our country's war effort have survived, historians and researchers have relied most heavily on official records. However, a fuller and truer picture of how Canadians participated in and were affected by the war can be drawn by consulting a wider range of documents, such as personal wartime diaries and memoirs created by private individuals.

A particularly unique and fascinating diary was kept by war artist Molly Lamb Bobak of the Canadian Women's Army Corps (CWAC). While it is possible to locate material about women war artists and female military involvement in such official sources as the war correspondence of the Canadian War Records Committee held by the National Gallery of Canada and from the files of the Department of National Defence at the National Archives of Canada, the information gathered from these sources will be incomplete and will reflect either the artistic or the military aspect, not both. Molly Lamb Bobak's diary strikes a good balance. And it provides an intriguing glimpse into one person's war.

Titled "'W110278' — the Diary of a C.W.A.C.," her journal, which dates between November 1942 and June 1945, is a very impressive and substantial work. Created in a variety of media, mostly pencil, watercolour, charcoal and pen and ink, it measures 45.6 x 30.5 cm and contains 147 folios, with an additional 48 single-sheet sketches interleaved among its pages. This loose diary was housed in a handmade portfolio cover that protected it during its considerable travels with the artist throughout the war.

As a diary, Molly's journal differs from the traditional format. Unlike those kept by Bobak's fellow war artists Charles Comfort and Campbell Tinning, it does not rely merely upon the written word for the expression of thoughts. Instead, her journal is a combination of visual images and words, a combination Bobak had already developed in an earlier illustrated diary, "The Daily Chore Girl — Galiano's Dish Rag."[1] Other interesting features of Bobak's war diary include its newspaper-style format and its often humorous depiction of events. Styled as if it were a daily broadsheet, with letters from the editor and special features, the diary succeeds in preserving a real feeling for the daily events of the period, while at the same time tickling the reader's funny-bone with amusing personal anecdotes and visual puns.

Originally created for Bobak's own record and entertainment, the importance of her war journal was, almost from its conception, recognized by others. To A.Y. Jackson, for instance, an adviser to the Canadian War Records Committee on the selection of artists for the country's official war art program, it demonstrated the artist's potential as a war

[1] In 1992 Molly Lamb Bobak donated her diary "The Daily Chore Girl — Galiano's Dish Rag" to the National Archives of Canada (acc. no. 1992-450).

artist.[2] To others, particularly her fellow CWACs, the diary with its many insightful observations and comments about life in the CWACs represented an invaluable record of the CWACs' role in the war effort. This idea is clearly demonstrated in an article that was published in June 1945 in *C.W.A.C. News Letter:*

> When the war is history and army careers a past, Lieut. Lamb's scrap book should be made available to all Cwacs ... that they may live through its pages and echo the chuckles that are saved there for the future ... It is our story, told by one of us as it was lived by us all.[3]

Over time, the value and uniqueness of Bobak's war diary as both historical record and work of art have become more apparent. The growing interest in Canadian women's history and in women artists in Canadian art history, as well as an ongoing interest in Canadian military history, has ensured this. While the existence of the diary has long been known, it was not until 1989, when the artist generously donated her remarkable collection to the National Archives of Canada, that the work became widely accessible to researchers. This work is now regarded as one of the treasures of the National Archives of Canada. It is with great pleasure that the National Archives has co-operated in this long-awaited publication of the war diary of Molly Lamb Bobak. We know that Canadians in every walk of life will read and enjoy this marvelous record of our past.

Terresa McIntosh
Art Archivist
Documentary Art and Photography Division
National Archives of Canada

[2] National Gallery of Canada, 7.1-J Correspondence with/re Artists (Jackson, A.Y), file 4, letter from A.Y. Jackson to H.O. McCurry, March 28, 1943.

[3] "Life as it's painted," *C.W.A.C. News Letter* 2, no. 5 (June 1945): 10–11.

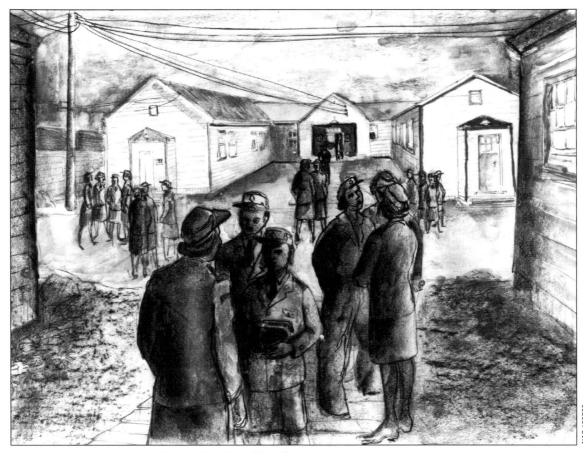

At Canadian Army Trades School, 1943, Hamilton, Ontario

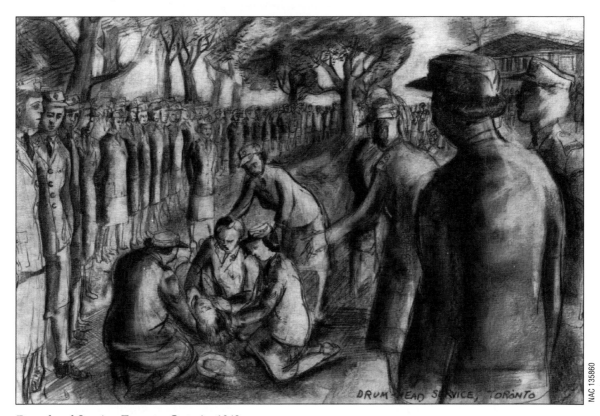

Drumhead Service, Toronto, Ontario, 1943

INTRODUCTION
The Genesis of *Double Duty*

———————— ◆ ————————

I n essence, every book begins with an idea that has surfaced in the mind of a writer. The idea may be the product of a random flash of insight or inspiration, or more likely of something that has evolved through an internal filtering process, almost subconsciously, until it finds its own expression. It was this "filtration syndrome" that led to my interest in Molly Lamb Bobak — the first Canadian woman to be officially designated as a war artist.

During the past decade, increasing interest in the Canadian experience in both world wars has been reflected in a plethora of books, plays, exhibitions and documentary films. Most recently, a widely publicized television series — "The Valour and the Horror" — which documented aspects of Canada's military involvement during World War II, presented a controversial new perspective on events long past. In terms of visual impact, one of the most dramatic elements of this three-part mini-series was the inclusion of a number of highly evocative paintings and drawings culled from the collection of the Canadian War Museum. This recognition of art as a reflection of the human condition in time of war came as a personal affirmation of my own efforts to document the wartime experiences of Molly Lamb Bobak, a talented young Vancouver painter, fresh out of art school, who enlisted in the Canadian Women's Army Corps in November 1942 full of patriotic zeal, but armed with a singular ambition. She wanted to become a war artist.

For more than two years she pursued this elusive goal with unflagging determination. Her efforts were at last rewarded by her inclusion, as the only woman, in the roster of thirty-three designated war artists. However, her appointment for overseas duty was only approved once peace in the European theatre was assured by the surrender of Nazi Germany in May 1945.

My first awareness of the existence of Molly Lamb Bobak and her artistic accomplishments was entirely peripheral. It came through a letter written to me in 1984 in connection with research I was doing for a projected book on the wartime experiences of Canadian servicewomen during World War II. (My correspondent was, in fact, an American who had chosen to come up to Canada along with a number of her compatriots. Because the age limit for enlistment for military service in the U.S. was twenty-one, compared to eighteen in Canada, she opted for a cross-border solution.) Her letter, accompanied by several photographs, included a brief excerpt from one of her own letters home — dated June 14, 1945:

> One of my friends — Molly Lamb — is finally getting a real break in the war; although in the usual stupid way, they've kept her around doing nothing for nearly two years now. She's an artist — and a damn good one and she's just been appointed the first woman war artist in Canada. She's got her commission and she's going overseas for eight weeks on command. (Incidentally on ten dollars a day command pay!) It has worked out beautifully at last. She'll be over long enough for the experience end of it and be able to do a good job painting;

yet won't be over there for years as most of the girls who are over there now with the occupation troops are bound to be. (Letter from Barbara Cole Feiden to Carolyn Gossage, April 7, 1984)

"That's interesting," I mutter as I place the letter in my correspondence files. "Good for Molly Lamb!" I then proceed to immerse myself in a morass of paperwork, interviews and transcription. Light years later, in the spring of 1991, when I have come up with something vaguely resembling a manuscript and, better yet, have found a publisher who is actually enthusiastic about turning it into a book, it is time to think about the selection of photographs and a cover. By now I have accumulated a fairly impressive array of period piece photos, but which photo will be most effective for the cover?

After much deliberation, the dilemma is solved. Why not select a painting from the collection of military art at the Canadian War Museum? Why not, in fact, a painting by Molly Lamb Bobak, formerly of the Canadian Women's Army Corps, whose work continues to receive accolades and critical acclaim across Canada.

In high anticipation, I set off for Ottawa and the storage vaults of our national war museum at Vimy House. It seems that only about 10–15 percent of the museum's collection is on display at any given time, due to lack of exhibition space, but I have been assured that one of the Vimy House staff will be pleased to be of assistance when I arrive.

After going through the signing-in formalities, I am introduced to an archivist who graciously places herself at my disposal and leads me through the labyrinth. As I enter the cavernous temperature-controlled "inner sanctum" where the visual record of our military history — rack upon rack of it — is preserved for posterity, I am overcome with an indescribable sense of awe. It is all here. The battlefields, the convoys of the North Atlantic, the dogfights in the sky. And dozens of portraits — an infinity of landscapes of the human face.

For the moment, though, Molly Bobak's work is the priority. One by one the racks are slid out. From published reproductions, I recognize her magnificent portrait of Private Roy in the canteen, the glorious V-J Day celebrations in London in August 1945, the Canadian Women's Army Corps marching off on Sunday church parade, and other canvasses less familiar but unmistakably the work of Molly Lamb Bobak, captivating in their distinctive stylistic blend of whimsy and strength.

I wander through the racks and back again. I stop to admire the work of two other Canadian artists commissioned to paint women's contribution to the war effort, marvelling over the spontaneous energy of Pegi Nicol Macleod's great swirls of colour and the hard-edged angularity of Paraskeva Clark's oils. Then back to the quest for the Bobak painting that will be exactly right as a companion piece for the book's title, *Greatcoats and Glamour Boots* — a painting that will best evoke remembered times and places for the 45,000 women who enlisted in the service of their country during World War II as members of the Canadian Women's Army Corps, the RCAF Women's Division or the Women's Royal Canadian Naval Service.

And suddenly I know I've found it: *CWAC Officer Cadets and N.C.O.s Waiting for the Montreal Train* (1945) by Molly Lamb Bobak. A CWAC officer stands in the soot-speckled snow just below the wooden platform. She has an air of watchful authority as she looks up at her flock shivering in their greatcoats while they listen for the train whistle. A uniformed soldier stands stiffly to one side, next to a priest. On the other side a fashionable woman and her little girl in red peer down the track. Above them, the red peaked roof of the Ste. Anne de Bellevue station, iced with snow, provides shelter from the flakes that fall from a leaden sky.

If I had struck gold, I could hardly have been more ecstatic. I decide to telephone Molly Bobak in Fredericton and share my excitement. We talk or, more accurately, she

listens patiently as I babble on about the painting and how wonderful it is to have found it. At this point she asks if I have seen her war journals. She's just recently given them to the National Archives. "They're rather fun," she tells me. "Perhaps if you're interested and can spare the time, you may want to take a look at them. There are quite a few illustrations and sketches, because I wrote it as a sort of pseudo newspaper. Actually, I offered to give them to the War Museum ages ago, but they didn't seem to want them, so I'm happy they've gone to the archives!"

I leave for Ottawa the following week. Terresa McIntosh, archivist in the Documentary Art and Photography Division, gives me a warm welcome and ushers me into yet another temperature-controlled chamber. Here we find the original pages of Molly Bobak's "newspaper" journal, carefully stored between protective layers of tissue-like paper. Several pages are illustrated in watercolour. The rest are embellished by pen and ink or pencil drawings, and all are wonderful beyond expectation.

I spend the rest of the day with a magnifying glass, peering at the photocopied pages that Terresa has given me to read through and admire. I am barely through the first page before I start to grin. The inherent charm and humour of the diarist are immediately captivating. Before long the researcher sharing the table with me is compelled to ask the inevitable question: What's so funny? We are, after all, in the National Archives. "Well," I tell him, "actually, it's a war diary." A war diary! Quizzical look.

Molly Lamb Bobak's diaries are, in fact, far more than the usual hand-written random jottings entered as a personal record of daily joys and travails. Rather, they are a lively and richly illustrated chronicle — a self-published series of news bulletins, with Molly Lamb and her CWAC experiences providing the subject matter for imaginary members of the press who report events of note on a weekly basis for almost three years.

The first edition of "W110278" (published "in between serving soldiers in the canteen between 6–10 at night") is dated Vancouver Barracks, November 22, 1942. It is dedicated ("humbly") to A.Y. Jackson and the headline announces: "GIRL TAKES DRASTIC STEP! 'YOU'RE IN THE ARMY NOW.'" Volume One takes the reader through Private Lamb's induction into the Canadian Women's Army Corps in Vancouver and on to basic training at Camp Vermilion in Alberta. It is here that the new recruits (a.k.a. "guppies") receive their first dose of regimented military life. They are introduced to marching and drill, to the dreaded innoculations and to the general routine that countless other young Canadian men and women are experiencing first hand across the country.

Subsequent volumes of "W110278" log Private Lamb's reactions to her various cross-Canada postings and assignments from November 1942 to the spring of 1945. They present often hilarious insights into off-duty activities and antics. These lively accounts, told from the vantage point of a high-spirited twenty-year-old art student who desperately wants to become a war artist, are entertaining in themselves, but it is the engaging illustrations she has created to accompany her reportage that bring it to life. They bear witness to her exuberant vitality, but more importantly, they demonstrate a talent that clearly cannot — and will not — be contained.

This is confirmed by a handful of fine and evocative drawings that I come upon after reading the last entry. They are, in effect, an eloquent visual postscript to the Bobak journals. I am immediately determined that at least some of these drawings will be included in my book on Canada's World War II servicewomen.

As it turns out, everyone involved is equally charmed. There is general consensus that selected drawings would be ideal as chapter divisions. With the co-operation of the National Archives, I arrange to have the necessary reproductions completed in time for the publisher's deadline and I wake up to find it's all over.

Mission accomplished. But another mission has begun to percolate ...

Now, in this present volume, nearly fifty years after the fact, Molly Lamb Bobak's unique contribution as the first woman in uniform to be officially designated as a Canadian war artist will find the wider audience it deserves.

Note: Since the pages of "W110278" — Molly Bobak's newspaper-diary — represent a distinctive form of documentary art, it seemed imperative to present the selected excerpts in their original form. However, because the reportage was written by hand and is thus occasionally difficult to decipher, a compromise solution has been implemented. Each of the hand-written pages has been reproduced as a kind of miniature "thumbprint" to accompany the transcribed text and details from the original illustrations. The "thumbprints" as well as the reproductions of complete works are identified by the catalogue number of the appropriate body – either the National Archives of Canada (NAC) or the Canadian War Museum (CWM).

For purposes of continuity and context, the diary selections have been divided into chapters. In turn, each chapter is introduced by a brief preview of the pages that follow. In essence, these introductory passages are intended as bridges between the various stages of Molly's army career as she struggled to fulfil her ambition to become a Canadian war artist.

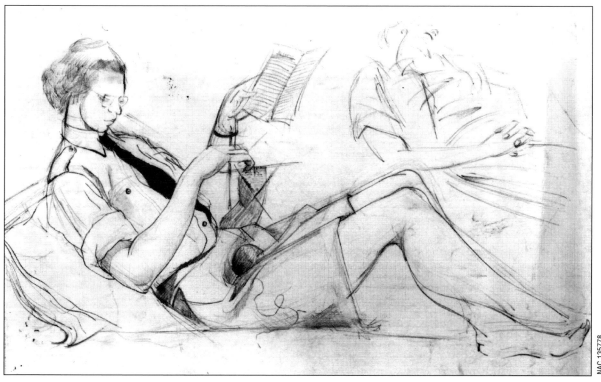

NAC 135778

CWACs relaxing, 1943

PRELUDE TO
"W110278"

———————— ◆ ————————

Do artists need a special environment? I think some do; but I also think that a person's painting really does come from within. My father was quite interested in painting. He knew the Group of Seven and fought for them, so he had a lot of their work around the house ... I just grew up with these things all around me and started drawing just as all children do.

— Molly Lamb Bobak
CBC Interview, Fredericton, N.B.
April 16, 1966

Growing up in Burnaby Lake, British Columbia, in the 1920s, young Molly Lamb was highly unlikely to have found matters of artistic environment to be of much consequence. All she knew was that she hated school ("except for kindergarten") but loved to paint and draw. And even this did not strike her as anything different or unusual. It was simply something she did.

Molly remembers her childhood in Burnaby Lake as a time of laughter and delight. In *Wildflowers of Canada: Impressions and Sketches of a Field Artist,* she writes:

How much space we had! Meadows, woods, tangled gardens, streams, ponds — and, of course, the deserted old Mervin house, with its dark weathered wood and broken windows ... There were water lilies on Deer Lake and transparent amber water smelling of reeds and Oriental poppies growing at the edge of the lake .

Molly's childhood exposure to the idyllic woodland environment of Burnaby Lake and the familiar presence of painters and their work may well have had a distinct bearing on her own artistic development. (A.Y Jackson and Fred Varley occasionally dropped by for a visit with her father, H. Mortimer Lamb, a long-time friend and supporter whom they had known in Montreal long before the Group of Seven evolved. Lamb had been president of the Canadian Mining Association at the time and was among the first to recognize the potential of their work.) In any event, Molly's natural inclination to draw and paint, together with her antipathy to formal education, led her straight to the doors of the Vancouver School of Art. At sixteen, she entered a four-year program, followed by a year of post-graduate studies. One of the teachers who most inspired her was Jack Shadbolt.

Then, during the summer of 1942, Molly took a summer job on Vancouver Island working at Yellow Point Lodge. By now, Canada had been at war for almost three years. Hong Kong and Singapore had fallen and the "relocation" of the Japanese living on the West Coast was well under way. After Pearl Harbor, fear of an impending attack by Japan had become the raison d'être for dispossession on a grand scale. Only in retrospect do we realize the shameful magnitude of this officially enforced exodus that was so quietly but effectively orchestrated in the name of national security.

Like many others of her generation, Molly was only vaguely aware of the government's solution to the perceived Japanese threat in British Columbia. For most Canadians, the larger war was the one being fought overseas. Britain was still under siege from the air and the names Dunkirk and Dieppe had become synonymous with death and defeat. Recruiting posters were everywhere. Exhortations to join up were carried from coast to coast — on the radio, at the movie theatres, in the newspapers and magazines. And by the fall of 1941 women were included in the nation's mobilization campaign. Both the army and the air force had begun enlisting recruits for the Canadian Women's Army Corps (CWAC) and the Canadian Women's Auxiliary Air Force (CWAAF — later designated as the RCAF, Women's Division). The navy followed suit within the year.

But twenty-year-old Molly Lamb had already decided on the army. "GIRL TAKES DRASTIC STEP" — the headline in the first edition of her wartime chronicle — became an overnight reality in November 1942.

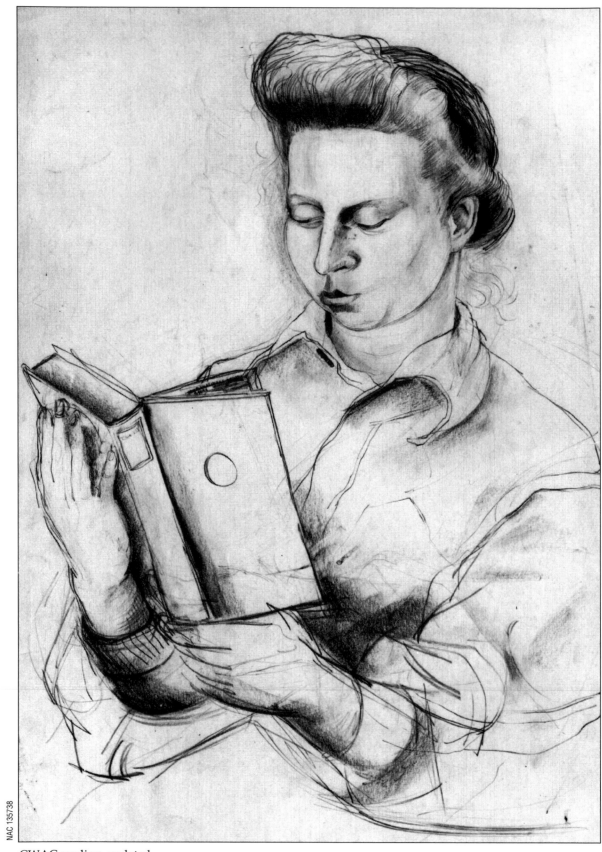

CWAC reading, undated

W110278

THE PERSONAL
WAR RECORDS

OF
PRIVATE LAMB M.

THIS BOOK IS HUMBLY
DEDICATED TO
A.Y. JACKSON

O N E

---◆---

"YOU'RE IN THE ARMY NOW"

(November 1942 – February 1943)

The decision to enlist as a recruit in the Canadian Women's Army Corps — to become Private Lamb, M. — Service #W110278 — is a spontaneous one and like the majority of her uniformed counterparts, Molly is naively unprepared for the depersonalization process that lies ahead. The mandatory medical and signing-up procedure goes well enough, but the first real shock to her sensibilities comes when a bustling private — brusque and uncommunicative — shows her to her quarters in the Vancouver Barracks and tells her, in passing, that she's going to have to learn to walk a lot faster.

"It was bare, bare, bare," she recalls, "even to the naked light bulb over the brown double bunk which was to be my bed — the top half. I wondered what I'd done ... I decided to go out into the grey November air as fast as I could, but they wouldn't let me. I had to have a pass."

Eventually she manages to procure permission to go and meet her mother. The ensuing tale of woe, coupled with an uncharacteristic lack of interest in food, alarms "Mum" to the point where she is prepared to move heaven and earth to extricate her daughter from the clutches of the military. A letter to Prime Minister Mackenzie King will take care of it. Not to worry.

Within a few days, however, the need for rescue is all but forgotten. Private Lamb has taken a new lease on army life. Her roommates are fun. Washing dishes in the basement canteen is fun. Even the food passes muster. And in her spare time — what there is of it — Molly begins working on the first edition of "W110278."

A month later, the scene changes radically as Molly finds herself en route to basic training camp in the far reaches of Vermilion, Alberta. The record of the journey — "published on the C.N.R." — opens with the headline "LAMB LEAVES FOR TRAINING: 24 HOUR BEDLAM FOR HARASSED PRIVATE AS BASIC TRAINING LOOMS!" and the accompanying artist's version of a "photo opportunity" shows Private Lamb surrounded by the uniformed crowd waiting to board the train. She sits perched on a suitcase with a sketch pad balanced on her lap.

When the train pulls into the Vermilion station at 5:30 a.m. two days later, our new recruit discovers that the thermometer reading is 33 below zero. She is still wearing West Coast gear — a short tartan skirt, saddle shoes and bobby socks, no hat, no gloves — and gains instant notoriety by having to be driven to the barracks in the staff car while the rest of the new batch of "guppies" are paraded through the snow to the old Agricultural College converted for wartime use.

Ensuing editions of "W110278" vividly depict the rigours of a month of basic training. Molly's sketches of "A Typical Day" — which begins at 5:30 a.m. — are eloquent testimony to the common ordeals these trainees endure in such remarkably good spirits. There is the bewildered neophyte being introduced to the use of a gas mask respirator; the waitress-in-training vainly attempting to juggle serving bowls, plates and coffee and still keep smiling; and, best of all, the frost-bitten recruits on the windswept parade square as they "DRILL, DRILL, DRILL IN THE COLD, COLD SNOW!" with collars up and earflaps down.

Molly's first Christmas away from home is described as "a great adventure":

It was a night of ice and mystery, as if the story of the Snow Queen by Hans Christian Andersen and the Nativity were put together. I did my rounds, carrying my siren and flashlight ... Through the snow I went, into the Q.M. building, across to the officers' quarters and back around the school. And all the time the moon floated above the trees and the lights shone on the fire escapes, and the snow crunched under my feet.

At last it is ten o'clock — "Shift over!" Away goes Private Lamb along the road to Vermilion to the welcome warmth of the Boston Cafe for coffee and sandwiches. Then on to midnight mass — the inspiration for a full-page illustrated poem that marks the final edition of "W110278" for 1942.

Lamb's New Year's entries about "The 'Private' Life of Basement Bay" are written in a more frivolous vein, purported to be full of "authentic truths" about the twelve roommates who share stories of home and boyfriends, cigarettes and food fantasies, laughter and dreams. Molly's ability to capture the essence of an era is coming into its own. But her dreams of becoming a war artist seem far too distant. She resolves to be patient — if only for the moment. Besides she's having an adventure. She's in the army!

After a month at Vermilion — "marching about with arms swinging, shining buttons, having drill, learning about VD and first aid, and singing inane songs like 'Hitler, the CWAC's Are on Their Way! Britain Expect Us Any Day ... The Nazi Blighters Will Pay'" — it is time for the assembled trainees to be dispatched in various directions to perform their assigned duties.

For Molly, the Vermilion experience represents a personal discovery: "It was a certain comfort to understand that basically we are all alike. Maybe the CWAC uniform had something to do with it, or all that marching we had to do together."

While her former roommates head off to their new postings, Molly remains in Vermilion to begin training the next batch of guppies. She is promoted to the rank of lance-corporal and is elated when her particular talents gain new recognition. Volume Two of "W110278" announces: "ARTIST GETS WONDERFUL CHANCE TO EXECUTE GREATEST EFFORT." Molly has been asked to create a six-foot mural in the Personnel Selection building. It will highlight all the trades offered by the CWAC. "See? Here is a cook and there a driver, and the girl with the dressmaker's dummy is a seamstress. There is a Sergeant instructor — a hospital assistant, a wireless operator — all in traditional blue line of the great Paul Cézanne. Already the possibilities are alive!"

But work on this artistic challenge is rudely interrupted by orders from on high. Lance-Corporal Lamb has been singled out as potential N.C.O. material and is scheduled for transfer to a non-commissioned officers' training school in Ste. Anne de Bellevue, outside Montreal. This is sure to provide new scope for her sketchbook and journal. She boards the train in Edmonton in high anticipation, and it rolls off down the track. It is Molly's first taste of cross-Canada travel. With her nose pressed firmly against the windowpane, she revels in it.

NO.1 EDITION
PUBLISHED IN BETWEEN
SERVING SOLDIERS IN THE
CANTEEN — 6 TO 10 AT NIGHT

W110278

PUBLISHED DAILY
VANCOUVER BARRACKS
NOVEMBER 22ND 1942

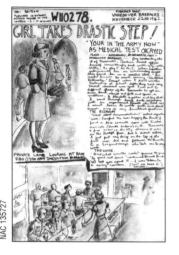

NAC 135727

GIRL TAKES DRASTIC STEP!

"YOU'RE IN THE ARMY NOW" AS MEDICAL TEST OKAYED.

FLASH ... WEDNESDAY, NOVEMBER 18, 1942

VANCOUVER BARRACKS ... On Wednesday, the 18th of November, Civilian Lamb offered herself unwillingly and willingly, willy-nilly, to the CWAC. When reporters interviewed her on Wednesday night they found her in a mental state. "I've never known so much misery," she stated torturedly. "Except when I didn't win the scholarship at school. After they said my second medical was good, I was sent to different floors of the Barracks to get an arm band, a knife and fork and spoon, a mattress, 3 blankets, a pillow and two sheets ... I went through long dark corridors with an experienced Private who told me I must learn to walk faster and didn't answer any of my bewildered questions."

THE BEDROOM

"What about accommodation?" asked reporters. "Well," laughed the now-happy Pte. Lamb, "I found a bare concrete room with twelve iron cots (double deckers) in it. There was a fine view of the city because it was on the twelfth floor, but I didn't notice. I just put my things on top of the first iron bed and followed the Private to a Sergeant-major who took me to my work."

THE WORK

"And what was the work?" queried the press. "If you're not bored," continued Private Lamb, "I'll tell you about it ... I was taken to a noisy canteen, where I met the Corporal and there were lots of girls in green uniforms. The Corporal took me into a dark, small room with two benches in it and some CWAC uniform tunics hanging on pegs.

"'Here' said the Corporal, 'Here is a uniform for you.' So I put on a size 16 and pleaded, 'Can I do dishes instead of serving?', because I was scared to go to the counters. So I was allowed to." "And then?" asked reporters. "Well, then I did dishes," stated the well-fed Private with a smile. "And then I went home and got my suitcase and spent a while getting consoled by my mother. I came back to Barracks and climbed miserably into my bed. I said my whole Rosary in my misery before I went to sleep. So ended my first day in the Army."

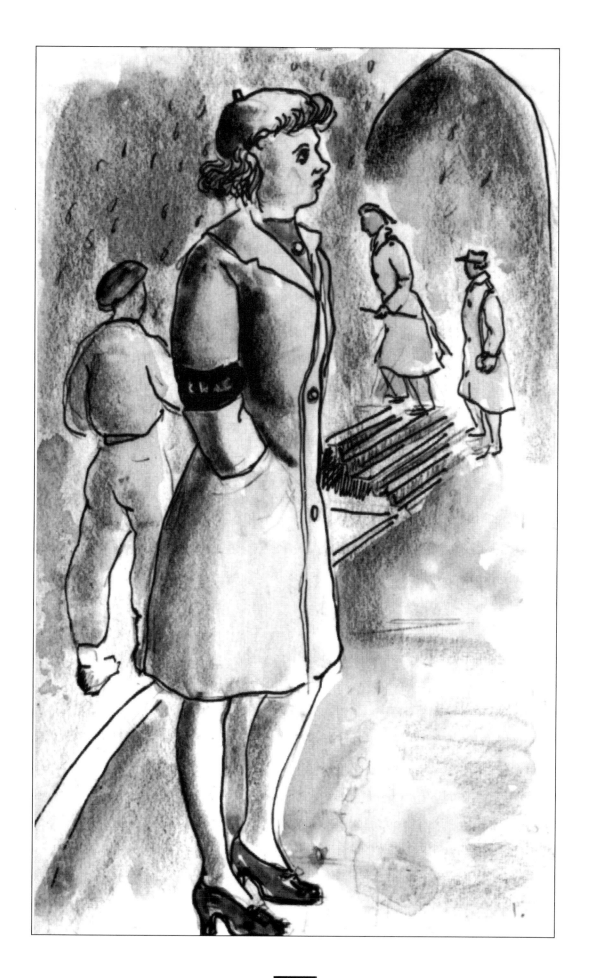

FRIDAY ENDS MISERABLE BEGINNING

BUT MARRED BY DEPARTURE OF GREAT FRIEND AND ARTIST, PTE. ASPELL

"Who would have thought," mused Private Lamb after lights out on Friday night, "that this time last year when Peter and I were at the art school — who would have thought that I should be in this army cot and that Peter will leave tomorrow for Camrose, Alberta with the Royal Canadian Engineers? Well, I wouldn't!" Authorities are led to believe that although the Farewell of Privates Lamb and Aspell was a tragic affair, it was not at all hopeless.

Camrose is near Edmonton, and Vermilion, where Pte. Lamb will be sent to train is also near Edmonton. "So," beamed the the hopeful private, "maybe we can have Christmas together. Besides, I feel better now — the Army is O.K."

DAY TWO BEWILDERS ALREADY BEWILDERED PRIVATE!

RECRUIT LAMB FINDS OUT HOW THE ARMY EATS — OUR CAMERAMAN TOOK THIS AT 5 O'CLOCK ON THURSDAY, NOVEMBER 19TH. ASKED REPORTERS "HOW WAS THE FOOD?" STATED PTE. LAMB, "VERY GOOD!" "DID YOU EAT IT?" "NO, NOT UNTIL THE NEXT DAY."

TO OUR READERS

This is the first in a Daily Series of illustrated papers to be called WII0278. They will be continued until the end of the war and will describe the egotistical life of one Private Lamb of the Canadian Women's Army Corps. And with the permission of other members of the army (and sometimes without) there will be illustrated articles and poems of incidents which happen every day.

Don't fail to read the second number with actual living scenes of Bedroom life in the Vancouver Barracks! Authentic in every detail! We hope you will like our effort which for the time being is published while serving customers in the canteen. The Editor.

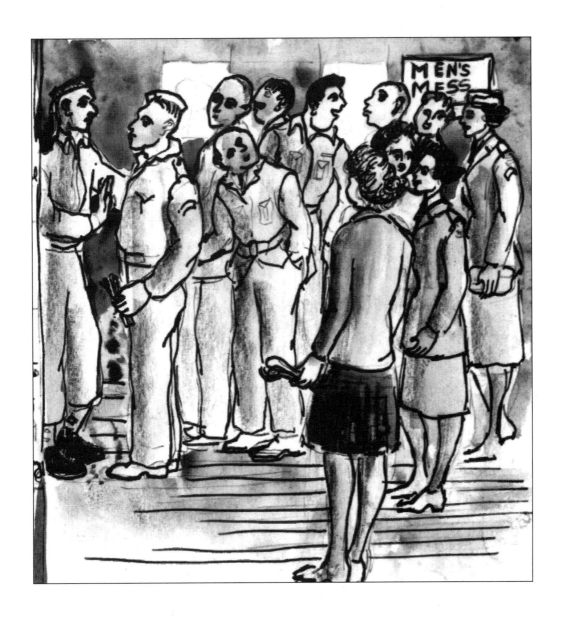

FAST FRIENDS FOUND

"Well, I'll start from my bunk and work towards the window," shouted Pte. Lamb. "Mary sleeps below my bed. She's a short little girl — I guess about 19 or so and she used to live in a place called Westholme on Vancouver Island, where there are five bridges and a beautiful river and this river becomes full of dying salmon in the autumn. I remember seeing them splashing helplessly in the shallow water and the gulls and crows killed them." (Reporters steered the conversation back to Mary at this point.) "Well, Mary is very cheerful and she wouldn't get mad, I think, and she lets you share the bathroom in the morning and she tells you about rules and things you don't understand."

LETTERS THRILL SOLDIER

ALTHOUGH NOT LONELY, LETTERS FROM HOME ETC. KEEP PRIVATE CHEERFUL

"Almost every time I go to the Orderly Room there is a letter from home," beamed Rookie Lamb E.A.L. (Enjoys Army life) E.F.D. (except for dirt). There is nothing so good for "that intangible something called morale as a letter. Now that I am on the inside let me remind all mothers that it is most important to keep writing."

VISIT TO PRIVATE HOME PROVES FATAL ...

"HOW CAN WE HOPE FOR A GOOD WORLD WHEN IGNORANCE IS RAMPANT?" ASKS MOODY GIRL AFTER VILE SOCIAL EVENING

Sunday evening ... Vancouver was bathed in the golden light of a November sunset and Private Lamb thought a walk in the Park would be fine after a day in the Basement Canteen, but Pte. M. Gallon (true name withheld) F.S.S. (fat sandwich spreader) C.G.B.N. (collosal but good natured) invited Pte. Lamb and Corporal H. Pathetic (true name withheld) D.O.H.F. (dead on her feet) to her home for dinner, as there was no taking no for an answer. Pte. Lamb had to go with a fixed smile on her face. Stated Private: "We got on the street car and went almost out to Marpole. The air was so fresh, but we were herded into a small overheated airtight house. Corporal Pathetic and I sat on the furniture suite and talked with Father.

"Behind me on the wall was a sign in gold and red which said, 'JESUS ONLY' and on a stool were six orange books by Zane Grey and a dictionary. We had a fairly pleasant but overheated time at supper because we ate off thin plates and we had chicken, and lemon pie, but after that we spent the whole evening discussing nothing." It is reported that the hot and uncomfortable private sat through it all and later she was asked to talk Scotch. "The climax," she later told the press, "is that I said, 'Aye, and I think I hear a street car and if I'm no mistaken it's gettin' late — aye!'"

SOCIETY NOTE

Noticed at the hotel on Tuesday night were four members of the Y.P.L. Society of S. (Yellow Point Lodge Society of Slaves) (Private Lamb worked there during the summer). The four members indulged in burgundy, tamales, "My Sister Eileen" (a movie) and pineapple sundaes. Private Lamb thought it one of the finest nights she has had since her confinement. "And I was in by twelve," she commented.

PUBLISHED IN THE
CANTEEN. AT 9 O'CLOCK.
NUMBER IV

W110278

VANCOUVER BARRACKS
DECEMBER SECOND, 1942.
WEDNESDAY.

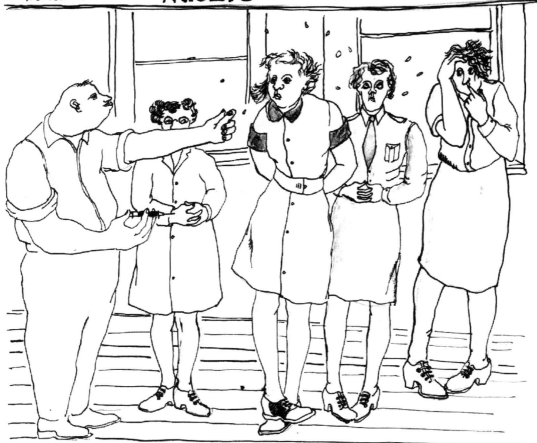

THIS IS THE INOCULATION PARADE AND · · · ·

THIS IS A BLOOD TEST

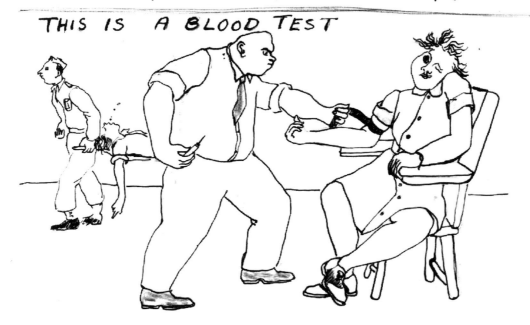

NUMBER VI

W110278

PUBLISHED ON THE C.N.R. TRAIN
DECEMBER EIGHTH,
WEDNESDAY, 1942

LAMB LEAVES FOR TRAINING

24 HOUR BEDLAM FOR HARASSED PRIVATE AS BASIC TRAINING LOOMS AT CAMP VERMILION, ALBERTA!

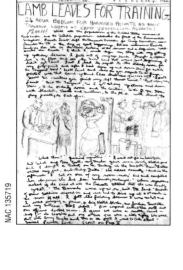

FLASH — While all the population of the United States remembered Pearl Harbour and the Catholic population celebrated the feast of the Immaculate Conception, Private Lamb left the Vancouver Barracks for Camp Vermilion, Alberta.

December 7th — the day of the great happenings. Let us interview Private Lamb as she sits in the train looking at the snow and a deep river. "Well," smiled the Private, "I think I must begin my story with my getting up yesterday, because I fell out of my top bunk, through a clothes line to the floor and all the kids said that was a good beginning. I didn't get hurt. First I had to report to the orderly room for my finger prints and after I had been up and down stairs for awhile the sergeant said, 'Well, Lamb ... and how do you expect to be fingerprinted with that bound-up thumb?' ... 'I don't know, sir, unless you print my left thumb twice.' 'Get along, now, Lamb,' said the Sergeant, so I got along upstairs and downstairs to the orderly room and the canteen, to the Q.M. (Quarter Master's) stores with blankets, sheets and mattress, to the M.O. (Medical Officer) with thumb (caught in window earlier), to pay parade, to the Post Office."

"What then?" queried reporters. "I went out for an hour to the Art School and Mr. Scott, my teacher gave me a lovely sketch pad and I bought a ticket on a turkey in the Seaforth draw. I also visited my pal, Archbishop Duke," she added casually. "And in the afternoon I sat on one of my room-mate's beds and comforted her because she had been honourably discharged." When reporters asked if she cried at all, the Private stated that she was terribly upset. "The Barracks were upset, too," continued Private Lamb, "Hundreds of new soldiers moved in and we had to line up at six o'clock in the main hall. I felt like fainting, because I was so hot. I was carrying a purse, four big sketch blocks, an Indian sweater and my suitcase. But I didn't (faint).

"Our corporal called the roll and the officers looked us over. I guess we were a motley crowd — half of us in civvies and one or two of us were a little tipsy. We were put into army trucks and this is the part I want to talk about," smiled the Private. "You see," stated Private Lamb, "most people just hear about troops moving, but they don't get a chance to actually be a troop in a truck. We moved out of a high brick archway with our suitcases and kit and soldiers helped us into the lorries. I sat against the wall and looked out between khaki backs at the warm lights and misty rain. It was so wonderful and we waved and sang all the way to the station. I didn't, though. One girl sang louder than everyone and she put disagreeable trills and sobs in the 'White Cliffs of Dover.'"

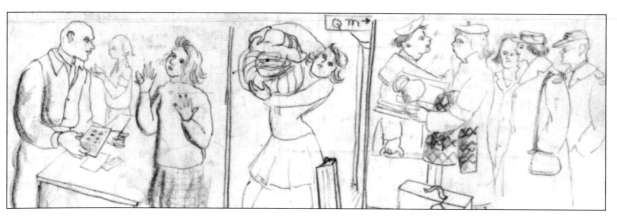

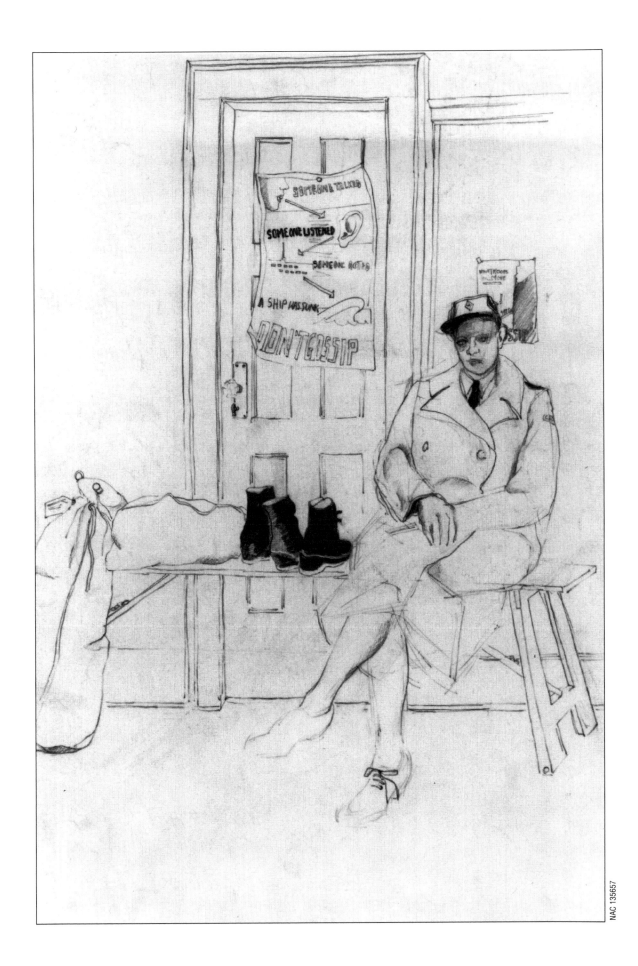

SNOW AT STATION

"The trucks stopped in the station yard and we came out, down to the slush on the ground. The engine was steaming and a few conductors stood about and then we all filed into the station. Some of us had people to see us off. I had Uncle Stew and Ena and they brought some chocolates. It is fine to have someone to say good-bye to you and my friends (Uncle Stew and Ena) waited for over an hour while we tapped and signalled to each other through the storm windows."

TRAIN LEAVES

The Private then stated that the train left the station and the new life began.

GIRL CELEBRATES FIRST NIGHT ON TRAIN

THRILL FOR TRAVELLING PRIVATE

With the help of Porter Alec, our reporters found Private Lamb almost asleep in an upper berth. But they woke her up and asked for an interview. "Surely," demurred Private Lamb propping herself up on her two pillows. Private Clearwater, Private Lamb's great friend, popped her head from the lower berth and said she would answer the questions. "Oh," said reporters, who were obviously taken aback by Pte. Clearwater's beauty. "Well, tell us — how do you like the train?" "I have travelled from Alberta, my home, to B.C. once or twice and I still get a thrill to feel the wheels pulling me along. I like to look out the window and see the snowy hills." Pte. Lamb J. (jealous) shouted that it was too bad that the Canyon (Fraser) was passed in the dark but that she was very, very tired and comfortable.

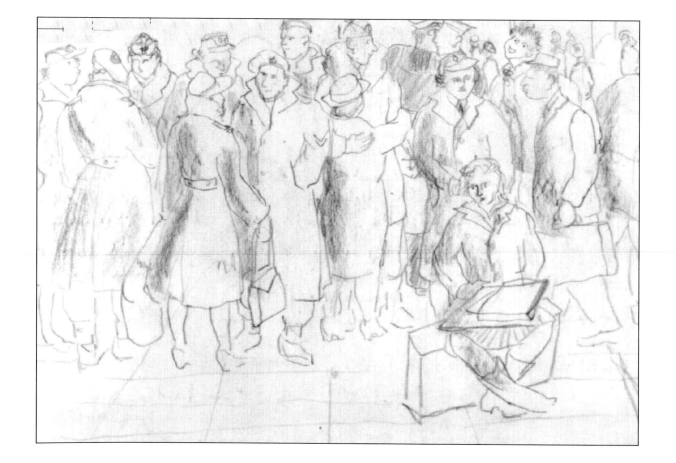

SUPER MEAL SERVED TO PRIVATES AS TRAIN TRAVELS ONWARD

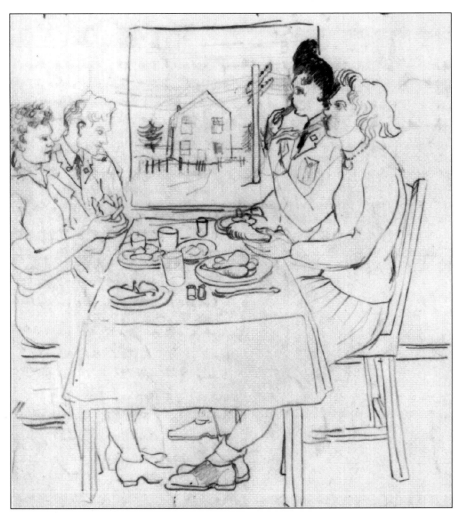

NAC 135717

SECOND NIGHT IN TRAIN EXPERIENCED BY GIRL – RUDELY INTERRUPTED BY PORTER AND OFFICER IN ALBERTA: 5:30 (A.M.)

GIRL LEAVES TRAIN STOCKINGLESS, GLOVELESS! WINTER WEATHER OF -33 BELOW!!

"Well, I hardly had time to wash," burst out Pte. Lamb to the Press. "We were told to get out of the train at 5:30 and so we had to. Out I went into the station with my sketchpads, Indian sweater and no stockings or gloves. But I did get a lovely ride to the Barracks and became notorious at once." (Editor's note: It is a known fact that Private Lamb loves notoriety.) "But, what about the station?" queried Press. "Well," answered the Private, "I ... I ... we got off as I said and in the station room we saw groups of sleepy people, who were privates from Saskatchewan, Ontario and Alberta. I noticed one with long underwear right down her legs and grease on her face. She was huge with narrow eyes and a dominating personality. The air was cold and clear."

TRAINING BEGINS WITH BANG!

PRIVATE'S EYES LOSE SLEEP AS AMAZING CORRALLING ROUNDS UP ROOKIES

"SUCH DISCIPLINE!" REMARKS GIRL, WITH EXPRESSION OF TERROR!

NAC 135716

FLASH — BASIC TRAINING CENTRE, VERMILION, DECEMBER 10 ... Our reporters followed up the Arrival Story with eagerness here this morning, even though the temperature was -33 below. The early morning was dark with a new moon shining. The lights of Vermilion made the town an exciting mystery, but the recruits were paraded at once to their barracks. Groups of them straggled through the snow for half a mile until they reached the great Agricultural College, converted into barracks. Reporters marched with girls into the gym, where, as Pte. Lamb said, "We sat for almost two hours until we were taken to the tall old wooden building where the Q.M. stores were. I remember a neat-looking person next to me and a bale of towels and two girls at a desk. They were wrapped in blankets. They were smoking and drinking coffee. A Sergeant came in with cake and my knees went weak. The recruits — or Guppies, as they are called in Vermilion, signed for silverware, towels and respirators. And then they were marched into the ... uh ... mess to eat."

Reporters asked a typical private how she liked the first Training Camp meal. "Well, it would have been good if it had been hot dishwater. We had bacon, coffee and porridge!"

ASSIGNED TO PLATOONS!

"We were then," sighed a Private, "assigned to our platoons. I noticed a red-faced girl — Private Lamb — was marched into Number One Platoon." Then the corporals went into a huddle with the sergeant and then the platoons were marched off to sleeping quarters. Let us follow the much-pulverized Private Lamb, marching along the corridors with a bewildered look.

THE BASEMENT BAY!

"Private Lamb," asked reporters, "won't you tell us something about your first reaction to your sleeping quarters — the Basement Bay?" "With pleasure," said Private Lamb. "First of all, twelve of us were herded into the room, so that meant there were six double-decker beds. We slung our blankets on any bunk we fancied and then looked at each other to see who we had to get along with. I was lucky because Pte. MacDonald from Vancouver was with me and she and I have a mutual friendship with Uncle Stew and Ena (see story of dramatic send-off at C.N.R. station). There were two other girls from Vancouver and the rest came from the prairies and the Peace River ..."

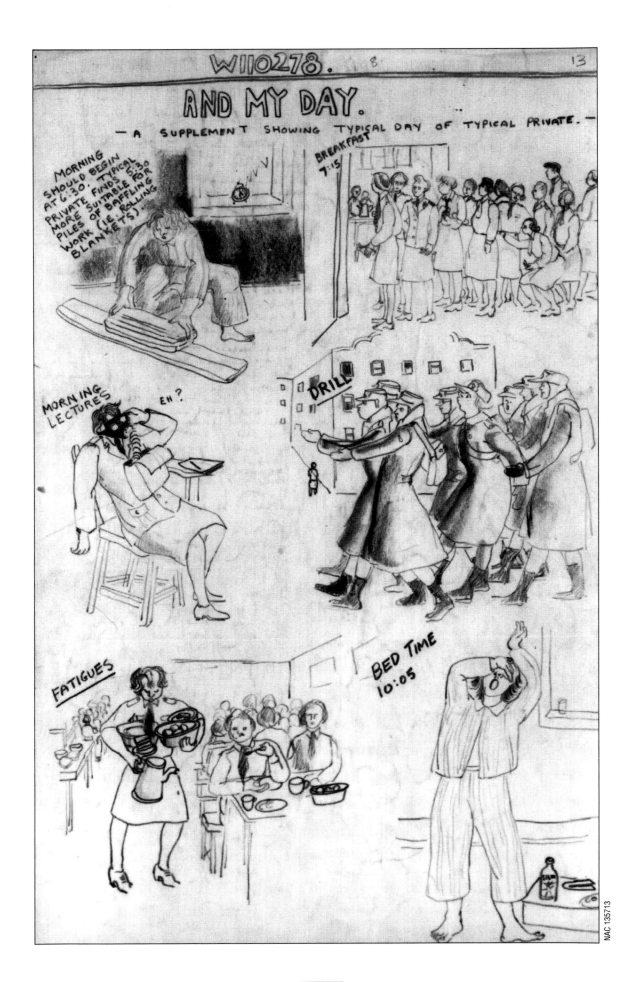

"HAVE I PULL OR LUCK?" ASKS ARTIST

NOTICE ON DUTY ROSTER INFORMS PRIVATE THAT TURNIPS, POTATOES WAIT IN KITCHEN.

"I was informed," reported Private Lamb, "that I must report to the kitchen at fifteen minutes to six on the following morning." On the following morning Pte. Lamb reported with Ptes. Leighton (standing) and Lenky (back view) and was put to work peeling turnips. ("Which," smiled the Private, "was not bad.") Later the privates peeled potatoes, which — by reports — is merely depositing potatoes in machine (see cut) and then, in reclining position, picking the eyes from same.

"Well, we did slit a cabbage or two, peel a dozen onions, wash a floor or two, but that is called "fatigue." The rest of the time," mused Pte. Lamb, "we talked boy-friends (censored to the Press, regrettably) and politics, until we were sent to get our respirators for a gas drill. I took the opportunity to get my sketch pad and the cook became interested. So I drew away all morning and gave the cook a picture of herself out of gratitude. The Army," confirms Pte. Lamb, "is alright."

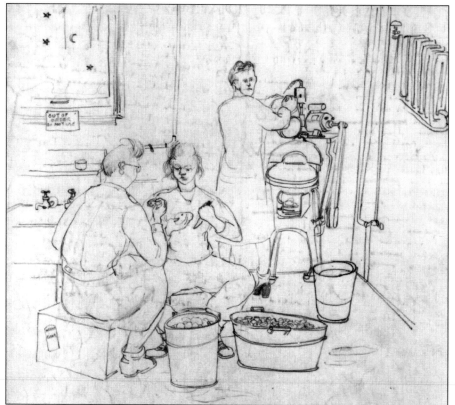

DRILL, DRILL, DRILL AS GUPPIES TURN PROS OUT IN THE COLD, COLD SNOW

{This article deals with "Things you ought to know about Basic Training" by a Model Private O.W.K. (one who knows).}

There are certain things in the army that are necessary and one of them is drill. If you ask the question "Why?" I would reply, "Because."

Drill in the Spring may be pleasant, but I shall tell you about drill in the winter.

Typical day — Tuesday. Typical time — ten o'clock. Typical platoon — Number One. Typical weather — North wind (fierce), snow, 30 below. The platoon is marched out with many insults and abuses. They stop at the parade square with inferiority complexes and frost bite. Just as they are concentrating hard — also other suffering platoons — they hear a dreadful siren — GAS! They fumble with respirators and drop their caps on the ground. Their hands freeze hard before they can get into their mits again. Then hundreds of amusing orders are shouted to them, making them hysterical inside their gas masks.

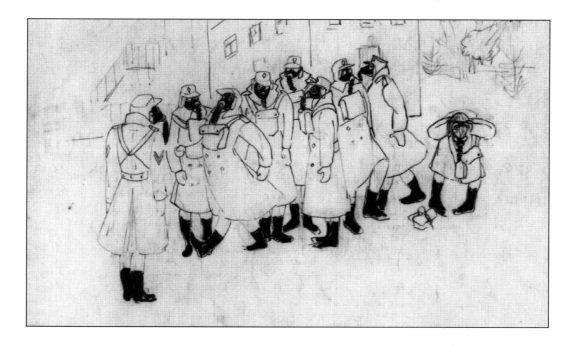

DECEMBER 16 – 20th

CHRISTMAS SHOPPING LOOMS!

BUSY SATURDAY SEES PRESENTS, CARDS, LETTERS SENT AWAY!

SATURDAY — FLASH — With a purse full of money Private Lamb checked out for a day of Christmas shopping in the town. "There was," observed Private Lamb, "a sharp wind blowing, which froze my face." Private Caneul V.N. (very nice) walked in with Pte. Lamb but as she had to get a permanent wave, Pte. Lamb shopped alone.

"I bought tangerines, gardening gloves, Yardley's soap, baby slippers and quite a few things," said the elated girl, "and it was great fun."

CALAMITY ON HOMEWARD MARCH

"I bought a banana for Pte. 'Mac' who loves bananas and cream. And I spoke with a very old lady in the store, who loved the coast and I told her all about my home on Galiano Island and about the arbutus trees and the sea lapping the rocks and the blackbirds wheeling with the seagulls!"

Later our reporters saw the Private staggering back to Barracks, her arms loaded with parcels. Suddenly she was confronted by two of her officers. Later she told the press, "My mind became a propeller. I felt my parcels drop and my hat get caught in some branches (see authentic flash picture). I felt my mit hit my cheek and I realized I had saluted. My officers smiled and said hello, but I'm afraid I couldn't manage to reply just then."

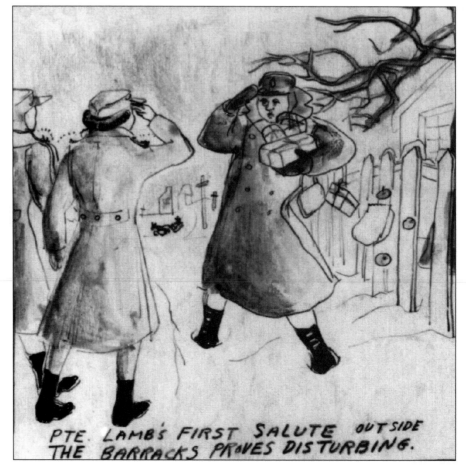

PTE. LAMB'S FIRST SALUTE OUTSIDE THE BARRACKS PROVES DISTURBING.

FIRST CHRISTMAS AWAY FROM HOME GREAT ADVENTURE!
FATIGUES, FUN, INVITATIONS AND MASS KEEP BUSY PRIVATE HOPPING!

The dramatic events of the last four days blast W110278's headlines even before the assassination of France's Admiral Darlen. How could it be otherwise as the great news deals with North Pole's Santa Claus and Vermilion Training Camp's Private Lamb?

TRAINEES LEAVE IN SMALL MORNING HOURS OF THURSDAY, 24TH OF DECEMBER

From first-hand information it was reported that many privates left for home and friends on Wednesday night. At an interview later, one typical private related, "We packed our stuff in our haversacks and rolled our blankets on our beds. The train was supposed to leave at two in the morning but it didn't arrive until 6:15. Privates fell asleep on the station floor, on benches and on one another, while Privates Lamb and MacDonald rested pleasantly in the new privacy of their room."

"After a leisurely breakfast," drawled Private Lamb H.M. (holiday mood) 'Mac' and I went to the main hall to help decorate the Christmas tree. Tinsel and lights and icicles and angel hair. Sergeant Ward officiated informally and the tree was a great success."

REAL ADVENTURE BEGINS

But for Private Lamb, the adventure began at 8:30 on Christmas Eve. "It was," stated the Private solemnly, "a night of ice and mystery, as if the story of the Snow Queen by Hans Christian Andersen and the Nativity were put together. I did my rounds, carrying my siren and flashlight.

"Through the snow I went into the Q.M. building and all the different new places, across to the officers' quarters, back around the school and all the time the moon shone above the trees and the floodlights shone on the fire escapes and the snow crunched under my feet."

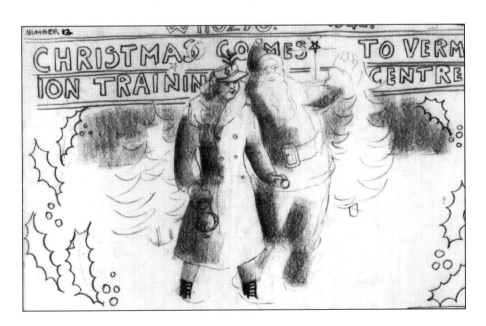

GIRL SPENDS AFTERNOON IN SLAUGHTERHOUSE!

NO CAUSE FOR ALARM AS ARTIST DRAWS BEAUTIFUL BLACK-HAIRED BUTCHER

DECEMBER 24, THURSDAY — FLASH — At the invitation of L/Cpl. MacDonald, the butcher, Private Lamb went to the slaughter room in the afternoon of Christmas Eve. Said the tired but elated Private, "They gave me a coat to put on with one stripe on the sleeve. At once I felt superior and my drawing was a success. There I sat looking in the door while the cook fed me chocolate and L/Cpl. MacDonald stood very still holding a leg of beef. I would like to paint her," went on the artist, "because she has beautiful eyes and black hair. And all the while I was drawing there was a queer mumbling of voices from another room arguing about sergeants and commissioned officers."

SHIFT OVER, AWAY GOES PRIVATE LAMB

At ten-thirty, the fire piquet ended and special reporters saw Private Lamb going along the road to Vermilion. Reporters testified that a car stopped and the Private got in beside L/Cpl. MacDonald and the Sergeant cook and another member of the kitchen.

FIRST STOP, BOSTON CAFE

Reporters went on to state that the "Quacks" first went to the Boston Cafe for coffee and sandwiches. It was noticed with pleasure that L/Cpl. MacDonald treated the Private to her coffee and cookies.

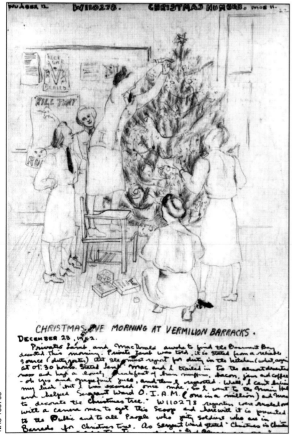

CHRISTMAS EVE MORNING AT VERMILION BARRACKS.

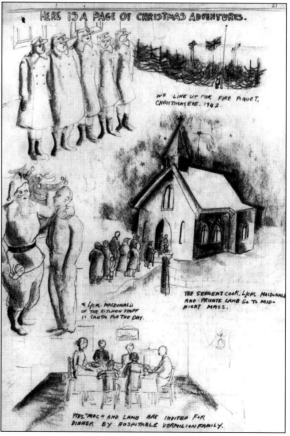

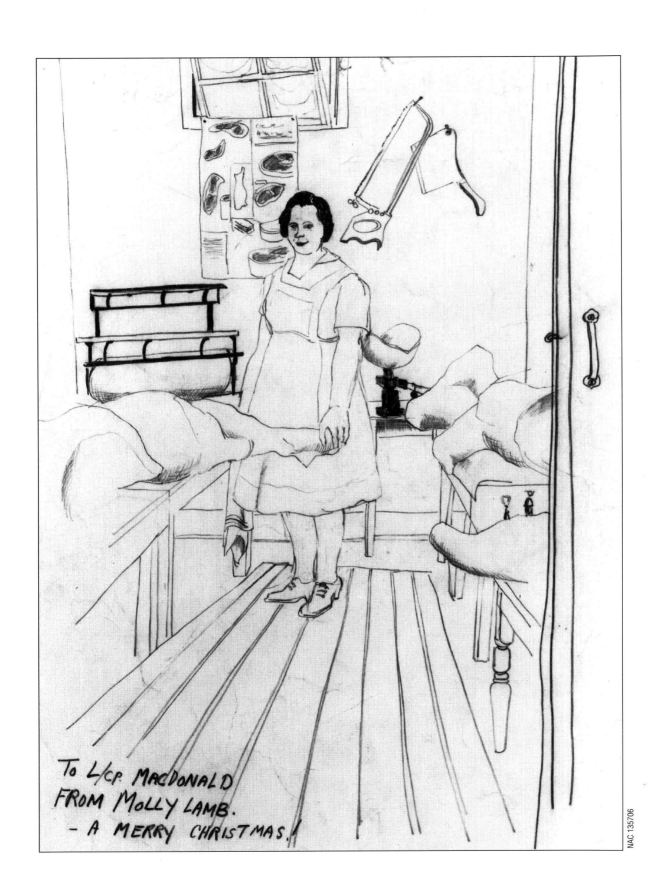

STRIPES ARE WET WITH ALLIES DRINK

CEREMONY RELIGIOUSLY PERFORMED IN BOSTON CAFE!

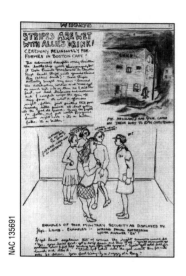

The Admiral's daughter may christen battleships with champagne, but it took Private MacDonald to christen L/Cpl. Lamb's stripe with genuine Chinese tea (allies' drink). "Those stripes actually singed my arm," beamed the celebrating soldier, "and 'Mac' got as much kick out of it as I did! In fact we had bananas and ice cream and I couldn't wipe the grin off my face."... Oh what a glorious night, folks. Just picture that poor measly little private at last getting into the good old groove — Yessir, the fight's on folks, and just watch L/Cpl. Lamb's right hook — It's a killer, folks! It's a killer!

EXAMPLES OF POOR MILITARY SECURITY AS DISPLAYED BY L/CPL. LAMB
EXAMPLES: WRONG FACIAL EXPRESSION
WEAK ANSWER — "EH?"

L/Cpl. Lamb explains that, of course, the right answers would be:

"Yes, your hair's foul. — Get a soup basin and trim it off."

"You'll darn well go overseas when I feel like sending you ... You vile guppie!"

"You'll get old bull for lunch and like it."

"Stockings! Whatever do you want them for?
It's only 60 below. You fool sissy ... You ---- old bag!"

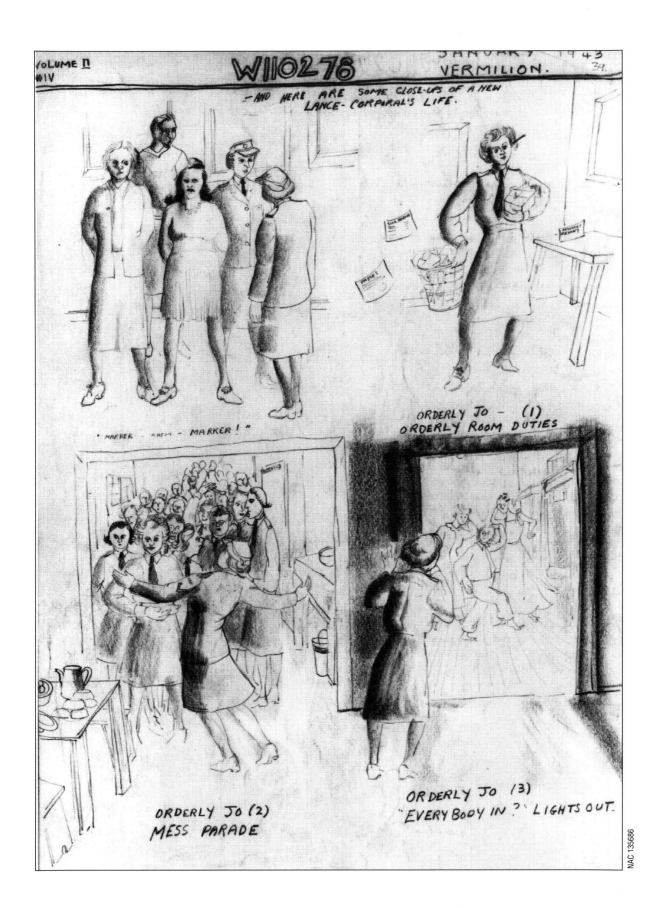

FIRE PIQUET

The snow drifts down not daring to disturb the cold
Night on the fire lights
And this building sharp-edged with sky
And the storm doors shut.
So in the dim lighted canteen, the corporal,
Tousle-headed, sprawls on a sofa and runs
Her tongue around her lips
And down below in the kitchen
We cooks have baked our pumpkin pies
We've baked our pies and now we sit
And sip our tea and read the leaves. And tell
Each other what we see.
The night wears on and the corporal
Stirs a foot to poke the sleeping dog.
He thumps his tail against the floor
And smiles and goes to sleep once more.

Below we cooks have cooled our pies
We've cooled our pies and now we put
Away the tea and one by one
We go upstairs to bed.
The corporal rubs her sleepy eyes, clicks
The snappers on her boots and clumps
Through quiet halls.
Then out into the high sharp night
She goes. Her footsteps like the dry
Grating of two jewels or joints without a lubricant
She curls within her boots, her toes.
Her rounds complete, the corporal
Then returns and slips into a chair,
And sighing, flings her muffler down
And runs her silent fingers through
Her tousled hair.

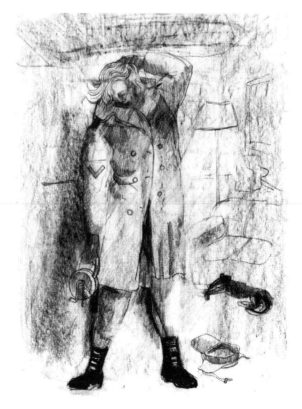

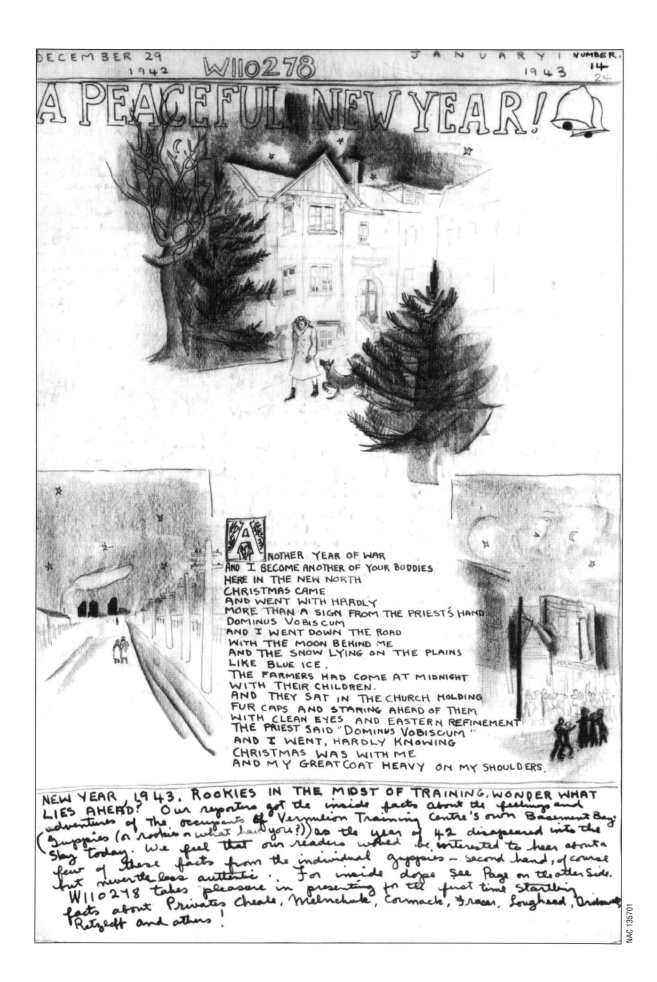

A PEACEFUL NEW YEAR!

NOTHER YEAR OF WAR
AND I BECOME ANOTHER OF YOUR BUDDIES
HERE IN THE NEW NORTH
CHRISTMAS CAME
AND WENT WITH HARDLY
MORE THAN A SIGN FROM THE PRIEST'S HAND
DOMINUS VOBISCUM
AND I WENT DOWN THE ROAD
WITH THE MOON BEHIND ME
AND THE SNOW LYING ON THE PLAINS
LIKE BLUE ICE.
THE FARMERS HAD COME AT MIDNIGHT
WITH THEIR CHILDREN.
AND THEY SAT IN THE CHURCH HOLDING
FUR CAPS AND STARING AHEAD OF THEM
WITH CLEAN EYES AND EASTERN REFINEMENT
THE PRIEST SAID "DOMINUS VOBISCUM"
AND I WENT, HARDLY KNOWING
CHRISTMAS WAS WITH ME
AND MY GREATCOAT HEAVY ON MY SHOULDERS.

NEW YEAR, 1943. ROOKIES IN THE MIDST OF TRAINING, WONDER WHAT LIES AHEAD? Our reporters got the inside facts about the feelings and adventures of the occupants of Vermilion Training Centre's own Basement Bay. (Guppies (or rookies or what have you?)) as the year of '42 disappeared into the slag today. We feel that our readers would be interested to hear about a few of these facts from the individual guppies — second hand, of course but nevertheless authentic. For inside dope see Page on the other side.
 W110278 takes pleasure in presenting for the first time startling facts about Privates Cheale, Melnchuk, Cormack, Fraser, Lougheed, Ardan, Rutzoff and others!

HEART-RENDING SCENES ON SUNDAY!

FATEFUL DAY BRINGS GHASTLY PARTING FOR LANCE-CORPORAL AND VERMILION FRIENDS. MOANING AND WEEPING AS TRAIN PULLS OUT!

FLASH — On Sunday January 31st, Vermilion Barracks lost another "B" Company. Reporters rushed to the scene at twelve noon. The mess was ringing with "The Khaki Shirts," "It's a Long Way to Tipperary" and "Auld Lang Syne."

"It was heart rending," remarked reporters, "to see the graduating girls. Later we were admitted to the gym where troops were lining up in their respective groups. It was noted that the only members of 'A' Company were Sergeant-Major Buchanan and L/Cpl. Lamb." "I had almost all my baggage on my back," related Lamb to the press. "And the nine of us going to Ste. Anne de Bellevue led the parade."

Through the hall marched the company, down the familiar road, to the station. Then on the train and away. "I pressed my face close to the double windows and waved to my friends and the train pulled out."

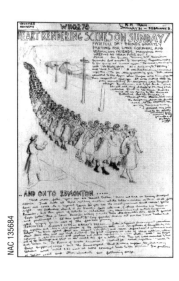

... AND ON TO EDMONTON ...

"And now, folks," yells our ace Travel-talker, "Here we are in sunny, beautiful Alberta. Just look at those rolling endless white hills — miles of them. Oh, oh, folks! Here we come to a typical town. Do you see the most prominent landmark? You're right — the Orthodox church à la Kremlin. Don't ask me if those churches are Greek or Russian, but this part of Alberta is inhabited by Ukrainians and central Europeans. Look folks! There is some Russian writing over that there blacksmith's store. Ain't it quaint and picturesque?" At this point "B" Company "Quacks" drown out our ace Travel-talker and start singing for the rest of the four-hour journey.

EDMONTON — QUEENLY CITY — ARTIST'S DREAM

Later a typical Lance-Corporal was interviewed by reporters and here is her version of the entrance into and occupation of Edmonton by our troops. "The train glided past an airport (she states) and never before have I witnessed such clear blue sky and red-brick buildings. The first impression was of sharp outlines — intense colours like diamonds and sapphires and rubies opened onto a white cloth ... We bulged out of the cars and stood in the mild air for a little while. Then we were marched to trucks and were taken to the Prince of Wales armouries.

"What for?" asked reporters. "Well, to have our supper, of course," said the Lance-Corporal. "And it WAS a supper, too; but a very tedious wait until 9:30 — until we were conveyed back to the station."

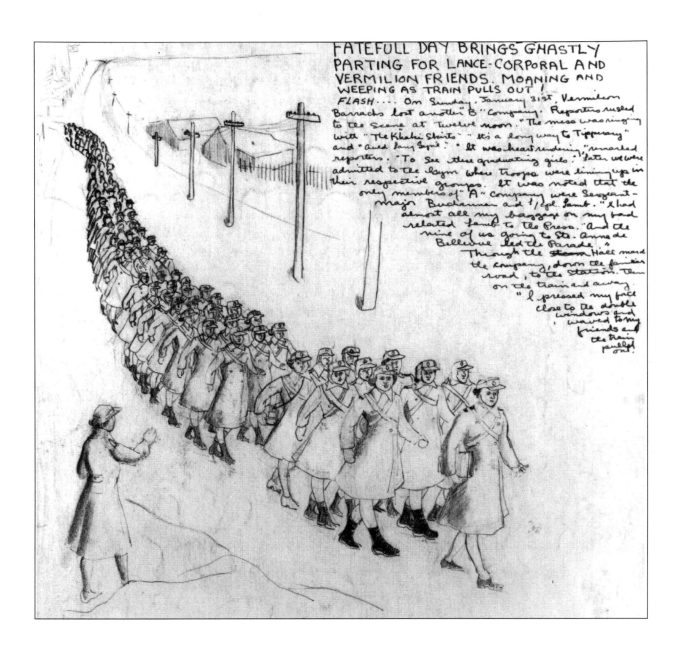

FATEFULL DAY BRINGS GHASTLY
PARTING FOR LANCE-CORPORAL AND
VERMILION FRIENDS. MOANING AND
WEEPING AS TRAIN PULLS OUT!

FLASH.... On Sunday, January 31st, Vermilion Barracks lost another "B" Company. Reporters rushed to the scene at Twelve noon. "The mess was ringing with "The Khaki Shirts" "It's a long way to Tipperary" and "Auld Lang Syne". "It was heart rendering," remarked reporters. "To see these graduating girls." Later we were admitted to the playin where troops were lining up in their respective groups. It was noted that the only members of "A" company were Sergeant-major Buchanan and L/cpl. Lamb. "I had almost all my baggage on my bad related Lamb to the Press. "And the nine of us going to Ste. Anne de Bellevue led the Parade." Though the Hall marched the company, down the famous road, to the Station. Then on the train and away. "I pressed my face close to the double windows and waved to my friends and the train pulled out.

45

CORPORAL CROSSES CONTINENT
TRAIN ROLLS THROUGH PROVINCES AS NEW LIFE LOOMS! HAPPY? THE LANCE JACK SHOULD HAVE BEEN ...

And for three nights and three days Lance-Corporal Lamb travelled. Yea, verily and it came to pass that on the morning of the third day, the train was stopped in the land of Ste. Anne de Bellevue — a land of brick and stone and hard winters, which is the custom of Quebec.

And on the third morning also, came trucks from the College with drivers which met the train. And Lance-Corporal Lamb was sorely troubled. "Yea, have I been through lands which cast no shadow but only frozen fields under the sky ... and villages have I seen and villagers.

"And on the second morning I did see a land of trees and sunlight and on the second night I did see the city which is called Winnipeg. And there was a multitude in the station with warriors among them from the armies of George the King, and of Roosevelt the Leader and many had dark skins of the South. And many cried out for the fruits of the Okanagan and valleys of the West and fruits of the orchards of the South. And the serving maids were sore tried.

"And I did see, also, the city disappear into the night and I slept a fitful sleep. Yea, and I awoke in a land likened to my own and my thoughts crossed the land of frozen lakes and the land of the plains and mountains to the sea of the West and I was troubled.

"Then came I to the land of spires and my heart leaped with joy and in the cold dawn did I arrive in Ottawa, which is the city of the Rulers of Canada.

"Then did I rejoice openly with my countenance alight — as the man who hath quaffed much wine — for never did mine eyes behold such things!"

And it came to pass that these things ended and Lance-Corporal Lamb crossed into the building of discipline and the shadow of the pillars fell across the door.

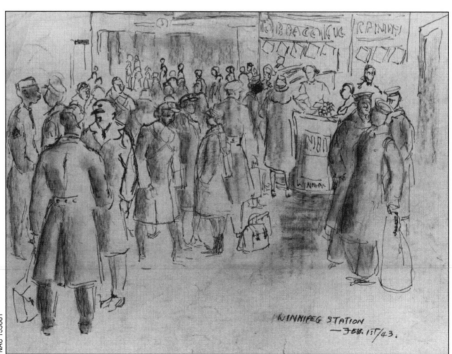

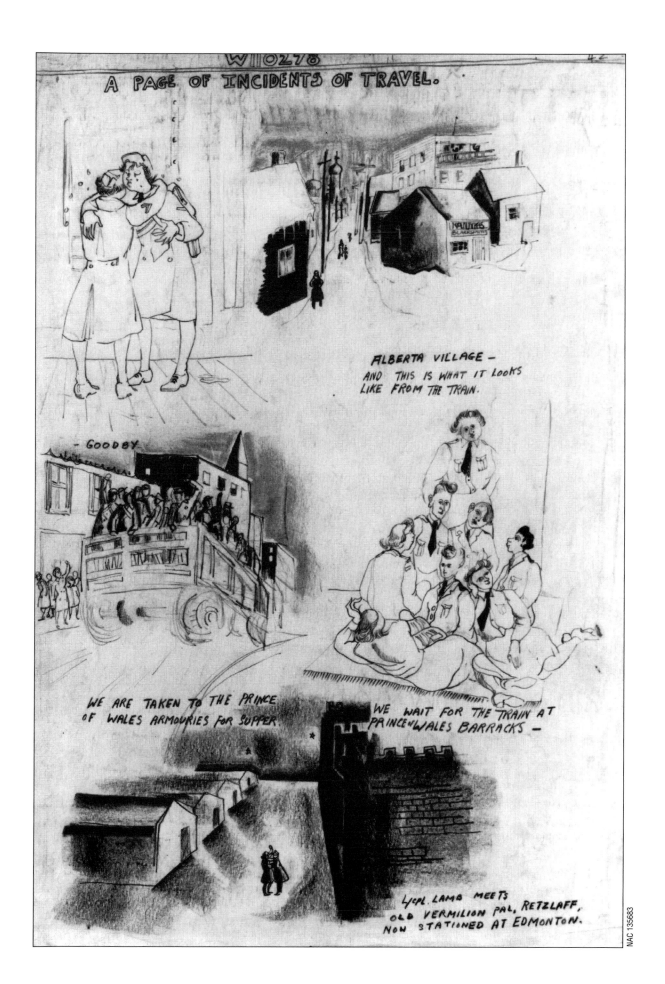

T W O

———————— ◆ ————————

"C'EST LA GUERRE"

(February 1943 – March 1943)

Three days and three nights later, Lance-Corporal Lamb has finally reached her destination, but the ensuing four weeks spent in the N.C.O. Wing of MacDonald College become a litany of disaster. From the outset, the plethora of "stupid" rules and regulations goes strictly against the grain. Imagine having to keep your gloves on while walking through the halls of the college! Molly is alternately bored, homesick and generally out of her depth. In short, it is an ordeal with few redeeming features. Her single source of solace — in this place where frivolity has been sacrificed on the altar of discipline — is the discovery of a kindred spirit. They call themselves Don Quixote and Sancho and together they roam the streets of the village.

When I saw the red brick houses and the stone shops and the church and the sleighs and the children — then such joy filled me, I could hardly contain myself! ... Adjusting oneself to new surroundings is a very difficult problem, which only time can solve. It seems one has to suffer to learn anything.

Perhaps the best gauge of Molly's disenchantment with her new situation is the poem she wrote in a moment of despair:

It must be so nice	*I cannot help thinking*
For a Quack to relax	*Without my heart sinking*
To slide on the ice	*How galling — how stinking!*
Or swim in the pool	*We're held in submission*
Or to fool once or twice	*We're wrapped in tradition*
With a sensible rule	*Behind a great door.*

The author's closing comment reads: "Obviously the work of a demented mind." Poor beknighted Molly Lamb. The army has done her a great disservice.

But a trip to Montreal — "the most exciting city in the world" — restores her high spirits. She finds it breathtaking, and her sketches of herself and her new-found friend gazing at the sights are full of wonder and delight. They dine out, feasting on chicken and wine — "Waiter, some Bordeaux, toute de suite — Bordeaux tres rouge" — then off to the theatre — "Vive Montreal! Quel nuit!"

Molly spends her twenty-first birthday in bed after what she describes as "The Amazing Ride of Molly Lamb." Found swooning on her bunk, she has been transported by stretcher to the college sick bay. There she languishes in luxury for several days

recovering from a bout of flu. Reluctantly she returns to continue her induction into the intricacies and responsibilities of becoming an N.C.O.

Just before graduation, Molly is given one final "late pass" to Montreal. In four sketches she sums up the events of a memorable day. First she decides to make a call on a house, two doors from the Galerie des Beaux Arts on Sherbrooke Street. "My mother used to live here," explains Lamb. "Well," says savage lady, "She doesn't now." "I know," answers Lamb. The next sketch finds her in the Beaux Arts, "in a room of 19th century 'brown' painters. 'L/Cpl. Lamb finds great Utrillo!'"

Sketch Three features her talking with "Dr. Lismer of the Group of Seven" and in the last, we see two small uniformed figures visiting St. Joseph's Oratory "in a raging blizzard." They fall on ice, cut their knees and arrive back at Ste. Anne perilously late. Passing through the dimly lit halls, they discover their new postings on the bulletin board. Molly is going home to Vancouver!

Rejoicing, she makes her way to her room and finds an envelope on her bed. It is marked O.H.M.S. — very official-looking. In the semi-darkness, it is difficult to make much sense out of the contents, but it appears to be some sort of questionnaire for Canadian artists. "At that moment, I thought for sure my dream was realized and I was accepted as a war recorder along with such names as Holgate, Hughes, Goransen and Schaefer. Wow, what a night!" The next morning she fills out the form and, full of hope, awaits further news.

The trip back home to the Coast is duly recorded in Molly's sketchbook. The headline speaks volumes: "FRENCH-CANADIAN, NEGRO, CHINESE, AMERICANS AND CWAC'S TURN JOURNEY INTO PARTY AS TRAIN DASHES TO WESTERN TERMINUS! HERE W110278 SENDS NEWS PICTURES ON THE BROTHERHOOD OF MAN ... OR FUN ON THE RUN!"

This eye-witness account, written as the merry band makes its way westward, confirms the veracity of the headline:

> Led by an Air Force girl, dressed as a Red Cross nurse, about twelve members of the tourist car gallivanted through the whole train on a tour for money for the Red Cross. Romeo and Juliet — one from the Air Force, one from the Navy — Pansy Yokum from the CWAC — Olive Oyl, Snow White, Ghandi and many more came through appealing for funds. Loggers, highway workers, businessmen, American Army colonels, Negro troops — everyone dug into their pockets until the sum of $22.00 was realized. This reporter was amazed at the cleverness of the costumes which were made from C.P.R. towels and sheets and odds and ends of "kit."
>
> The whole train was in a delighted uproar, folks, as the wave swept by. It was a glorious night to remember and when the Parade was ended, a party took place in the smoker which lasted hilariously into the night.
>
> The train careened on towards the coast!

In retrospect, Molly observes that train travel is probably one of the most effective means of bringing people of all races, creeds and colour together. Why not set up a school-on-wheels after the war is won? And the subjects taught should include reading, writing and "no prejudice" classes. (As we sit teetering on the brink of a national unity crisis, with regular coast-to-coast rail service all but a forgotten dream, it is hard to disagree. Bring on the trains! Bring on the passengers! Bring on the party!)

Early March 1943 finds Molly back on her home turf ("Weak-kneed Girl Weeps to See Land of Dead Bracken and Newborn Spring"). Resisting the urge to call her mother right away, she opts for something more dramatic — a surprise visit to Galiano. But before catching the ferry, she has other places to go and other people to see.

A jubilant report in "W110278" records the events of an evening's reunion of painters Lamb (Molly), Shadbolt (Jack) and Friefeld (Eric) — the latter two both "Sappers" at the Camouflage School. At dinner they fill the entire table with each other's drawings. Later they talk far into the night — of painting and war records and Canadian art and a glorious future. More toasts, more clinking of glasses. Another night to remember.

Molly's arrival on Galiano the following day has been carefully orchestrated. Her mother is given a message that a parcel for her is due on Saturday's ferry and she is to pick it up personally. As the passengers disembark, "Mum" remarks casually to a friend, "There's a CWAC," and goes off to find the purser and retrieve her parcel. Molly's shrieks finally capture her attention and it's off to Arbutus Point for three blissful days.

As anyone who has ever served in uniform can attest, the brief hours spent at home on leave seem over almost before they have begun. The glorious Galiano spring and her mother's cooking fade into the distance as the ferry carries Lance-Corporal Lamb back to reality and a transfer to Toronto. The army, in all its wisdom, has recognized Lamb's artistic potential and is sending her on a drafting course. "A drafting course? I can draw, Ma'am, but I can't draft. I mean — they're very different." Besides, she has been anticipating many repeat performances of her reunion with fellow artists Shadbolt and Friefeld.

Lance-Corporal Lamb reports that the unwelcome news precipitates a shouting match, but the commanding officer of the 29th CWAC Company remains resolute. Orders are orders.

As she waits for her transfer, Molly consoles herself with the knowledge that Toronto is the home of A.Y. Jackson, her father's old friend. Perhaps that will help compensate for all this upheaval in her life. Reluctantly she prepares to board the train for yet another cross-Canada sojourn.

On the platform, surrounded by friends and well-wishers, calamity strikes! To her horror, Molly discovers her ticket is missing. Kitbag and haversacks are searched in vain. Frantically, she makes a mad dash back to the barracks. No ticket. The train pulls out on schedule and "Lance Jack" Lamb is in hot water up to her ears. Eventually the "lost" ticket turns up in the Orderly Room and the next day Molly heads for the station. The final edition of "W110278," Book One, Volume Two, ends on a less exuberant note.

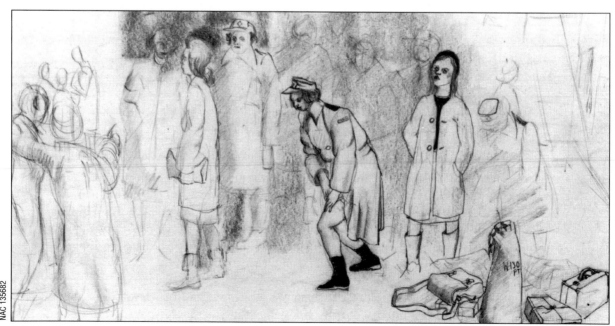

NAC 135682

Waiting in Edmonton, February 1943

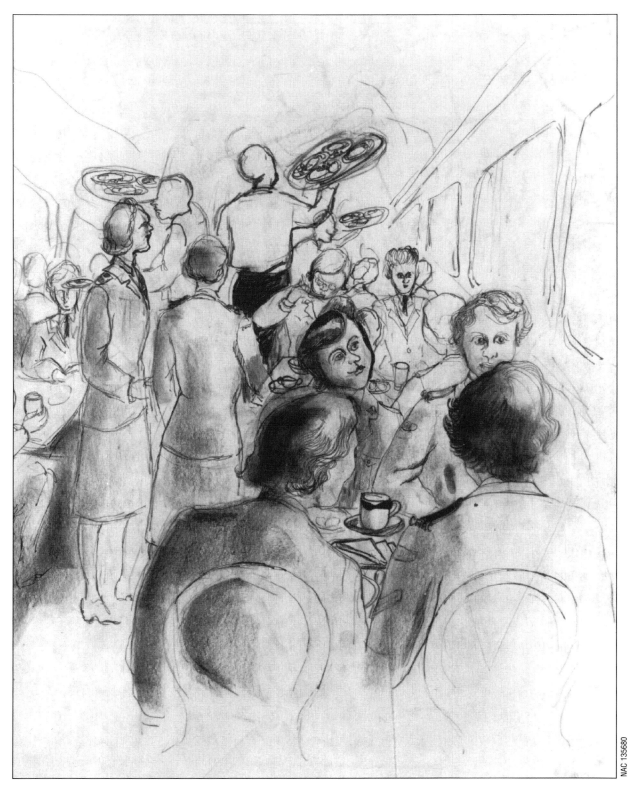

Train dining car, February 1943

AND TRAINING BEGINS FOR N.C.O.

FIRST WEEK SPENT IN MISERABLE
ADJUSTING — BUT FRIDAY BRINGS SUNSHINE!

Psychoanalysts and brain specialists reported on Monday to the Press that the condition of "Lamb" was "Poor ... mental attitude bewildered and fuzzy. Decline indicated. Brain in horrible state of disruption." And there was comparatively little change until the Thursday of the same week. Said psychoanalysts, "The poor girl could hardly keep her head clear. She told me she dreamt of train wrecks and breaking bridges. The only thing that went on normally was eating."

"You see," said the girl, "Rules — although necessary — are fearful things. For instance, we couldn't even walk in the halls with our gloves off. At first that sounded like cold misery, but when Thursday came, it seemed quite natural to wear gloves in the halls and tunics in the Mess Hall. Ahh — life isn't so bad." Psychoanalysts were relieved that their patient was completely cured and on Friday they packed their bags and departed.

AIR RAIDS SCATTER ROUTE MARCHERS!
VILLAGERS AMUSED AS TROOPS TAKE COVER

FLASH — FRIDAY — Troops were manoeuvring in the village of Ste. Anne de Bellevue this afternoon when two "hostile" aircraft came over. Sergeant Crabtree immediately blew the long, successive blasts on the whistle and manoeuvring troops delightedly leapt for cover (see below).

Some troops were lucky enough to find a snowslide until the hostile (air)craft had passed. So a delightful raid was had by all.

"Perhaps," reflected a typical lance-corporal, "my cousins in England would feel a little differently than we did."

After two raids, the Company march continued, accompanied by little squealing French children, who also thought the attacks were great fun.

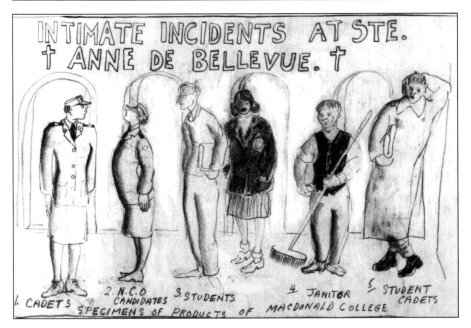

NAC 135675

FOR THE BENEFIT OF COLLECTORS OF "HUMAN BEINGS, THEIR TYPES," W110278 PRESENTS FIVE EXAMPLES OF SPECIMENS TO BE FOUND AT MACDONALD COLLEGE, QUEBEC

EXAMPLE I — CADET — A cadet is something that is being trained to be an Officer. It wears white tabs on its epaulets to identify it. It lives in the main residence and spends weekends having fun in Montreal.

EXAMPLE II — N.C.O. — This lives in another building, called THE ADMIN. building. It spends its time very much in the same way as its more significant cousin, the cadet, but it climbs more. This is because it lives in a high altitude. It is told to be industrious in order that it may exist and (it) worries a lot.

EXAMPLE III — STUDENTS — These are most picturesque things which may be seen during odd times in the long, tiled halls. The female is by far the most attractive. She wears a crested blazer and a grey-green striped uniform — most becoming. Her hair is generally very long to infuriate the species known as N.C.O. candidates. These (students) patriotically have either a pig shave or sleep at night on curlers. The male species vacantly carry books about "Cows' Diseases in Spring" for I believe they are agricultural students.

EXAMPLE IV — JANITOR — very rare type — lives underground for the most part and performs necessary duties with brooms, furnaces etc. It is not without a sense of humour such as, "Ow, I see you be postin' letters to your young man again. Wot's 'e got that I 'aven't? etc." This is to the girl who is posting 25 letters for all her comrades.

EXAMPLE V — STUDENT CADET — This type is identical to Type II student, only it wears a soldier suit on Tuesdays and makes military noises with its heels as it goes down the halls.

LAMB AND BECHTOLD BEHOLD THE EAST!
"THE MOST EXCITING CITY IN THE WORLD!!!" EXPLODES LANCE-CORPORAL

From an authentic and most reliable source, it is stated that the East has conquered L/Cpls. Lamb O. (overcome) and Bechtold S. (speechless). When W110278 reporters interviewed the lancejacks on Sunday morning, they were exploding with praises for Canada's first city.

"Montreal?" gasped Lamb to the press, "Why, it has more tradition and feeling than any city I have ever seen ... And the cathedrals — oh, they take your breath away! We spent our Saturday afternoon there and, of course, we explored everything we could ... Notre Dame — we crossed the square slowly and the snow fell over us like a mass of duck down."

"MODOM" ELIZABETH ARDEN FEATHER-CUTS LAMB
— OR — "AM I SHEARED?" ASKS LANCE-CORPORAL

Into the feminine atmosphere of Elizabeth Arden's salon of Beauty trooped khaki-coated Lamb. "Modom," clad in corsets and black silk, formally escorted Khaki Lamb to Marcel — chief feather-cutter. Said Lamb, "The Army says it must be short, Monsieur." ... "Oui," said Marcel. But it is reported that he did not — and would not — cut it to the required length. For ten dollars, said Marcel, Miss Lamb could have a permanent, non? "No," said Lamb A.P. (army-paid). Later Marcel ushered Lamb back to "Modom," who presented the lance-corporal with a bill for $1.50. Back at the College, L/Cpl. Bechtold snipped all the back of Lamb's head. Again "C'est la guerre!" declared Lamb.

WINE FOR LANCE-JACKS! MERRY DINNER FOR MERRY CELEBRATORS!

In the gay social whirl of war-minded Montreal, noticed among the 400, were uniformed debutantes, Lamb and Bechtold, swilling wine with a chicken dinner in a famous uptown restaurant. "Waiter, some Bordeaux, toute de suite," L/Cpl. Bechtold was heard to remark. "Oui, oui, garçon, Bordeaux très rouge," added L/Cpl. Lamb. After this beautiful orgy, the uniformed debs betook themselves to the theatre to witness "The Black Swan," which they enjoyed only because they would have enjoyed anything.

"There were daffodils in the foyer," gasped L/Cpl. Bechtold — "Très jolies fleurs!" "Oui,'" added L/Cpl. Lamb. "Ahh, printemps! C'est la guerre! Vive Montreal! Oh garçon, Quel nuit!"

With that the lance-corporals yawned and spread themselves out on the train seat and slept all the way home. It is reported that when the train passed Station Pointe Claire, Lamb was filled with nostalgic feelings. "You see," she pointed out, "we have an old album at home with pictures of the Lamb family of over 20 years ago — at this same Pointe Claire — and I had no idea I would ever be near the place!"

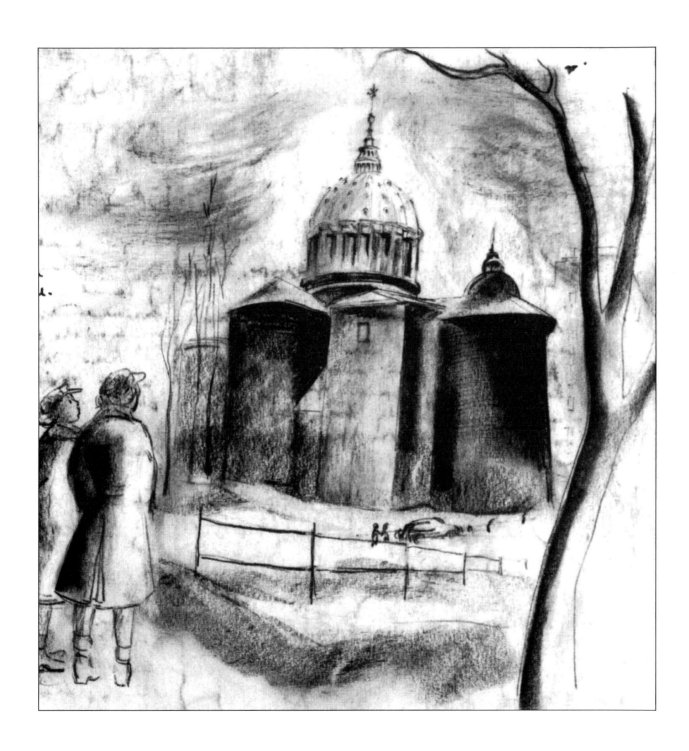

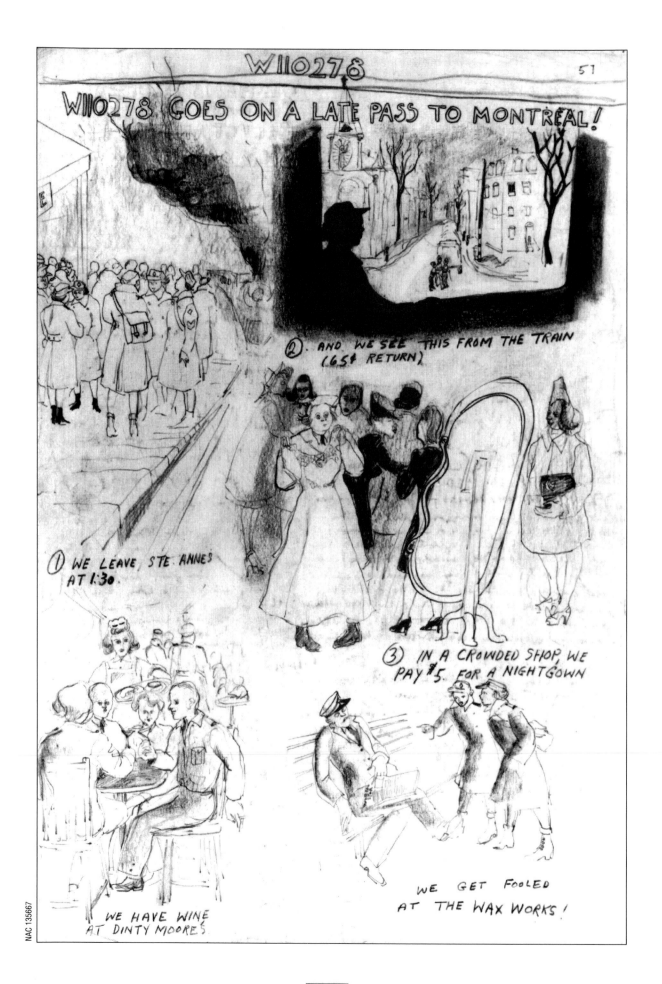

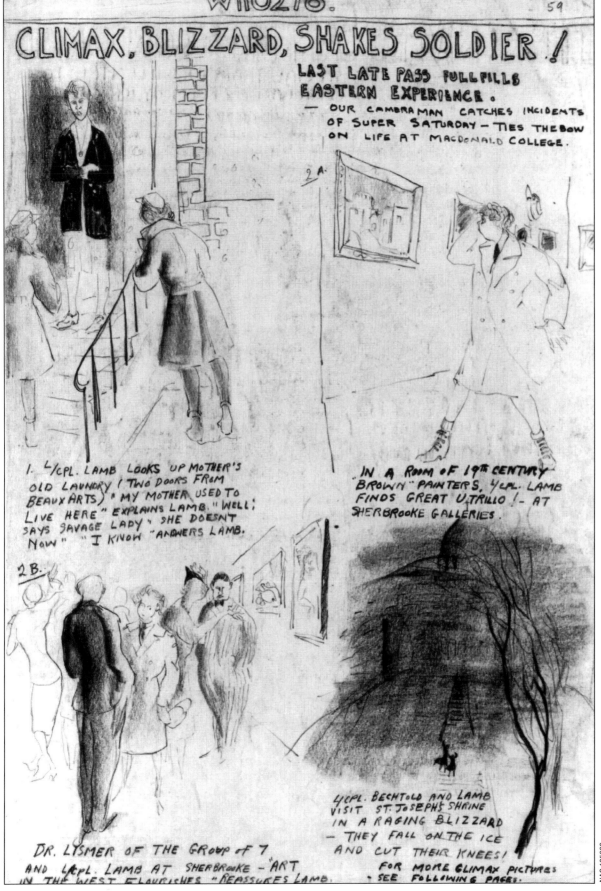

CLIMAX, BLIZZARD, SHAKES SOLDIER!

LAST LATE PASS FULLFILLS EASTERN EXPERIENCE.

— OUR CAMERAMAN CATCHES INCIDENTS OF SUPER SATURDAY — TIES THE BOW ON LIFE AT MACDONALD COLLEGE.

2 A.

1. L/CPL. LAMB LOOKS UP MOTHER'S OLD LAUNDRY (TWO DOORS FROM BEAUX ARTS) " MY MOTHER USED TO LIVE HERE " EXPLAINS LAMB, " WELL; SAYS SAVAGE LADY " SHE DOESN'T NOW " " I KNOW "ANSWERS LAMB.

"IN A ROOM OF 19ᵗʰ CENTURY "BROWN" PAINTERS, L/CPL. LAMB FINDS GREAT UTRILLO ! — AT SHERBROOKE GALLERIES.

2 B.

DR. LYSMER OF THE GROUP OF 7 AND L/CPL. LAMB AT SHERBROOKE - "ART IN THE WEST FLOURISHES "REASSURES LAMB.

L/CPL. BECHTOLD AND LAMB VISIT ST. JOSEPH'S SHRINE IN A RAGING BLIZZARD — THEY FALL ON THE ICE AND CUT THEIR KNEES! FOR MORE CLIMAX PICTURES · SEE FOLLOWING PAGES.

LETTER ON BED MAY TURN LAMB'S TALE!
FATEFUL SATURDAY NIGHT EXTRA FLASH

Describing her adventures to reporters later, L/Cpl. Lamb stated, "I was trying, in the dark to get some meaning from the words 'I'm going home' ... I climbed up to my bunk, where my hand touched a fat envelope. The kids were almost asleep after the first uproar, but I climbed down again and rushed into the hall, where I could see O.H.M.S. (On His Majesty's Service).

" 'O.H.M.S.!' said the envelope," continued the dizzy L/Cpl ... "I tore it open and found that it contained a questionnaire for Canadian artists. At that moment I thought for sure my dream was realized and I was accepted as a war recorder along with such names as Holgate, Hughes, Fisher, Goransen and Schaefer. Well, it was a nice dream and it may come true because I filled out the questionnaire the next day.

"All the kids came out in the hall again and a poor drowsy orderly officer had to break it up. Wow, what a night, eh, Sandy?"

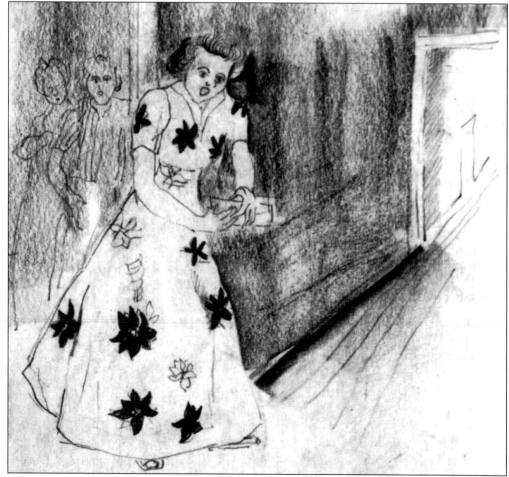

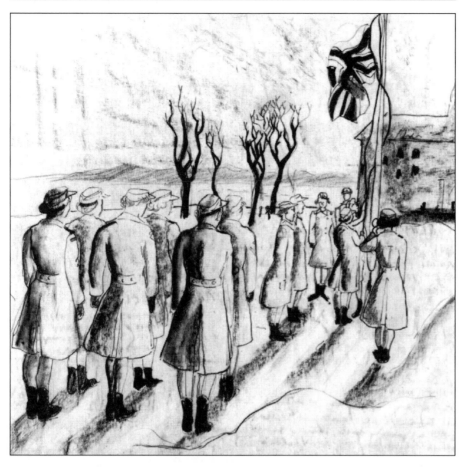

RETREAT, SUNDAY MARCH 7 — SUN SETS DRAMATICALLY
ON LAST DUTY, AND LAST EVENING AT STE. ANNE

W110278 REFLECTS PAST MONTH

BY MOLLY WOLCOTT LAMB

The end came on Monday, when the westbound train came out of the night. French-Canada disappeared and home was at the end of the line. In her upper bunk, the lance-corporal reviewed the month of Advanced N.C.O. Course and the adventures it held ... Ohh, the concert on Friday night where she repeated her old standby "Bloody Tower." Ohh ... the #2 Platoon party at Canada House — beer and foul sandwiches — and wonderful Pte. MacAvity reciting "The Face on the Bar-room Floor" ... The Board of Officers who asked what sort of pencils she used instead of, "Do you wish to draw for the C.W.A.C.?" ... The N.C.O. graduation ceremony where the poor Colonel had to shake hands with everyone and salute everyone, too ... Showing drawings hopefully to Personnel Selection Officer ... Fire piquet the last evening ... Mess orderly ... Bathroom fatigue...

The train has stopped. This must be Ottawa ... This story is so touching, that tears compel me to stop.

FROM COAST TO COAST IN A TOURIST COACH!

FRENCH CANADIAN, NEGRO, CHINESE, AMERICANS AND C.W.A.C.s TURN JOURNEY INTO PARTY AS TRAIN DASHES TO WESTERN TERMINUS! Here, W110278 presents news pictures on the brotherhood of man or Fun on the run.

1: WE HAVE SAID GOODBY TO STE. ANNES AND L/CPL. BECHTOLD (WHO STAYED AS AN INSTRUCTOR) AND WE TRUDGE, HEAVILY LADEN, TO THE STATION.

2: L/CPLS. KING AND LAMB MEET AMERICAN ALASKA-BOUND AIRFORCE MAN. THIS IS FIRST FRIEND IN FIRST FIVE MINUTES. NOTE L/CPL. KING'S ELGRECO-LIKE HANDS.

3 WE GET OFF THE TRAIN FOR 10 MINUTES AT HORNEPAYNE, ONT. AND MAKE FRIENDS WITH TWO ATLANTIC PATROL SAILORS.

4: WE SHARE OUR UPPER WITH AN AIR FORCE GIRL ON FURLOUGH FROM NEWFOUNDLAND. WE CAN'T SLEEP SO WE TALK ALL NIGHT.

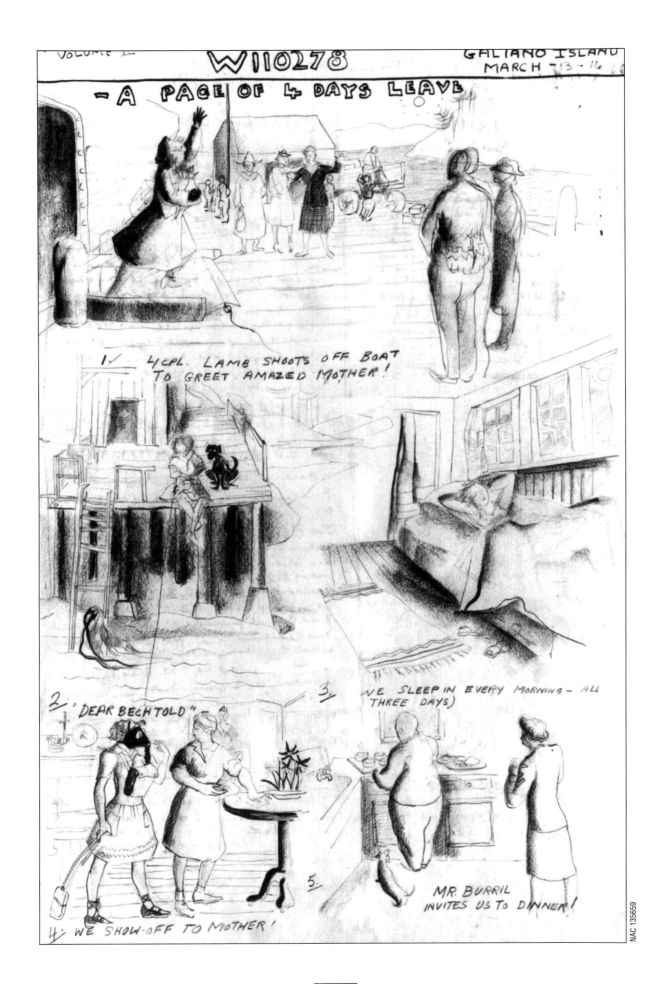

TRAIN LEAVES WITHOUT LAMB

NEWS PICTURES SHOWING THE CALAMITY OF LAMB

Our on-the-spot photographer caught these action shots on Sunday night at Vancouver's C.P.R. station during the worst moments in the Calamity of Lamb. The lance-corporal was all prepared to leave and she wept to reporters, "Gosh, all my friends were down to see me off, too. The baggage man asked for my tickets and I'd lost them. Oh, what a frenzy and what's more, I didn't find them, so the train left without me and I had to face my officer."

A later report confirms that the lost tickets were in the Orderly Room and Lamb left for Toronto and fresh adventure on the following night.

And now, dear public, we have come to the end of Volumes Two and One. We will say good-bye because the next book must be begun and the war goes on.

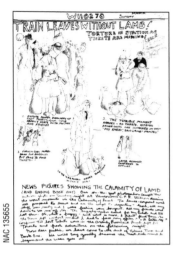

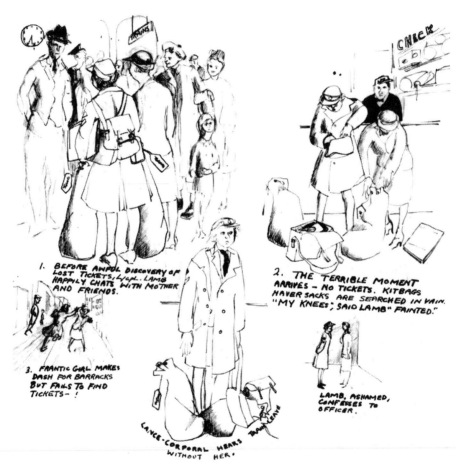

1. BEFORE AWFUL DISCOVERY OF LOST TICKETS, L/CPL. LAMB HAPPILY CHATS WITH MOTHER AND FRIENDS.

3. FRANTIC GIRL MAKES DASH FOR BARRACKS BUT FAILS TO FIND TICKETS-!

2. THE TERRIBLE MOMENT ARRIVES - NO TICKETS. KITBAGS HAVERSACKS ARE SEARCHED IN VAIN. "MY KNEES," SAID LAMB "FAINTED."

LAMB, ASHAMED, CONFESSES TO OFFICER.

LANCE-CORPORAL HEARS TRAIN LEAVE WITHOUT HER.

THREE

◆

"TORONTO THE GOOD" AND OTHER JOYS

(March 1943 – December 1943)

The wartime record of the adventures — and misadventures — of Molly Lamb are chronicled in Book Two of "W110278" with renewed verve and vitality. By now, she considers herself a veteran traveller, having zigzagged her way across Canada three times in less than six months. Dutifully she has reported to the drafting course in Toronto and finds it loathsome in the extreme. Somehow a way must be found to effect an escape.

In the interval, she becomes a clock-watcher — counting the minutes till classes are over for another day and she can make exploratory forays down Yonge Street and to the Kensington market, where she can buy bagels and other exotic compensations for her pain and suffering. And from her room in the CWAC barracks, she writes a note to A.Y. Jackson at his studio asking if she can visit him there and show him her illustrated journals. The response is affirmative and Molly's mood soars.

Jackson recognizes her artistic potential immediately and encourages her to continue her efforts. Privately he takes up the standard on her behalf in a letter to H.O."Harry" McCurry, the director of the National Gallery. Jackson describes her drawings as "very real stuff. The army from the inside as only a girl could see it. I know of no woman artist in Canada who could do such stuff under such conditions. If she had half a chance she could go places."

Molly has found a refuge and a friend. She returns often, usually bearing a bottle of Canadian wine, and before long A.Y. has become "Uncle Alex." Once he takes her next door to Keith McIvor's for supper in the cosy little shack Tom Thomson once lived in behind the Studio Building. She remembers loving the smell of it. (In the fifties, sculptor Frances Gage, a later inhabitant, expressed similar sentiments. The building — a monument of significance in Canadian art history — was subsequently disassembled and moved to the McMichael Canadian Art Collection in Kleinburg, Ontario.)

Through her new-found mentor, Molly also meets "The Girls" — Frances Loring and Florence Wyle, both of whom had done commissioned pieces for the Canadian War Records Office during World War I. By now, like their painter friends in the Group of Seven, they have become nationally recognized and their work is widely acclaimed. Their studio — still a landmark in Moore Park — is in an old-fashioned white frame church on Rosehill Avenue, within walking distance of the CWAC barracks at Avenue Road and St. Clair.

At some point during Molly's stay in Toronto, Jackson introduces her to Charles Comfort. The three dine together "in a Chinese restaurant on Elizabeth Street." Comfort is, by now, an official war artist home on leave from overseas. Molly writes: "I felt as if I was among the gods and I wanted very much to become a war artist, too, but then there didn't seem to be much chance of it."

One of Molly's most cherished mementos of Toronto is the David Milne watercolour that she buys from Douglas Duncan at his now defunct Picture Loan establishment upstairs on Charles Street just east of Yonge. Duncan handled Milne's work exclusively, and Molly, always an avid admirer of Milne, cannot resist the temptation. She spends $35.00 — more than a month's pay — but she and her treasured Milne watercolour are never to be parted.

Like her father before her, Molly has discovered the joy of collecting art that matters. She returns to base "feeling as if I owned the world."

Molly's own compulsion to draw consumes her waking hours. She never stops. Sketch after sketch, day after day — CWACs in the bathroom, in the dining hall, on parade; CWACs relaxing in the barracks, reading, knitting, writing letters. She draws non-stop and grows encouraged when a Canadian magazine, *New World*, discusses the possibility of publishing some of her work. Things are definitely looking up, but during duty hours she is still stuck at the drafting tables vainly attempting to draw straight lines as prescribed.

Clearly the time has come to go to the top. At Eastertime, she hitchhikes to Ottawa to plead her case and request a transfer to something more in keeping with her training as an artist — anything! And someone actually listens, but maybe with only half an ear. Lance-Corporal Lamb will report to Ottawa to work on detailed drawings of engines, wheel bases and such at the Trades Training Office. It is not exactly what Molly has envisaged. To compound her disappointment, it is swelteringly hot in Ottawa's Glebe Barracks. Discipline is tight and the atmosphere is highly charged and tense.

But there is worse to come. Molly returns from her furlough to the West twenty-eight hours late. She has been listed as "Absent Without Leave" and is informed (a) that she has automatically lost her corporal's stripes and (b) that the trades training division in Ottawa has decided it can do without her renderings of the inner workings of army vehicles. A new assignment awaits her elsewhere.

Just prior to her transfer from Ottawa "the reverted Private" adds her presence to the throng assembled in uniform for the filming of *Carry on Canada!* in the nation's capital. While the film's place in the history of Canadian cinematography may be all but forgotten, by July 1943 government advisers have begun to recognize the need for a more effective war propaganda campaign. Enlistment of volunteers is falling off. Increasingly there is talk of overseas conscription, despite earlier promises to Quebec. Perhaps a suitably rousing film will help turn things around.

Molly's illustrated account in "W110278" of the behind-the-scenes activity relating to the projected Ottawa footage for *Carry On, Canada!* conveys a sense of high excitement: "CAMERAS ROLL ON PARLIAMENT HILL! ... 'I'M IN THE MOVIES!' SHRIEKS EXCITED PRIVATE."

Not long after Molly's brief moment of stardom, the news breaks that the invasion of Sicily is under way. Private Lamb receives word that her transfer to Hamilton, Ontario, has gone through. Another move on the checkerboard of army life.

From the artistic standpoint, this new posting could bring Molly Lamb one rung further up the ladder. Better still, she is now only an hour's drive from Toronto and the friends she has made there. Once installed in Hamilton, she refers to it affectionately as the city "with a long green mound going around it, which the people call a mountain." The army has been given every assurance that when she is not otherwise occupied (helping to make charts for the School of Cookery on how to cut meat), she has permission to

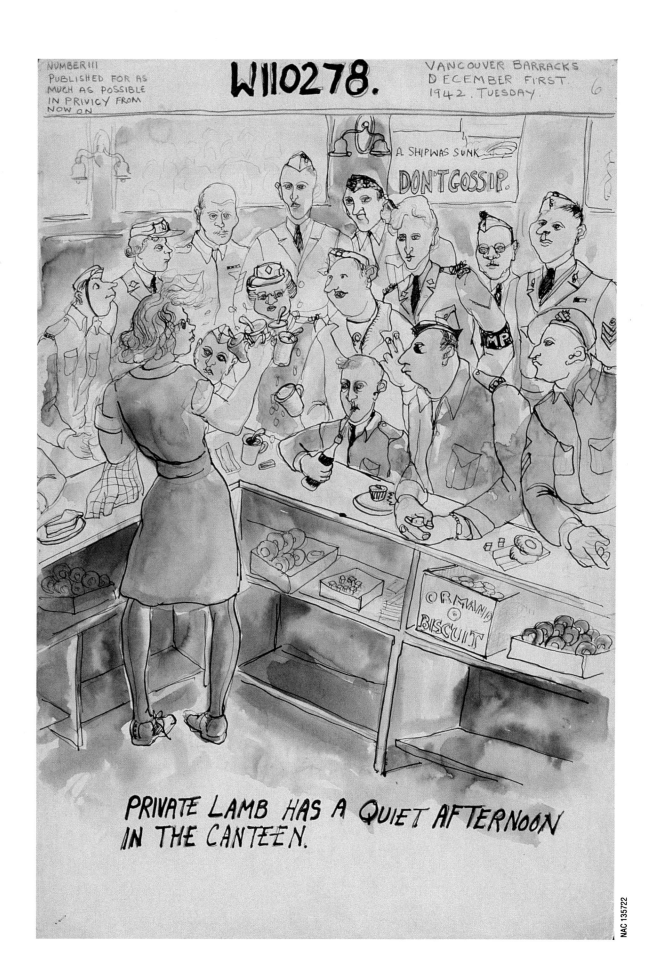

CASUALTY STILL C. B. AS WORLD WON'T WAIT. — FALL IN THE AIR.

— HAMILTON MILITARY HOSPITAL — (through Red Cross channels) The Red Cross, the only organization admitted into concentration camps etc. told the press last night that they had seen Pte. Lamb in the Hospital and that, eventhough she was being treated like a fatted calf, her spirit was low. They explained this was due to the fact that the girl was well but the ivy was still on her legs. They reported that she had one excitement. "I feel the autumn!" she told them excitedly — "It's in the air and it fills you with life — like the Spring does! And all sorts of wonderful freedom feelings fill you." The Red Cross also stated that the Private is eating like a wolf — even cadging bread from her friends.

YOUR RAMBLING REPORTER TALKS OF THIS + THAT.

Hallo folkes, here is your rambling reporter of C6 Ward speaking. FLASH (SIGH) after a strenuous day of ambling around the ward, reading True Confessions, making my bed a dozen times, taking eight showers, and saying "It's going to rain" in different tones all afternoon, I prepare my column for going to press.

CHIEF EXCITMENT on the ward front is listening to Vancouver acquaintance Peter Stursberg, C.B.R. reporter, speaking from Sicily about the Canadians — especially the fine Seaforths! and to hear also of Churchill's arrival this week at Quebec.

SUNDAY: Ward inmate, Poison Ivy Lamb, was allowed out on pass. On her return at 9 o'clock, she was in high spirits. "I walked down a long street (see below)" she stated "and visited a big hospital. I bought a dozen mauve asters and took them to a patient called Edna Freeman. She had a hurt ankle and she used to drive a crane in some war plant. So I have a new friend. I bought a chocolate soda and went to church — it was fine to get outside."

BELOW — SUNDAY — AUGUST 15 — PTE. LAMB, ON A PASS, WANDERS DOWN HAMILTON STREET —

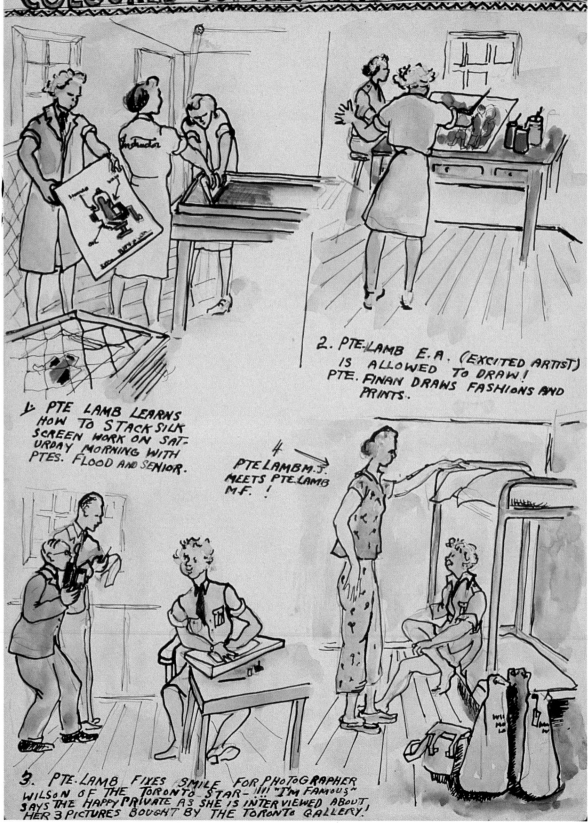

draw and paint to her heart's content — baseball games, an army wedding, whatever strikes her as appealing subject matter. The CWACs assigned to work at the Trades School in Hamilton form one small component in an extensive training establishment.

The student body is comprised mainly of so-called "Zombies" — men who have failed to volunteer for overseas duty. Many of the men and women who were part of this particular chapter of Canada's military history still associate the word "Zombie" with cowardice and vilification. For some, the mere thought of being posted for duty on a base full of Zombies would be tantamount to consorting with the enemy. Molly, however, is kept too busy drawing and painting to be unduly concerned about this aspect of her new situation. There are signs of hope on the horizon.

When a reporter and photographer from the *Toronto Star* turn up in Hamilton to interview Private Lamb about the recent publication of her work in the September 1943 issue of *New World* magazine and the acquisition of three of her pictures by the Toronto Art Gallery, Molly's morale reaches new heights.

And behind the scenes, decisions are in the making that relate to Molly's future. Canada's World War II art program has just received the official nod. For almost four years, Harry McCurry of the National Gallery and Vincent Massey, the Canadian high commissioner in London, have been practising the art of gentle persuasion. Their appeals for the creation of a national war art program have, to this point, failed to elicit much enthusiasm on the part of the government. Concerns about the expense involved have resulted in a great deal of federal foot-dragging. There is also the spectre of "modern art." And who will be responsible for the selection of the artists? There's no telling what unworthy and unsuitable canvasses might find their way into such a collection if artists are given free rein. But at long last, those pushing for a war art program find that patience has its reward. If art can be useful as a vehicle for helping promote the war effort, then perhaps the time has come to reconsider the inherent risks of such a venture.

In due course, the details are worked out and several candidates are officially designated for participation in the program as Canadian war artists. For Molly Lamb, however, the realization of her dream is little more than a far-distant glimmer of hope.

In terms of the war in Europe, reports from the Italian campaign are encouraging and on the Russian Front, "W110278" informs its readers, "everything is banging merrily along." The Russian advances are traced on a map placed on the office wall by one of the CWACs in Molly's unit.

Through the "divine" intervention of one of her company's senior officers, the October 1943 edition proudly announces that Private Lamb has been given her own office and will henceforth be working on making posters for Victory Loan drives and campaigns against disease, arranging parties and decorations, publishing the twenty-sixth CWAC Company newspaper, painting two small murals for the chapel "and any other job you can think of."

From its new headquarters, the editor of "W110278" sits drawing to the strains of Beethoven's Pastorale Symphony. She issues the following communiqué: "Watch out, Hitler! The Canadian Army's Private Lamb has found herself at last."

Happiness abounds, yet from the poet's corner, readers catch an unexpected glimpse of the past — and distant longing:

Ah, when I was at Art School
Says Army girl ...
Returning, now we are away,
We think of mountains blue with night
And mountains ever climbing to the clouds
And reaching arms — and tears
And the heart's sound.

The streetcar grinding up the hill
The damp road flanked with pale, limp grass
The same,
The same and never changed from years before
When you and I crouched gazing
At the Gaugin on the library floor
And walked together on the puddled pavement
To the ferry slip
And crossed the bay finding
The old orchards of the Indians
And their church

And sitting awhile on the smooth
Round stones by the water's edge
We threw but one or two to see
The circles grow
The sun put sky upon the puddle's face.
The ocean lapped and licked
And lulled our minds to sleep
Each stone, one side held to the light
Threw a shadow long
And rolling deep.

Molly's emotional pendulum swings off in another direction when she and a new friend — another Private Lamb — hitchhike to Detroit in search of new adventure and pre-Christmas bargains across the border: "LAMBS LOOSE IN MICHIGAN,U.S.A. ... Flash: Hitch-hiking 220 miles on Friday afternoon (November 28th,1943) Ptes. Lamb and Lamb descended on the city of Detroit the same night."

Gasoline shortages have dictated the need to develop the fine art of extending a well-turned thumb. In wartime, although it is strictly against the rules, accepting a ride from a stranger has become common practice for women in uniform. Miraculously, no one seems much the worse for it. On the whole, the benefits of mobility appear to have outweighed the element of risk involved.

In any case, the assortment of vehicles and travelling companions of varying shapes, sizes and descriptions that transport Molly from pillar to post and back again during her army career provide the irrepressible editor of "W110278" with an endless supply of entertaining subjects. From tippling speed-demons and lotharios to evangelists and little old ladies out for a Sunday drive, they come and they go as regularly as a forty-eight-hour pass. At the side of the road, the uniform works wonders. All rides are gratefully accepted, although, by the end of the ride, the degree of gratitude may be gauged by the sighs of relief that follow. Sometimes it is a case of "leap in — limp out," but every ride has its entertainment value, even if only after the fact.

For Molly, the proximity of Toronto is a relief in itself. She can indulge herself in off-duty visits to the art gallery and drop in for a chat with Uncle Alex. He encourages her to submit her drawings published by *New World* magazine for a forthcoming show of Canadian art that is being planned for exhibition in London. This warrants another news flash for "W110278"'s readers: "AMAZING NEWS ON ART FRONT STIRS GIRL!" 1943 has been a banner year.

W110278.

THE LIFE OF A REVERTED LANCE-CORPORAL, PTE. LAMB, A.W.O.L. ETC.

BOOK II.

INTRODUCTION June 9th, 1943

This is Book Two of the Army Life of Pte. Lamb (reverted Lance-Corporal etc.). The first book tells of life in a canteen, a Basic Training Centre and an Advanced Training Centre. It ends on a sad day in March when Pte. Lamb lost her ticket to Toronto and was left on the station (platform) at Vancouver.

But the ticket was found in the barracks' Orderly Room and Pte. Lamb left the next evening for a drafting course in Toronto. But she didn't like drafting at all, so at Eastertime she hitch-hiked 300 miles to Ottawa to see what she could do about it ... And then Pte. Lamb was sent to Trades Training offices in Ottawa to draw universal joints and pinions and rear axles, but mostly to have great adventures.

On June 18th, she took a day coach back to Vancouver and now fresh adventure looms. Pte. Lamb begins Book Two in "The Life of a Reverted Lance-Corporal."

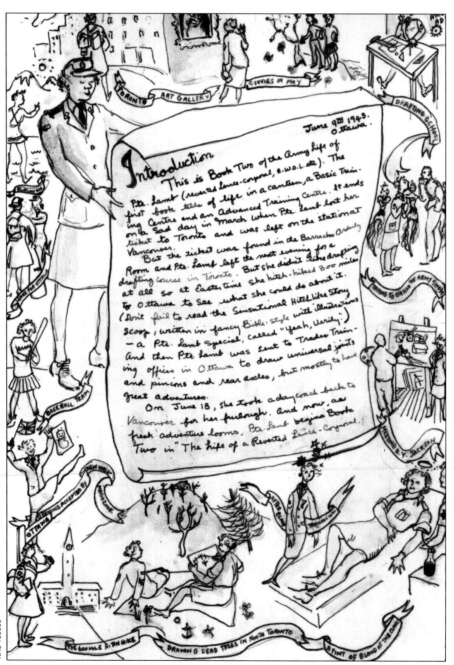

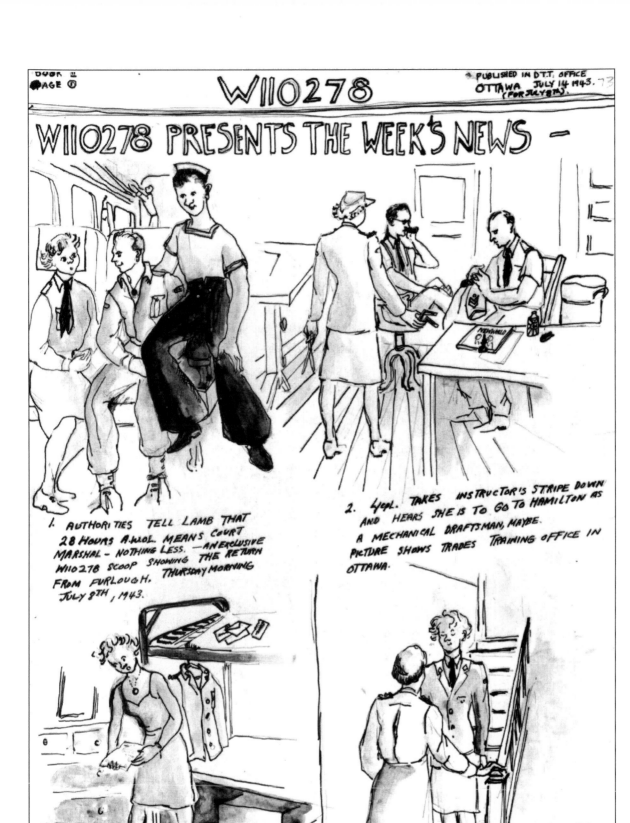

W110278

DTT OFFICE, OTTAWA
JULY 16TH 1943

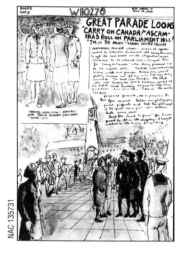

NAC 135731

GREAT PARADE LOOMS

"CARRY ON CANADA!" AS CAMERAS ROLL ON PARLIAMENT HILL!
"I'M IN THE MOVIES!" SHRIEKS EXCITED PRIVATE!

WEDNESDAY, JULY 14TH FLASH —

W110278 reporters rushed to Ottawa's Parliament Hill early this morning to get the lowdown on the stupendous movie scheduled to be released late in August. Scenes for "Carry on Canada" were being produced and — as one reporter states, "The Hill was covered with Wrens, Wafs and Quacks. Cameramen were adjusting cameras and officers were hoarsely shouting commands. The heat was terrific." Pte. Lamb, who was among the Quack platoons, reported that she didn't mind sweating because her lifelong ambition had come true. "I am in the movies," she said.

W110278 presents a preview to this epic movie. Below our photographers foiled piquets and took this photograph of the great scene, just after action shots were over.

Said Pte. Lamb to press, "Yes, I was proud to be in this display — I haven't worked in the army for so long."

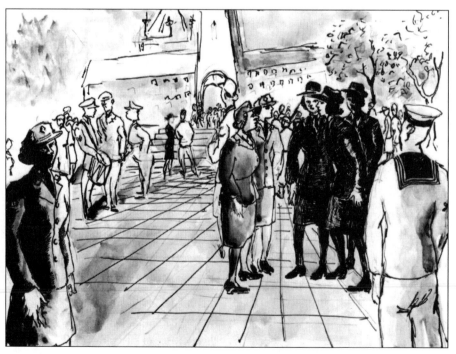

W110278

MUSSOLINI RESIGNS — REVERTED LANCE-CORPORAL CELEBRATES IN TORONTO

WAR NEWS IS GREAT AS REUNION IS HELD IN TORONTO OVER WEEKEND

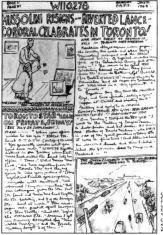

Headlines blazed across every paper in the country this weekend when Italy's Mussolini resigned and the Allies stormed Sicily. A typical reverted lance-jack of the Canadian Army put it this way:

"The news is so good that celebrating seemed in order. My friend from Ste. Anne de Bellevue, Corporal Bechtold (see Book One Of W110278), came all the way to Hamilton and at noon on Saturday we hitchhiked in a big yellow truck to Toronto."

Reporters say they saw the reverted L/Cpl. and two friends eating a great supper at Child's and visiting the Art Gallery and going to a movie.

SUNDAY — TYPICAL REV. L/CPL. SEES GREATEST MASTERPIECES!! HIGHLIGHT OF TRIP

"On Sunday," testified the Rev (Reverted) L/Cpl., "I went to the Gallery of Douglas Duncan, a bookbinder and art dealer. He showed me sketches of David Milne — who I think is one of the greatest painters of today. Oh, it was a fine time! And later we had an excellent lunch and then hitchhiked the 40 miles back to camp in a Packard."

TORONTO STAR CALLS ON PRIVATE; FRIDAY

FLASH ... "When your officer wishes to see you," stated Pte. Lamb O.T.O.T.W. (On top of the world), "you generally wonder what you have done now."

W110278 reporters listened in on Friday when Lieutenant MacLeod called Pte. Lamb into her office. "These," stated Miss MacLeod, "are two reporters from the great Toronto Star and they are going to take your picture." (Here egotistical Private goes completely berzerk with excitement.)

"We observed," say our reporters, "that our colleagues from the Star shot Pte. Lamb and Miss MacLeod together — the private saluting; and three of the benign private hard at work. Star newspapermen predict great scoops in the Star shortly."

"And all," sighed the overcome private, "because I got my drawing accepted by New World magazine ... and the Toronto (Art) Gallery bought three of them!"

W110278

PUBLISHED IN BED
HAMILTON, AUGUST 3RD

HORRIBLE FATE OF INNOCENT PRIVATE!
"THEY GOT ME IN THE LEGS" TESTIFIES CASUALTY AS ENEMY SILENTLY ATTACKS

AUGUST 1ST — Another stinging blow was dealt to one of our troops today, when the enemy applied further atrocious tactics on our side. "It was like Pearl Harbor," admitted Pte. Lamb C. (casualty!). "The enemy dealt me a stinging blow which completely surprised me and was strictly outside the international code as set up in Geneva."

The private, looking like death in her bed, told reporters that she was walking happily across the wet clover fields to the baseball diamond and the next morning, she had what she thought was a heat rash. "Although I was hungry," she admitted, "I starved for a day — and suffered from hunger — I can tell you! The next day, in spite of health salts, the rash was worse."

M.O. (medical officer) SOLVES ENEMY TACTICS

"So I went to the M.O.," went on the private, "and guess what he said?" ... "Mustard gas?" queried reporters. "No," sadly smiled the private, "POISON IVY ... and now, today, I look like a living ad for the BEFORE part of an exema advertisement." Reporters confirm this and add that the private has been laid up for three days. However, morale is high and spirits are fighting mad.

AN ARTICLE BY OUR ART CRITIC

We visited an art studio at the Canadian Army Trades School today — a rare thing to find in an army camp — just how long it will exist is another story. But we found the artist, Pte. Lamb H.I.T.S. (Happy in the service) N.R.C.A. (not Royal Canadian Academy) deep in the painting of a baseball game. "I haven't any canvas at the moment," the artist told us, "so this is sort of an oil and watercolour and drawing on paper. Of course, you can't get the quality that you can on canvas — but I'm sort of pleased with the composition." She then showed us a small canvas — more complete in itself than the baseball game. "This," she said, "is a composition from the back door of our C.W.A.C. hut. It was arrived at very quickly — more quickly than this laboured thing of an Ottawa street. Gosh, I feel full of painting now ... and here is a thing I'm starting called 'Army Wedding.' A little C.W.A.C. called Jenny was married in the chapel yesterday."

"But what of your real work?" we queried. "Oh," said Private Lamb, "there's some roasts over there. I drew them for the Cooks' School — it's how you roll lamb."

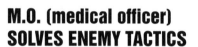

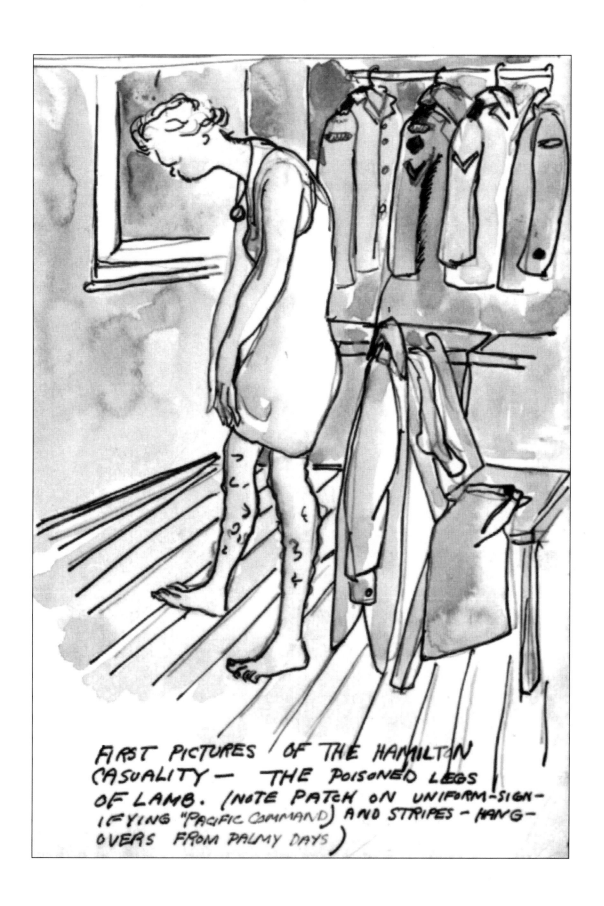

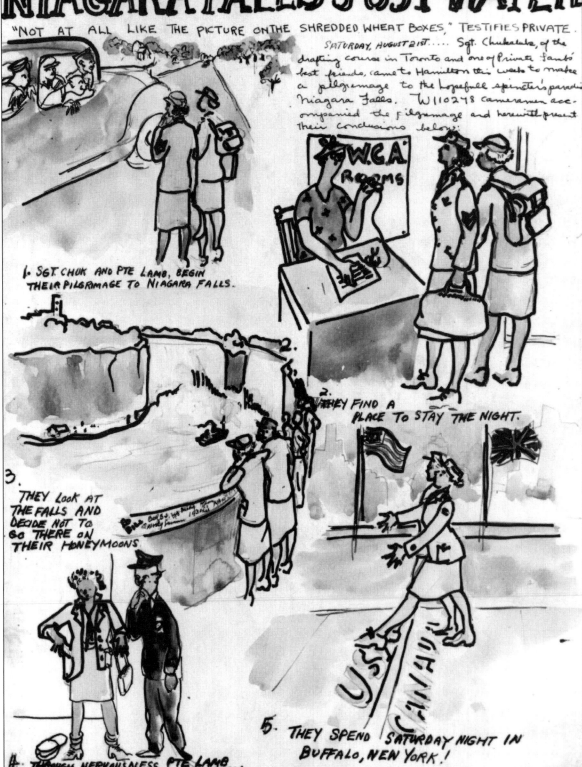

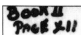

W110278

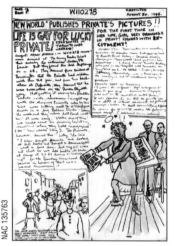

NAC 135763

NEW WORLD
PUBLISHES PRIVATE'S PICTURES

FOR THE FIRST TIME IN HER LIFE, GIRL SEES DRAWINGS IN PRINT! CHOKES WITH EXCITEMENT!

MONDAY 23RD — From authoritative military sources, the dramatic news broke over the head of Private Lamb today — Canada's leading magazine New World had published her drawings. "I heard through Private Lindsay, who was in the Hospital with tonsillitis the same time as I," she stated. "Lindsay said that Johnny, the orderly, was a subscriber to the magazine and he mentioned seeing the pictures."

PRIVATE KEPT IN SUSPENSE

"I was," she confessed, "kept in suspense for three or four days — because the magazine was not on the newsstands until Friday."

It was obvious to see that the private was in a state of intense excitement and photographers managed — under the most excruciating difficulties — to secure for W110278 readers the following news scoop (exclusive army release).

LIFE IS GAY FOR LUCKY PRIVATE!
CELEBRATES IN TORONTO OVER WEEKEND!

FRIDAY EVENING — W110278 newsmen arrived at the Army trades school this evening to interview lucky Pte. Lamb. But they found she had left camp on a 48 (48 hour leave). They learned from sailors at Burlington that the private had ridden with them that far; and from two bachelors at Oakville, they learned that she was somewhere on the Queen Elizabeth Way.

Hot-footing it along the Hamilton-Toronto route, newsmen caught up with the elusive private, who — by this time — was sitting next to a transport driver in a big yellow truck.

During the weekend they never lost touch with her. "It was easy," states one of them, "We could count on finding her at any newstand where they sold magazines." ... The Private, however, denied this. "Why," she said, "I also bought presents and looked at art books and bought a banana split. What a fine day! But my 48 was cut short as we all had to be back at Camp at 23:59 hours on Saturday night for the Sunday drum-head service in honour of the C.W.A.C. Second Anniversary."

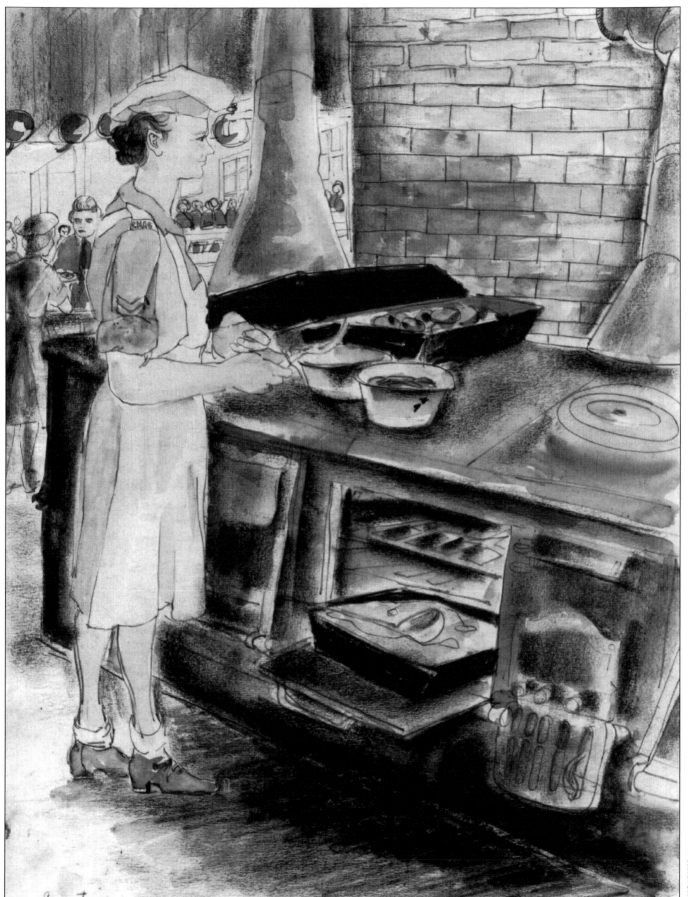

NAC 135767

HOPE CHEST FOR DUBIOUS CWAC

FIRST PURCHASE REQUIRES UNDERSTANDING SORT OF SPOUSE

(Reporters admit that the headline of today's W110278 is a bit misleading, but in order to sell newspapers, a bit of romance is certainly needed.) ...

CHARLES STREET, TORONTO — FLASH — Witnesses state that on Saturday afternoon they saw a member of the C.W.A.C. weaving and tottering down the street; and, as civilians, they called upon the law to intervene. Police say the girl in question was one Pte. Lamb M.J. (Molly Joan). When asked if she had been drinking, the girl replied, "Yes —"

"What?" demanded witnesses. The Private replied, "I've been drinking in the most wonderful watercolour I have seen in a long time — a David Milne — and I bought it! I bought it!"

Further questioning revealed that the Private saw this watercolour (which is a composition of mushrooms) in Douglas Duncan's Studio and promptly knew she must own it. Said the Private, "It will look fine when I get a house. Of course, I will have to marry someone who loves David Milne, too — and yet be practical enough to build a wall to hang it on." Then she added, "This is a free country. Let me go!" which the police did. Reporters found themselves scratching their heads and mumbling to themselves ... "David Milne? Mushrooms? Practical husbands?" ... But the Private came back to camp feeling as if she owned the world.

SEPTEMBER — A MERRY MONTH — AND TWO PARTIES!

"September," summed up our special summary writers, "was a merry month. On the Lamb front, there was a part in the Army play, the buying of a watercolour, the hope of getting home for Christmas, the news of a transfer to another job and two lovely dances at the Connaught Hotel ... On the war front — everything banging along merrily on the Italian and Russian Fronts. Cpl. Barlow, of the Training Aids Dept., put a map up on the wall and traced the advances of the Russians, delighting herself with the pronouncing of long Russian names.

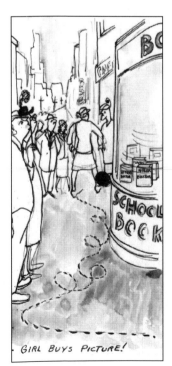

. GIRL BUYS PICTURE!

CONNIE HAS A BIRTHDAY AND BOTH LAMBS GET VERY HAPPY IN THE HOTEL.

PICTURES HOT FROM THE BARRIE EVENT.

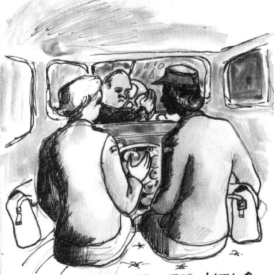

1 WE GET TEMPTED WITH A BASKET OF TOMATOES IN THE BACK OF THE CAR IN WHICH WE HITCH-HIKED.

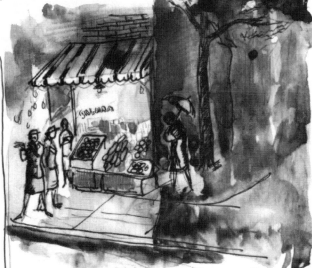

2. WE GET CAUGHT IN A SQUALL AT RICHMOND HILL - BUT A CORSET-SALESMAN PICKS US UP.

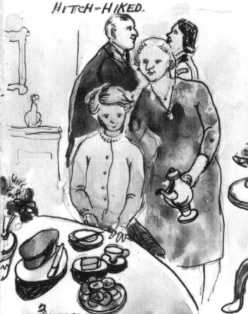

3. MRS. HUBBARD'S HOME-MADE BROWN BREAD!

WE GO FOR A SUNDAY DRIVE TO SEE THE JESUITS SHRINE AT MIDLAND.

— AND AT PENETANG, WE GO ABOARD A SUB-CHASER - AND BECAUSE WE COME FROM THE SEA WE GET A TOMATOE SANDWICH!

BOOK II
PAGE 20

W110278

C. A. T. S.
HAMILTON.
OCTOBER. 42

W110278 GOES SERVING AT SCOTCH MESS DINNER!

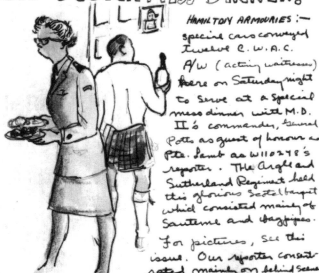

HAMILTON ARMOURIES :— special cars conveyed twelve C.W.A.C. A/W (acting waitresses) here on Saturday night to serve at a special mess dinner with M.D. II's commander, General Potts as guest of honour and Pte. Lamb as W110278's reporter. The Argyll and Sutherland Regiment held this glorious Scotch banquet which consisted mainly of Sauterne and bagpipes.

For pictures, see this issue. Our reporter consists rated mainly on behind scenes.

PTES. MOLLY + MARIAN LAMB (T.)(TRADES PAY) WATCH BONNY GAELIC TOAST !

2

— OUR REPORTER DISGUISED AS WAITRESS.

3. BUSY C.S.M. FINDS ICE CREAM OVER-FROZEN AND UNCUTABLE. BUSY LADIES KEEP PASSING PLATES. TIGHT OLD SOLDIER IS NO HELP.

4. TALL LAMBIE PUSHES OFF MERRY MAJOR WHO RESTED HIS HEAD AGAINST A REGIMENTAL CUP SHE HAD HIDDEN IN HER TUNIC FOR A SOUVENIR.

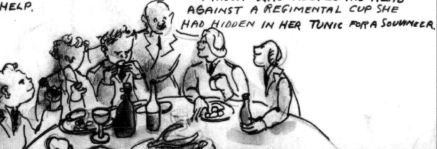

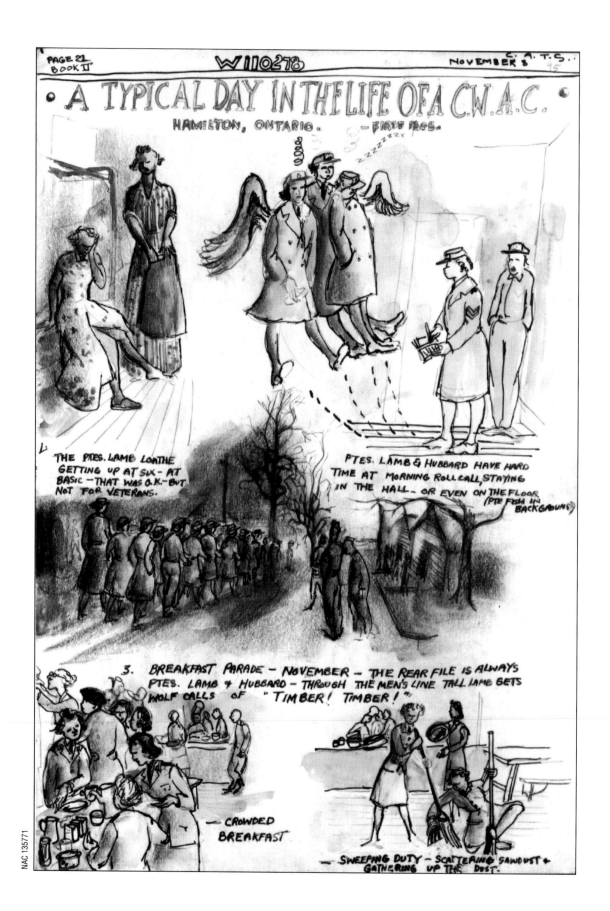

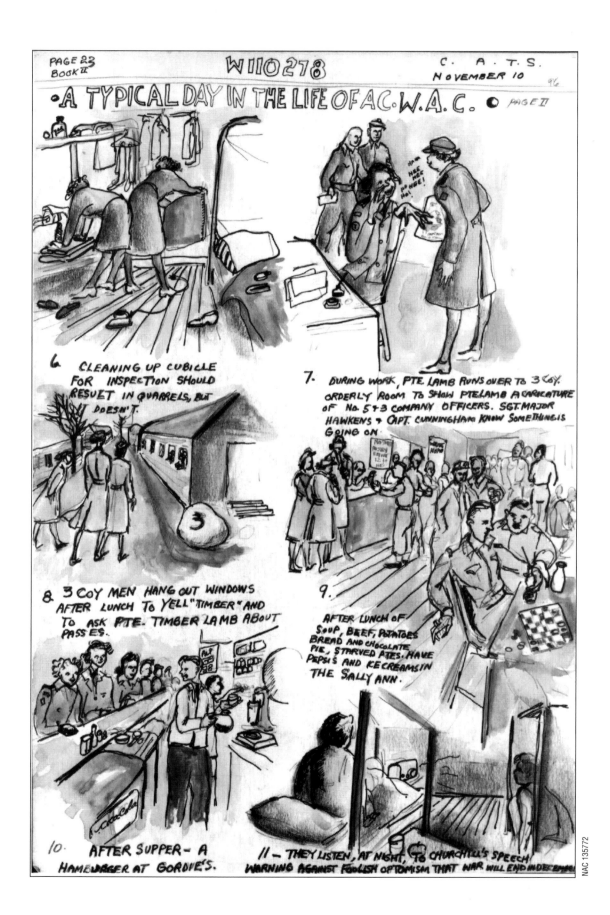

W110278

C.A.T.S. HAMILTON
NOVEMBER 20-24 (1943)

NAC 135774

TWO HUNDRED OF TORONTO'S FOUR HUNDRED EXPOSE THEMSELVES AT GALA AFFAIR

WEDNESDAY NIGHT

Hitch-hiking into Toronto tonight our reporters discovered, at the Art Gallery, two hundred of those members of society called the upper crust. Aimlessly, at first, Reporters Hubbard and Lamb wandered down the Gallery halls until they found a room full of maids, drinks and bodies. Said Hubbard, "The ceiling was covered with voices and the floor with shoes." Said Lamb, "After two Manhattans, we didn't know which was which, but we did manage to see an amazing assortment of art lovers."

The select group picked at a buffet supper served in the Court Room and the reporters must admit that here they met very genuine people. Here also they ate off the effects of the Manhattans.

Then they were ushered into another room to witness a movie of Tom Thompson's life. "I sat," said Lamb, "next to an American realist's idea of a drunken lady. This was a big canvas which I disliked intensely. — I disliked the quality of the paint, the stupid subject and the smarty-pants idea of the thing."

BAD CWACS PUNISHED. SCHOOL OF COOKERY BANS GIRLS!

Fat, well-fed CWAC's of the C.A.T.S. are secretly forming an underground movement to capture and torture those responsible for the School of Cookery Hoax which broke over the camp last week. Spoke well-fed Lamb, "We are forbidden to eat at the School of Cookery (toast for breakfast, unsweetened coffee, pie etc. etc.) because we didn't always comply to sweeping the floor and [to] seating arrangement rules. Now we eat bread and sweet coffee in No. 5 Coy. (Number 5 Company) lines — to the whistle-blowing of an offensive corporal." The girls are sad.

GIRL'S TECHNIQUE IMPROVES — COPES WITH WOLF IN A MASTERLY MANNER

FLASH — NOVEMBER 19TH — Armed with only one (1) potted plant, a haversack and a lashing tongue, Pte. Lamb L.R.R.H. (little red-riding-hiker) held a wolf at bay. The press got the story right from the private, as she shivered in the sleet and endeavoured to sketch the old town market in Barrie, on Sunday afternoon. Said the private, recalling vividly the ride, "I was having tough luck hitch-hiking. An old lady kept talking to me, so I guess the (passing) drivers thought I was just gossiping," she paused ... "Then, at last a black old Plymouth came along — driven by a very wolfish fellow. But, by now, with experience behind me, I foiled the enemy by camouflage (potted plant), strategy (beat him in a battle of words) and good defence position behind haversack. My objective was reached without loss."

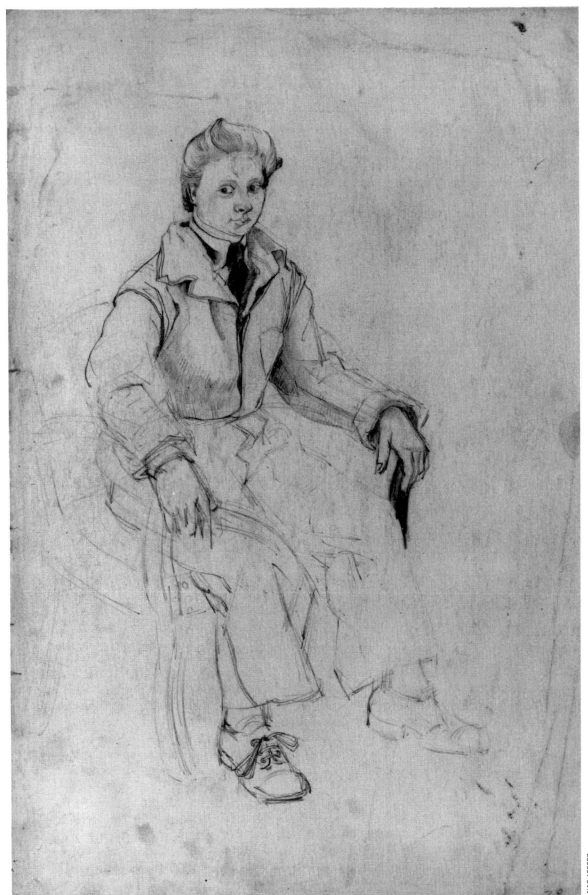

FOUR

◆

THE YEAR OF THE LAMB BEGINS

(January 1944 – April 1944)

"W110278"'s New Year's edition flashes the news that Private Lamb has attended a dance at Camp Borden near Barrie, Ontario, and drunk many toasts to Allied victories past and future. Once the New Year has been suitably rung in, however, there is serious work to be done on two new canvasses that she is planning to enter in the Canadian Army Art Show in February.

At the end of the month, with portfolio in hand she bravely sets off on her "second pilgrimage" to Ottawa. It is a long and arduous journey. "Three cars to Oshawa, then Pilgrim catches great transport hauling cheese to Montreal and rides with kind driver all the way to Prescott on the St. Lawrence." Our pilgrim arrives at midnight and finds there is no room at the hotel, so she is sent to "Birdie Birk's" tourist home, where she sleeps like a log and then thumbs onward to the nation's capital and the National Gallery.

The headlines of a subsequent edition — just before the editor's twenty-second birthday (February 26th) — bring news of fresh disasters: "WAR TAKES ON TERRIBLE ASPECT AS ARTIST FACES FIRING SQUAD ... LAMB NEAR BREAKING POINT!" "It was a little official yellow envelope," the report goes on, "which held the ghastly news. "

The work Molly has submitted for the army's art competition has been rejected by the military judges in Ottawa. Molly consoles herself with the thought that "Cézanne was in the same boat." And besides, her mother has sent her a wonderful raisin birthday cake, "with a tiny plate of rock plants instead of icing and they smell of pine needles and sea."

Then suddenly there is yet another reversal in the roller coaster fortunes of Private Lamb. She learns that her lance-corporal's stripes are soon to be pinned back on. She awards herself a privately struck medal for serving "one million doughnuts and soft drinks" in the Hamilton canteen. The she heads off for New York City with her friend Corporal Jones to celebrate her birthday in style.

Molly's accounts of her New York experiences will no doubt strike a responding chord in the memories of many former servicemen and servicewomen who managed to make their way to North America's eastern Mecca for a taste of its many wonders. The twenty-five-page special edition of "W110278" titled "New York By Thumb" is replete with colourful illustrations and details of the exciting trip beyond Canada's borders. Included on her personal itinerary is a visit to the dizzying heights of *Life* magazine's head office, where "W110278"'s editor meets her NYC counterparts. Molly displays some of her drawings and the response is highly flattering. "Very interesting!" they tell her. "Please do leave some of your work with us." Molly is thrilled and encouraged!

This special New York edition is followed closely by the "TRIUMPH ISSUE" dated March 1944. Due to some behind-the-scenes bungling, a rejection slip for Molly's entries in the Army Art Competition has been sent in error. Her work has been accepted after all and the pleasure of her company is requested in Ottawa at a reception given in honour of the prize winners at the National Gallery. The first prize has gone to a young artist serving overseas who is therefore unable to accept in person. His name is Bruno Bobak. Molly has been awarded second prize — a war bond — for her painting *Pay Parade*. The prize is to be shared with a soldier named Robert Bruce. And Princess Alice, wife of the governor general, will make the presentation.

Permission for leave is granted. Molly packs her kit bag and hits the road for Ottawa with thumb extended. She arrives somewhat the worse for wear and prepares for her finest hour by getting her hair done. She tries with dwindling hope to find a salon that will take her without an appointment, but all is not lost. A little establishment on Bank Street can fit her in for a quick perm. Molly's sixth sense tells her she is taking a serious risk, but she is driven by desperation. The result resembles a fright wig, but she must forget this last-minute disaster and practise her curtseying. Her public and a film crew await her arrival at 9 p.m.

It is a dazzling occasion, full of uniforms and bejewelled women in elegant evening gowns. "W110278" reports that Lance-Corporal Lamb's nervous agitation and freshly frizzled hairdo get the better of her. When it comes time to accept the coveted prize from Princess Alice, "excitement ran so high that the poor girl's knees quaked and the curtsey was a distinct failure. More like a bit from a jitterbug routine."

(The film crew in attendance have duly recorded the event and a copy is later sent overseas to be shown to the troops. Bruno Bobak sees it in Holland and wonders about the girl with the frizzy hair. Within a year he will discover her identity, when they share a studio together as war artists in London.)

In the April-May 1944 issue of *Canadian Art*, editor Walter Abell declares that the Canadian Army Art Exhibition constitutes a milestone in that it is the first time an official government agency has invited a cross-section of the Canadian people "to draw and paint its reactions to a phase of contemporary life, to enter its work in a national competition, and to exhibit the results at the National Gallery."

It is particularly heartening, he notes, that the show generated such a high level of public interest and attention. And given that the pictures on display come from "the rank and file members of the Army, as a leisure-hour pursuit after military duties," Abell is struck by the artists' degree of competence as well as by the humour, spontaneity and "insouciance" of so many of the entries. In particular, he commends the preponderance of "modern" works (a trend that also found favour with the contest judges — A.Y. Jackson, Arthur Lismer, Henri Masson and H.O. McCurry, director of the National Gallery).

Implicit in Abell's critique of the show is the suggestion that the public perception of the artistic merit of the prize-winners' work did not necessarily reflect that of the judges. For many viewers, the bewildering predominence of modern works posed "difficulties" in terms of appreciation. Had the composition of the jury been military or otherwise, the choices would undoubtedly have been based on assessments more heavily weighted towards the straight and narrow.

Meanwhile, oblivious to the controversy, the curly-topped Lamb makes her dreary, downtrodden way back to the counter of the Hamilton canteen to serve up her last few doughnuts. A transfer to Toronto is soon to spell the end of her days as a serving wench.

Molly is on the move.

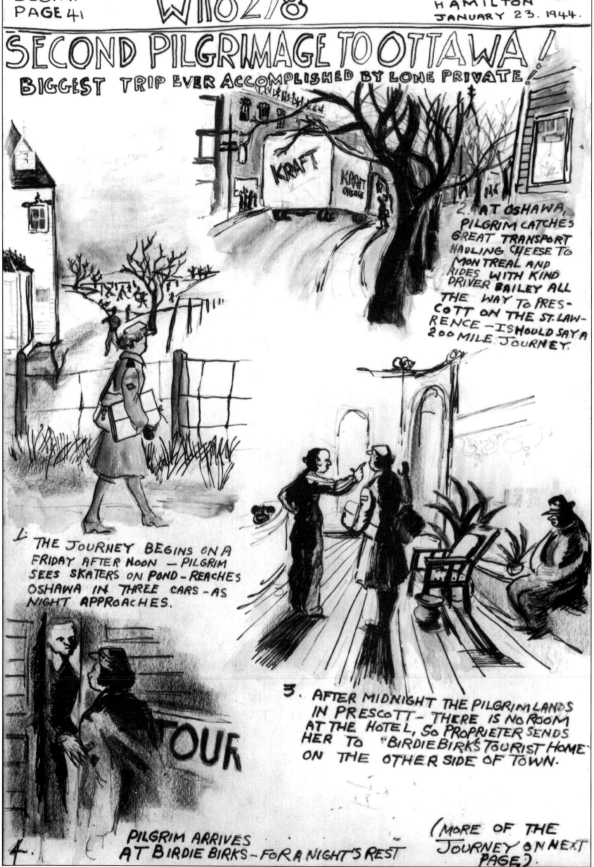

SECOND OTTAWA TRIP (CONTINUED)

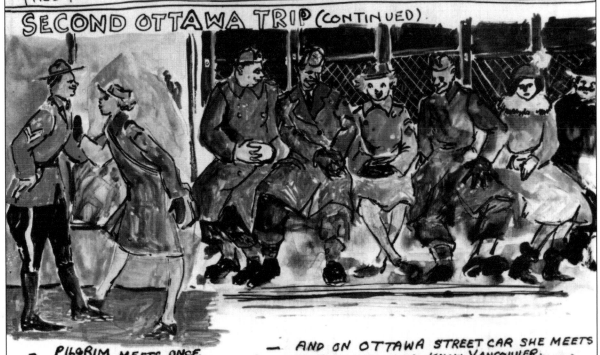

PILGRIM MEETS, ONCE MORE, WONDERFUL R.C.M.P. CORPORAL FRIEND, WHO GUARDS THE NATIONAL GALLERY.

— AND ON OTTAWA STREET CAR SHE MEETS 3 SOLDIERS WHO KNOW VANCOUVER.

— RE-UNION WITH KIND FRIENDS THE McCURRIES.

— AND ON THE RETURN TRIP PILGRIM MEETS JEW — WHO HAD READ "WAR & PEACE" IN HEBREW — "IT WAS" SAID PILGRIM THE BEST HITCHHIKE I EVER HAD — AND THE NICEST DRIVER I EVER MET."

— THEN CAME A NINE MILE WALK INTO KEMPTVILLE

"OH DEAR" SIGHS THE PRESS "MORE NECESSARY NEWS PICTURE MUST GO IN, SO WE FEEL THAT WE MUST SACRIFICE YET ANOTHER PAGE."

DO NOT FAIL TO READ "REVOLTUTION!" A STARTLING HUMAN DRAMA ABOUT A BOOK AND A GIRL! WHICH SHALL BE INCLUDED IN OUR NEW ISSUE!

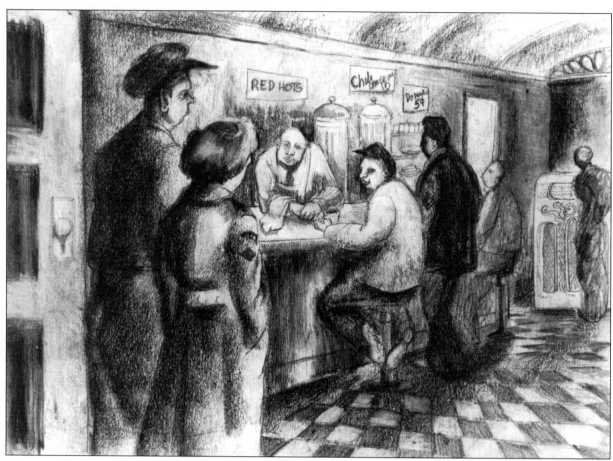

A Diner in Syracuse, N.Y., February 1944

NEW YORK BY THUMB.

FEBRUARY 24-28
1944.

THE PART ABOUT NEW YORK

(AS TOLD BY PRIVATE LAMB TO REPORTERS ON THEIR SECOND VISIT TO THE CANTEEN)

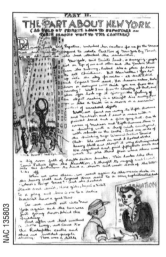

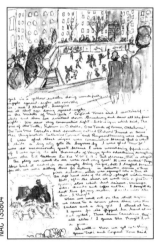

Private Lamb, said reporters, unlocked her canteen for us for the second time and graciously agreed to relate Part Two of New York By Thumb as soon as she had stacked the sandwiches.

"New York," said Private Lamb, "is amazing. People live on top of one another and the Yankee Stadium from the subway looked like a place for lions to eat Christians. But Manhattan! ... You look up into the sky for miles — at least I did — and Corporal Jones said, 'For heaven's sake, look down or everyone will think you are from the country!'

"Well, I am from the country, at that; and when you look up it gives you the feeling of an object rushing in a straight line away from you — like a trick in a movie or a surrealist picture of unrelated objects.

"Well, we found our way to Fifth Avenue and Madison and I saw a man with a pointed beard and a fine grey hat. On the corner of Madison and Fifth Avenue there is a building with a half-circle courtyard, with shrubs in the centre. And one side of the building says WOMEN'S ACTIVE SERVICE CLUB. We went in and I looked at the Hall and thought it very distinguished. We registered and paid fifty cents each and went to the third floor where there was a big room full of double decker bunks. 'This looks like the Tsar's Palace after the Revolution,' I thought to myself and I went off into the bathroom to have a shower and wash some of the hitch-hike off.

"When we were clean, we went again to the main desk in the hall and Corporal Jones said to a very sophisticated lady, 'Where's a Bingo Game?' and she looked very blank and said, 'Here, girls. Here's a ticket to a play and here is one to a radio broadcast. Have a good time!'

"So we went out into New York again and the sun was just going down behind the buildings. And after we had walked a little way, we came to the Rockefeller Centre and there we watched people skating. There was a little girl in a yellow sweater doing wonderfully supple spread-eagles all over the ice and I thought, 'Imagine me at that age doing spread-eagles in the middle of New York!'

"Corporal Jones and I watched for a while and then we walked down Broadway and saw all the famous sights. We saw very conservative light-bulb signs which said, 'The Voice of the Turtle,' 'Robeson in Othello,' 'One Touch of Venus,' 'Oklahoma,' 'The Two Mrs. Carrolls' and some other thing in which Katherine Cornell and Raymond Massey were acting.

"I was glad these signs were conservative because that is what a big city gets its 'bigness' from. New York was so unconsciously great, and I was wondering, beforehand, if I was going to see thousands of Varga girls advertising everything from the art galleries to the Y.W.C.A. ... But of course that was stupid.

"The play we went to see was not very good. It was called 'Peep Show' and it cashed in on simply being risque. But I laughed because, after all, we were sitting there for nothing. In between scenes a three-piece orchestra, which was squeezed into a box at the left-hand side of the stage, played violin music.

"Well, after the show, we went into a fine Jewish grocery store, which had raisins, sausages, oils, breads and coffee and tea. I bought the last two for my mother. 'How she will like this!' I thought.

"When we went out on the street again, we came to a corner where there were three sailors and a big girl. I stared at her, I guess, for she flipped her hand at me and yelled, 'These damn Canadians! They're all alike!' ... I guess she thought I was a prude.

"Ahh well, — then we got in a shiny green taxi and Corporal Jones said grandly ... 'Carnegie Hall.' And there we saw a coast to coast radio broadcast, which was dull, but it was fun to see what I had heard many times before on Friday nights at home. And we got a package of cigarettes given to us.

"And after the show, it was getting very late and we were tired, but we had to go first to the famous Automat and push nickles into slots for coffee and Danish pastry.

"'Ah,' said Corporal Jones, 'not bad for the amount of time we've been here!' (She sipped her coffee) 'We've been to a play, seen Times Square, Carnegie Hall, a radio program and now the Automat!'

"'That leaves,' I answered, 'The Statue of Liberty, Central Park, The Empire State Building, Coney Island, The Stork Club, The El Morocco — '

"'Come,' said Corporal Jones, 'Let's get to bed.'

"So we went back to The Women's Service Club and went to sleep; but before we did, we decided to go our separate ways in the morning and I thought, 'Ah, tomorrow — The Art Students' League and the Gallery of Durand-Reul and the Museum of Modern Art!' No doubt Corporal Jones was dreaming about the things she wanted to see, too.

"It was a dull day in the morning, but we felt very fine after the first sleep of our journey and we set out quite early for the Automat. After breakfast we parted and I walked up Fifth Avenue until I came to Fifty-seventh Street. On the way I saw fabulous diamonds and giant rubies and jewels set in gold. I saw wine glasses with beautiful stems and Italian primitive paintings, which were really done by Boticelli! But I never have looked into a diamond or a great jewel before ... They take your breath away, reporters!"

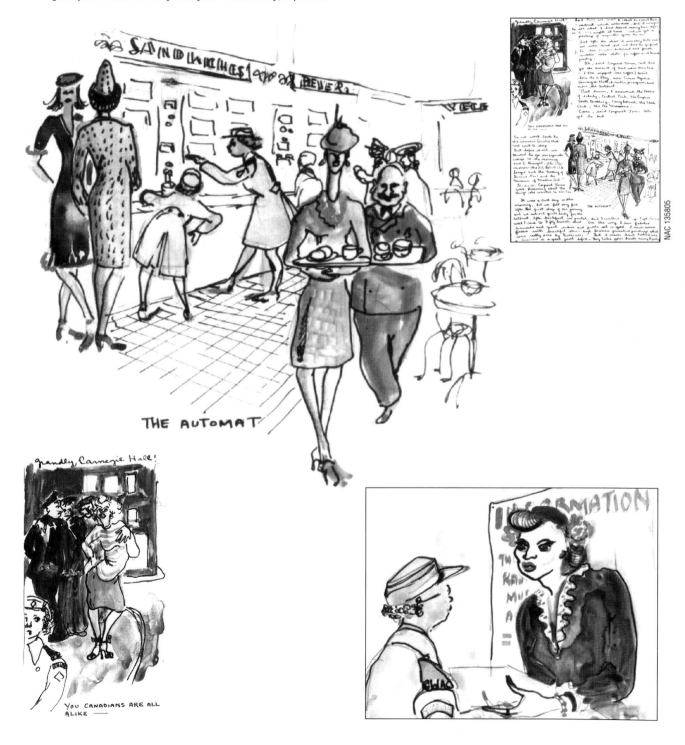

THE AUTOMAT

grandly, Carnegie Hall!

YOU CANADIANS ARE ALL ALIKE —

TRIUMPH ISSUE
THE SENSATIONAL LITTLE HOUR OF LAMB

OTTAWA ... MARCH ... FLASH!

Cinderella Lamb has had her little hour. From first-hand authorities comes the story of this successful girl who left Hamilton Trades School as a nobody and arrived back still a nobody, but at least a nobody with a "little hour." Reporters say that Cinderella hit Ottawa late on Monday night and that her fairy godmother got busy early Tuesday morning when the lance-corporal was asked to pose before her gem "Pay Parade" for the Canadian News reel.

Later, after meeting many good friends, she heard the staggering rumour that she had won second prize in the Canadian Army Art Show, which was to be opened that night. "Well," she testified, "I didn't know for sure whether it was true, but for the rest of the afternoon I practiced curtseying in case I met Princess Alice. And I had my hair trimmed and said 'Your Excellency' and 'Your Highness' once or twice so I would sound natural."

When the moment came, at nine o'clock that night, the girl found her rumour to be true. Excitement ran so high that the poor girl's knees quaked and the curtsey was a distinct failure — more like a jitterbug routine, suggest eye-witnesses.

After milling about in the thickly populated rooms, starry-eyed L/Cpl. Cinderella staggered home to friend Theo Greene's house, where she sent epic telegram home to Galiano Island.

For further details, see authentic pictures ...

SUICIDE PLOT FOILED IN TIME!

GIRL SAVED BY THE BELL!

A FAREWELL TO HAMILTON.

Authorities were shaken last night by the finding of a note near the canteen door, disclosing the terrible intentions of a desperate corporal (name withheld). The contents of the note stated (quote):

My nerves are shot. No longer can I stand the monotony of getting up, eating, standing in the canteen, eating and standing in the canteen again. Therefore I have decided to die — I think. I shall take my life either by the blunt canteen bread knife or by the gas from the Coca-Cola machine. Hallo, Mum. Don't worry (unquote).

Upon finding this note, authorities were frantic and went at once in search of the hopeless girl.

BREAD KNIFE WITH BLOOD TRACES!

Breaking in upon the canteen, authorities were horrified to find blood on the bread knife. They hastened to the Orderly Room, bearing their ghastly evidence with them and were almost upset by a frenzied girl, who was dancing up and down with joy.

They took their evidence to the Captain with tears in their eyes and demanded a search for the deceased girl. "Did you pass a very excited Lance-Corporal as you came in?" asked the Captain. "That is who you are looking for. She has just been posted to the Army Show in Toronto to paint scenery."

"But," said authorities, "what of this bloody knife?" the Lance-Corporal bounced up merrily. "Ah," (she said), "there's my knife ... I've been merrily eating bread and strawberry jam — celebrating my release from slavery."

"And what of this note?" asked authorities.

"Oh ... a whim — just a whim," said the lance-corporal.

AND NOW L/CPL. GETS READY TO LEAVE — "It's amazing," states the girl, "the amount of stuff you accumulate in a few months. I've got four kit bags and still I can't get everything in."

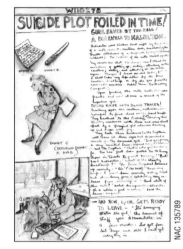

EXHIBIT A. EXHIBIT B.

EXHIBIT C. (EXPLODING EXHIBIT A. AND B.)

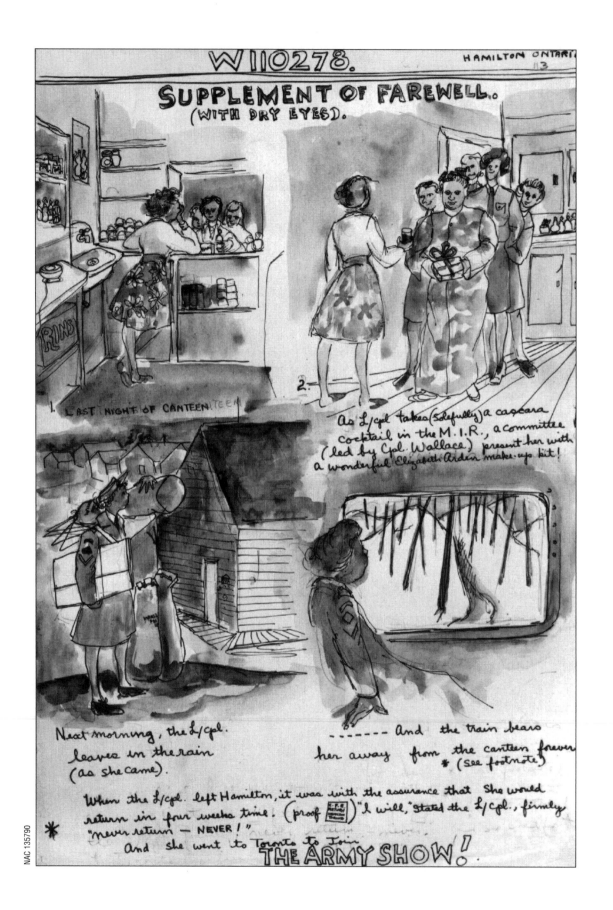

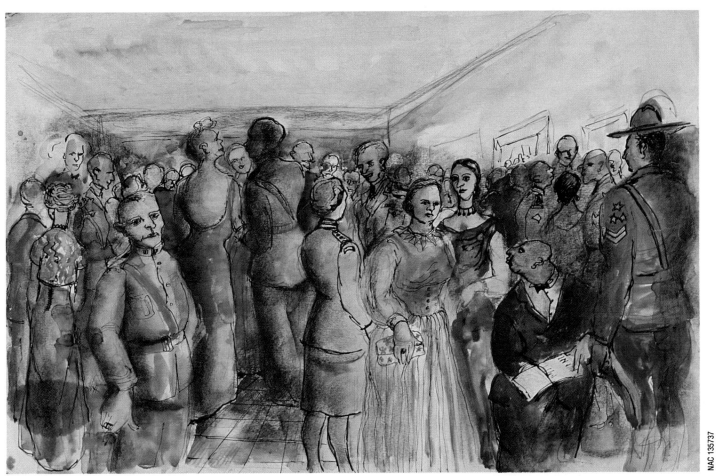

FOR LADIES W110278 PRESENTS
1943 FALL FASHIONS..

1. "HATS WILL BE ON THE FACE THIS FALL" SAYS MODOM MOUTON (ENGLISH PRONOUNCIATION LAMB).

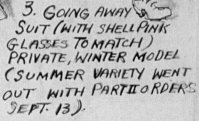

Q.M. STOR[E]

2. SPORTS MODEL FOR (BATTLE DRESS. THE BUSY MISS.

3. GOING AWAY SUIT (WITH SHELL PINK GLASSES TO MATCH) PRIVATE, WINTER MODEL (SUMMER VARIETY WENT OUT WITH PART II ORDERS SEPT. 13).

4 - BATTLE DRESS - REAR VIEW. - A CREATION FROM THE EXCELLENT SCHOOL OF COOKERY.

5

6.

THE FAMOUS RED SLIPPERS CADGED FROM MILITARY HOSPITAL AND LACQUERED AT WORK

THE NEW BRAEMAR SWEATER - WORN AFTER A DAYS WORK AND ON WEEKENDS - PEARLS BY BIRKS, NO LESS.

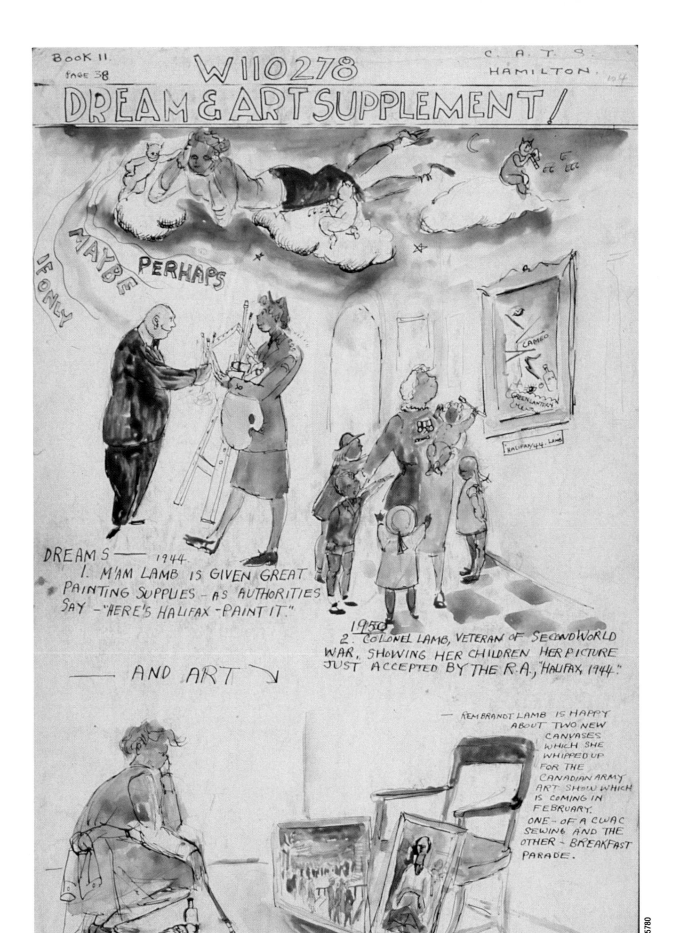

ARMY SHOW. 158
MAY. 1944.

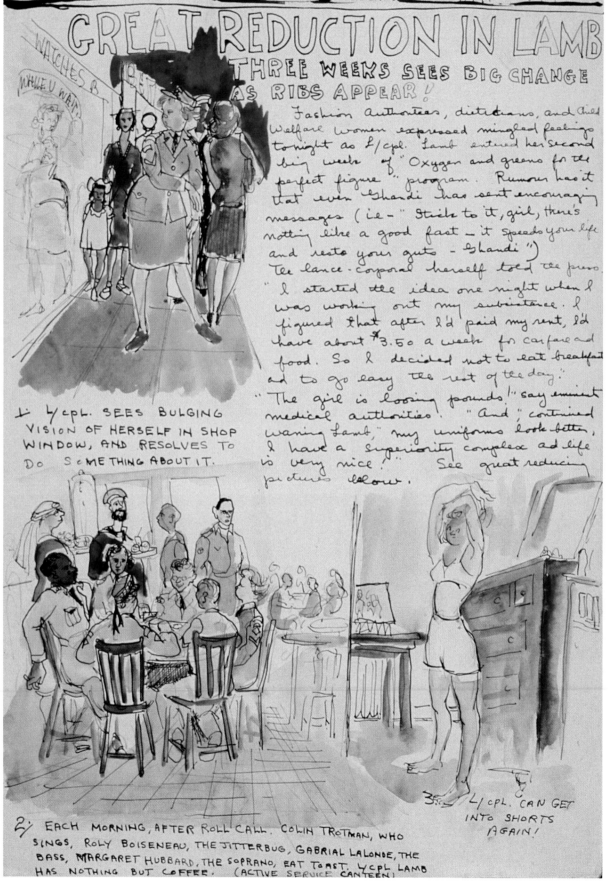

FIVE

---◆---

FORWARD MARCH

(April 1944 – June 1945)

Book Two of "W110278"'s second volume opens on April 4, 1944, with another news flash — "GIRL STATIONED ON DREADED TRINITY BARRACKS!" Much to Lance-Corporal Lamb's relief, the rumours relating to her new accommodation have outraced the facts. Toronto's infamous hostelry for CWACs is not the cockroach-infested horror house she has been led to expect. And, aside from having a nurse check her hair for head lice, everything is perfectly satisfactory. She even has her own room!

It is spring and life is full of new hope as Lamb walks through the grounds of the university and Queen's Park to her new job. She has been assigned to a unit that is part of the Canadian Army Show. Henceforth she will be required to paint and design sets. And in her spare time she can sketch the old Victoria Theatre, the dancers, the singers and the comedians who will soon become her new friends.

This is a far cry from drawing charts for the School of Cookery. "I really feel I've progressed," she confesses to reporters for "W110278." In short order, Molly becomes fast friends with her commanding officer, Ed Harris, and his wife, Ruth, who both encourage her to keep painting on her own. The National Gallery agrees to supply her with the necessities of artistic life — paints brushes and canvasses — "All free for nothing!" she cries. "I remember going to Loomis & Toles and buying yellows and reds and greens and blues and ochres. There's nothing like a tube of paint — better than cosmetics any day!"

Before long there are improvements in her living arrangements, too. She is no longer required to live in the barracks and is put on a "subsistence" allowance. Here again, fortune smiles in Molly's direction. On Prince Arthur Avenue, Gordon and Maybelle Andison, both French scholars at the University of Toronto, become her second family. She is given carte blanche to invite friends to drop in, and once or twice Fred Varley appears for a drink and the company of kindred spirits.

Leonard Brooks, a naval war artist, often comes by with his violin for a musical soiree, with Professor Andison providing the piano accompaniment. Molly also meets Glenn Gould's teacher, Alberto Guerrero, an old friend of the Andisons. Life goes rollicking along as Molly gains confidence in her new-found emancipation from the strictures of army life.

Her entries in "W110278" become more infrequent as her days and evenings grow increasingly full and less restricted, but the highlights are duly recorded, whenever possible.

The May 1st edition heralds the arrival at the theatre of an unexpected visitor — Jack Shadbolt. Another joyful reunion is soon under way as Molly and her former teacher do

the rounds of Eaton's Gallery and Little Denmark and visit with A.Y., who treats them to French burgundy.

Then Shadbolt has to catch a train and Molly goes back to painting snakes and stuffed fish at the theatre. Her mental health has been restored to a state of suspended happiness. First the prize, and now this — a job that verges on normality in a place that reverberates to the sounds of laughter and music and dancing feet. The parade square becomes a distant memory as Molly Lamb jumps on the show business bandwagon. The Army Show is preparing to go on the road and across the sea to England and the war zones of Europe. D-Day is barely a month away.

The next diary entry, this one of great personal significance for Lance-Corporal Lamb, reports — in a hot off the wires news flash — that the advisory committee for War Records artists has accepted the name of CWAC Lamb and she will be further advised on developments. The army — to its credit — has long been highly supportive of and sympathetic to her cause; however, then, as now, great patience is required of those who must wait for officialdom to take decisive action.

Molly decides to make another sojourn to New York City — once again making use of her finely honed skill in the art of the well-turned thumb. The ensuing July issue of "W110278" tells of trouble at the border: "The Peace Bridge Boys were in foul moods and my border pass had been marked all wrong in the Orderly Room. They wouldn't let me into the States, so I hitch-hiked to Niagara Falls and tried the Rainbow Bridge Boys." Here she has better luck and is finally on the road again with the usual motley assortment of rides. Finally, hot, sticky and exhausted, she arrives in the Bronx, where she searches out a delicatessen before heading for the Women's Service Centre in Manhattan. New York City in the sweltering July heat is not quite up to her expectations.

On her next leave, in August, she is allowed to travel in civilian clothes as she shuttles her way across Northern Ontario and the Prairies by train. When she sees the mountains, her spirits begin to rise. Presumably they remain on that level for the duration of her furlough, since there are no further entries in "W110278" until September. Perhaps the "reporters" have better things to do, as well as the editor!

On her return to the Army Show, L/Cpl. Lamb is informed that a special performance in Quebec City is being planned to coincide with the arrival of Churchill and Roosevelt. Since Molly has managed to negotiate a ticket for herself to accompany the troupe, she decides to mark the occasion with a special illustrated edition of "W110278":

> In London this month, on the hush-hush, Prime Minister Churchill told his wife, Clementine, "Pack your suitcase tonight, my dear, if you want to accompany me to Quebec." In Washington, President Roosevelt asked his wife, Eleanor, to postpone her duties and accompany him to Quebec also. And in Toronto, Canada, L/Cpl. Lamb donned a huge battle jacket and paraded herself before the Captain in the hope that a zany pleading act would win her a ticket to Quebec with the #7 Unit Show, which was leaving the next evening for that historical City of Conferences. Prime Minister Churchill and President Roosevelt were already installed in the Chateau (Frontenac) when L/Cpl. Lamb arrived with the Unit Show on a cold, grey afternoon in September.

Further reports from the editor do not appear until October, when "W110278" readers find that she has been briefly seconded from the Army Show to the CWAC Basic Training Centre in Kitchener, Ontario. Here, in her capacity as a "special staff artist" and recorder of events and places of significance, she is required to produce a series of drawings. This return to the routine of army life proves to be a harrowing experience — complete with the blowing of whistles at mealtimes and an almost instant reprimand about

her hair extending below the prescribed collar line. And when she sits down on the grass with her sketch pad, a brace of officious sergeants promptly tell her to remove herself. The knowledge that the duration of this assignment is mercifully short comforts her until her return to Toronto and to what she has come to regard as "normality."

For another few months, work at the theatre keeps her in high spirits. However the March 27, 1945, edition brings the news that she has been "struck from strength" and will be leaving the Army Show for greater glory at Officer Training School in Ste. Anne de Bellevue. Given her previous experience there, Molly has mixed feelings about this particular turn of the wheel of fortune. The final edition of "W110278," Book Two, Volume Two, marks the regretful end of L/Cpl. Lamb's "greatest year of life — the Canadian Army Show!" but promises further reports in Volume Three — "The Life of a Cadet."

It appears, however, that Cadet Lamb's days at Ste. Anne are kept so fully occupied with the intricacies of officer training that she is unable to report developments to "W110278" until after her graduation as a full-fledged second lieutenant.

A "W110278" news flash carries the headline: "LIFE BEGINS AS SECOND-LIEU-TENANT ... NO MORE HITCH-HIKES / NO MORE PRANKS / WE'RE NO LONGER / OTHER RANKS!"

Molly has graduated, yet the paper's reporters covering the newly "pipped" Lieutenant Lamb's celebratory evening in Montreal disclose unsettling details concerning her state of mind. She is quoted as saying she feels, not elated, but "confused, homesick, lonely, frustrated, unhappy, and restless."

She sees her friends off one by one at the Ste. Anne station until she becomes the last remaining cadet without a posting. When her orders to proceed to Ottawa finally come through, Lieutenant Lamb hastily packs up her kit and boards the train.

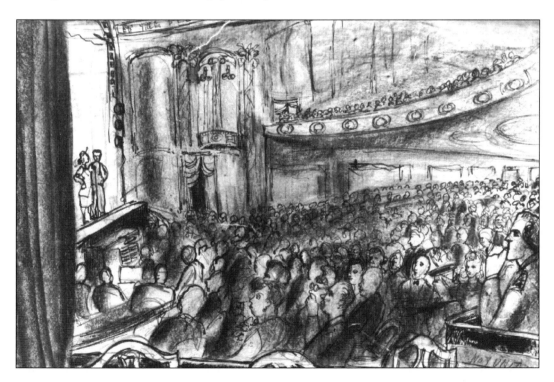

#7 Unit Canadian Army Show 1945 Quebec City
pen and ink on paper
450 x 300 cm
Collection of Everett Staples

"OTTAWA SCOOP — LAMB'S FATE REVEALED!" In a state of total disbelief, Molly finds herself "reeling down Bank Street, returning salutes to traffic lights!" After two and a half years of waiting and dashed hopes, her dream is about to be realized. Within a month she will be going overseas as a war artist. As in previous states of dejection or elation, she makes for the nearest delicatessen and orders a Pepsi and a pastrami sandwich. Heaven can wait. For the moment, this is close enough!

Embarkation leave comes as a richly deserved reward and Molly's unbounded elation carries her off on an orgy of celebration. On V.E. Day she hitches rides through the small towns along the route to Toronto, taking in the local revelry as she goes. On arrival she heads straight for the theatre for a joyful reunion with friends from the Army Show, then off for drinks at the CWAC officers' mess on Dale Avenue in the heart of Rosedale and an afternoon at the races. With victory in Europe assured, there is more than enough cause for celebration and frivolity. "W110278" reporters state that Lt. Lamb acquired a new understanding of Degas's and Toulouse-Lautrec's fascination with the racetrack. They also note that she placed her bets according to the colours of the jockeys' shirts and lost hers instead.

Before leaving for Ottawa, last but not least, Molly pays a farewell call on "A.Y." at his studio. She arrives with a bouquet of flowers for her mentor. In turn Jackson passes on advice and a letter of introduction to Vincent Massey in London.

During a brief interim stint at the Historical Section headquarters in Ottawa, Molly is to familiarize herself with the war art program. This includes the opportunity to get to know another war artist, one whose work she admires immensely. In Molly's view, Ed Hughes's large-scale canvasses of snowbound troops in the Aleutian Islands bear the imprint of an intensely personal and unique style of painting "outside the current fashions and movements." Molly is one of the privileged few allowed behind the barricade of filing cabinets where Ed Hughes works in self-imposed seclusion. She announces her presence by knocking on the cabinets, which he then shifts aside so she can squeeze her way in for a look at his work and a chance to talk shop.

The final "Bon Voyage" edition of "W110278" is dated Ottawa, June 18, 1945, and its pages document the details of the final preparations for the journey overseas. En route to Kitchener, where she will board the last train carrying CWACs to Halifax, the point of embarkation, she finds herself "as usual, surrounded by greatcoat, raincoat, drawings, haversack and suitcase — in a stuffy old coach — because all the sleepers were in Halifax bringing home the Canadian Army ... Lamb can't sleep for heat, dirt, excitement and interest." Directly behind her a returned RCAF prisoner-of-war is relating his experiences to a fellow officer. As morning breaks, Molly pens a farewell to Canada:

In the early dawn when mists
Lie close to earth
These fields I pass
As now I go away
I will remember
That all these fields are sweet.

These are my eyes
To follow the folding
Rolls of greenest land ...
My ears to sense
The silence of the mist.

This is my love
To hold it all the way
To hold for all it's worth
A mighty, silent song
To sing me home ...

Leaving Kitchener at 2 a.m. the following morning, Molly and her 350 companions grope their way through the moonlight to the mess hall for "enamel cups of coffee and enamel plates of bread and jam." As she makes her way back to her hut to finish packing and brush her teeth, she reflects on the things she will miss — "milkshakes, juke boxes — yes, I'll miss those." Then her mind goes blank. It's too early.

Soon it is time to clamber onto the army truck that carries them through the sleeping town to the station. "The whole draft was massed along the platform in a thick quiet group. Under the lights you could see their faces — chewing gum and nonchalant. A train shunted back and forth, a bit of dawn began to show. A crossing warning bell swung — dinging and donging. We waited two hours, then we boarded the train and the dawn came over the fields bright and fine. I walked through the carriages and saw the girls sleeping or smoking or talking sleepily to one another. Most of them had taken off their tunics and sat facing each other with their shirt sleeves rolled up."

And with that, the editor makes her way to a window seat and closes her eyes. "W110278" has been "put to bed" for the last time.

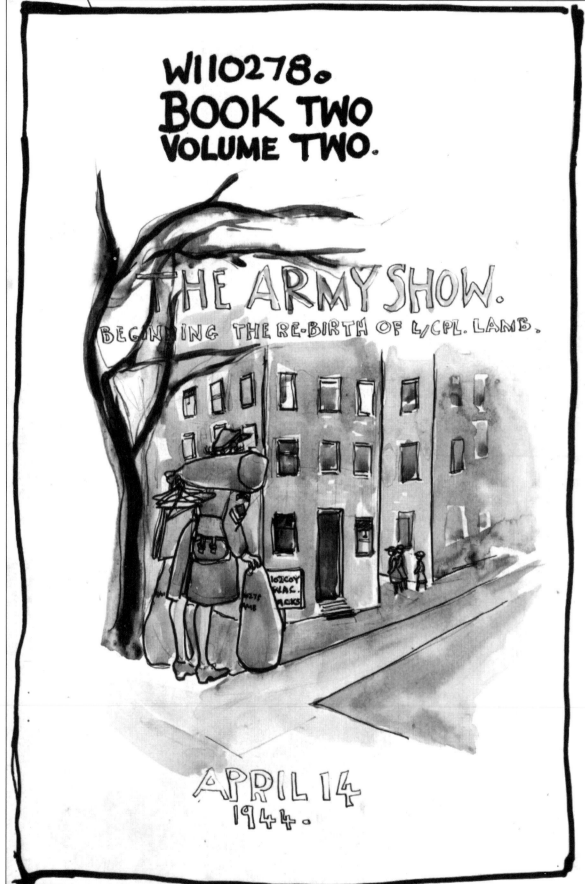

W110278

TRINITY BARRACKS
APRIL 14, 1944

GIRL STATIONED IN DREADED TRINITY ...

PREDICTED PRISON APPEARS TO BE A PALACE FOR ELATED LAMB!
"THIS IS NO HORROR HOUSE!"

TRINITY BARRACKS — It was officially announced today that, after nine months, L/Cpl. Lamb was delivered from Hamilton. (It was revealed that on the train she tore up her portion of her ticket marked "Toronto — Hamilton.") "If I want to go back, I'll hitch-hike," she said with great firmness, as the train passed wet snow banks and bleak spiked trees.

MET AT STATION

The promoted private was met at the Union Station by a prim corporal and an Amazon Driver and they whisked her off to her new home — the Dreaded Trinity Barracks. "This place," say authorities, "is the great rumour of the (military) district. Platoons of cockroaches are said to clamber up the walls. Fatigue squads are said to labour on their hands and knees while a sergeant laughs and cracks her knuckles."

WHAT LAMB FOUND

Rumours were rudely exploded when the Lance-Corporal was kindly ushered to a room of her own and didn't see a bug on the way. However to her surprise, a nurse looked for lice in her head. For further story of arrival see photos.

NAC 135822

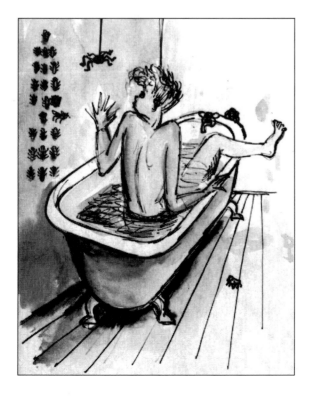

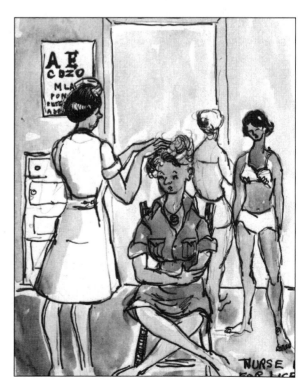

NEW LIFE! NEW HOPE! AS LAMB BECOMES SCENE PAINTER!

1 ELATED L/CPL WALKS TO WORK THROUGH UNIVESITY. SPRING IS HERE!

3. IN ARMY SHOW ORDERLY ROOM, GIRL MEET N.C.O. WITH TERRIFIC ENGLISH ACCENT. "I THOUGHT HE MUST COME FROM VANCOUVER ISLAND BECAUSE OF IT" CONFIDED GIRL, BUT HE CAME FROM SURREY AND HOLLYWOOD, AND LATER, WHEN WE WERE FRIENDS I CALLED HIM NOEL COWARD'S HANG OVER, AND HE CALLED ME ALL SORTS OF THINGS (NOTE VILE PIN-UP)

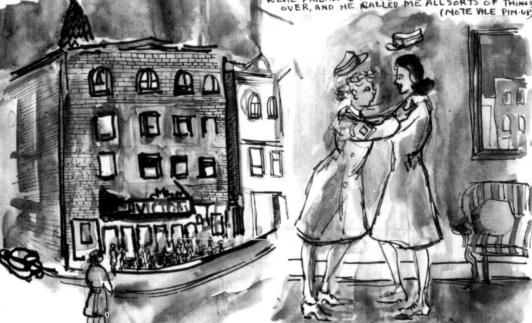

2. GIRL WONDERS IF SHELL EVER GET TO KNOW ALL THE ARMY SHOW PEOPLE, AS SHE COMES TO THEATRE.

4. REUNION OF HUBBARD AND LAMB! IN ROOM WHERE THEY HAD FIRST ARMY SHOW AUDITION

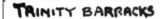

TRINITY BARRACKS **W110278** APRIL 15.

A FIRST DAY ACCOUNT OF THE ARMY SHOW?

1 **MISS SOREL N.Y.** (NEW YORK) (MARKED WITH X) REHEARSES C.WAC GIRLS FOR DANCE ABOUT CAIRO. L/CPL LAMB N.G. (NEW GIRL) HAS NOTHING TO DO , SO SHE SITS AND DRAWS, MAKES FRIENDS AND DISCOVERS HER PLACE OF WORK (SEE BELOW).

HIGH ABOVE STAGE IS THE PAINT BRIDGE HUNG WITH ROPES, WEIGHTS AND SANDBAGS. L/CPL. IS THRILLED. "PHANTOM OF THE OPERA STUFF!" SHE CRIES.

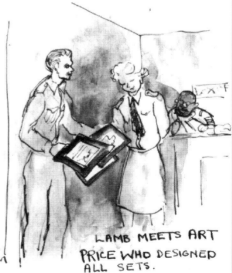

LAMB MEETS ART PRICE WHO DESIGNED ALL SETS.

NAC 135824

TORONTO **W110278** APRIL 18 (1944)

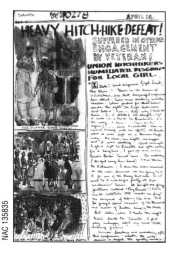

NAC 135835

HEAVY HITCH-HIKE DEFEAT
SUFFERED IN OTTAWA ENGAGEMENT BY VETERAN!
UNION HITCH-HIKERS HUMILIATED — DISGRACE FOR LOCAL GIRL

"I took," said disgraced L/Cpl. Lamb, "the train." Never in the Union of Hitch-hikers has that disgraceful confession been uttered. Even more shocking was the reason. When probed for three hours under the lights, the L/Cpl. broke down and sobbed ... "Fear — that's why I took the train. I ... I ... started out alright. I got a ride in a truck to Brockville. On the way I saw ... (here she broke down again) ... two accidents. At Brockville I was left on the barren highway — No cars, no lights, no supper and it was sleeting. About midnight I got a lift to Prescott and, after waiting a long time, I gave up and went to Birdie Birk's Tourist Home. The next day (the girl hung her head) I took the bus to Ottawa. I drew the War Memorial in the rain because we are going to use it for one of the Army Show sets.

"And I went to a wonderful party at Owen William's house. He bought one of my pictures called 'Pay Parade'! And he made cocktails that made me forget the disgrace of taking the bus. And he played some records of the Benedictine monks of Quebec singing the Mass."

"But later, when I took the night train back to Toronto, I felt very unhappy about my great hitch-hiking failure."

Union leaders are wondering, after this confession, whether this will excuse or expel the guilty member.

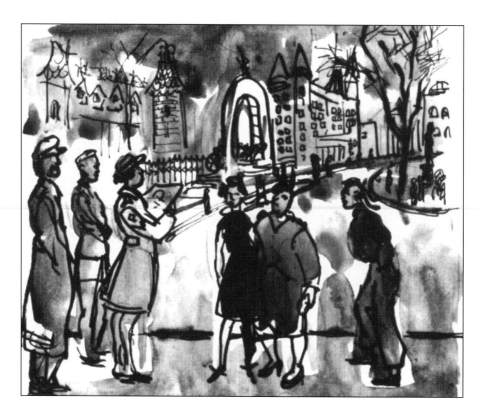

FIRST SETS ARRIVE!
WORK FOR JOYOUS GIRL!
LAMB PAINTS BATHROOM—GRADUATES TO RUSSIA

Sgt. Gill, who makes all the sets for the Army Show, had them delivered to the theatre early this morning. Apprentice Lamb first slapped paint on the bathroom scene. Later she graduated to the dramatic "crashed Nazi plane in Russia" scene. "I really went to town on the mosque-like domes of the background!" said the work-happy apprentice.

SCOOP FOR ARTIST! NEW FRIENDS FROM RECRUITING

Lieutenant Adams and Corporal Wells visited backstage this morning to ask L/Cpl. Lamb if she would illustrate some articles for them. "With all my heart," said the L/Cpl., thinking of the publicity.

It is rumoured that the drawings will be of CWAC activities and will appear in the *Canadian Home Journal*.

"WOULD HITLER HAVE TO DO THIS?" FLARE PAINTERS AS VICTORY LOAN SALESMEN MURDER "MAIRZY DOATS"!

"Hitler does some pretty drastic things," admit scene painters and stage hands, "but we doubt if he'd get his storm troopers to sing 'Mairzy Doats' to encourage them to buy War Savings Stamps." From high above the stage, workers watched a Victory rally take place in the Victoria Theatre. Said they, "We buy bonds without all that silly fuss. There's a whole afternoon and a whole lot of money wasted." They returned to their painting with sighs.

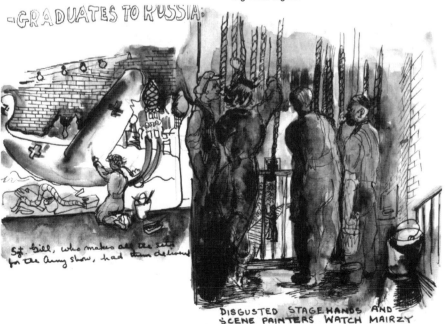

DISGUSTED STAGE HANDS AND SCENE PAINTERS WATCH MAIRZY

HIGHLIGHTS OF THE WEEK

THE SHOW GOES ON

The week of work on the Paint Bridge of the old Victoria Theatre continues. Reporters climbed the dark iron stairs, passed the dressing rooms, to the Bridge where Art Price, Molly Lamb, and veteran scene painter Mac were working on the set for the gypsy scene.

They found Mac showing off a bottle of French champagne to the Lance-Corporal. "I had ten of them at Christmas — got them for $60," confided Mac. "Too bad you weren't here then." Reporters say that Mac used to be a real barman in San Francisco back in 1910.

Below, on the stage, a girl was singing "I Make my Dates in Bed." She stopped and the piano started a jive number called "Hot Russian." Girls in shorts and shirts tied in a knot in front began kicking about; and two comedians shouted at each other.

The L/Cpl. began to paint an icon for the Russian scene and a civilian boy, wearing an overseas badge, came wandering up the stairs.

Reporters say that he was quite a character and that he seemed to take delight in agitating the Lance-Corporal about painting. He was a member — the lance-jack confided — of the young arty set she was beginning to meet in Toronto ... The work goes on.

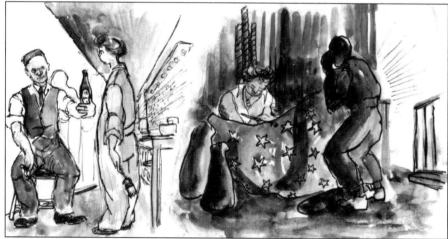

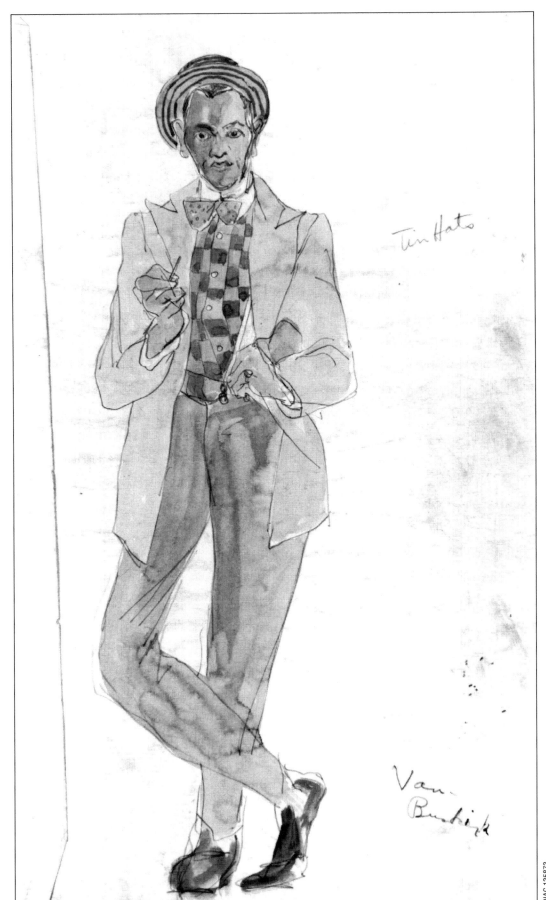

Tin Hats

Van
Burdick

W110278

NAC 135767

WAR RECORDS JOB LOOMS!
L/CPL. BEFORE HIGH DISTRICT OFFICIALS

FLASH ... HOT OFF THE WIRES ...

It was disclosed officially today from Ottawa that the advisory committee for War Records Artists had accepted the name of CWAC Lamb. W110278 reporters in Toronto rushed to the Army Show to be the first to get the scoop on the feelings of a typical lance-corporal.

SHE WASN'T THERE!

The girl, say reporters, wasn't there and, after an extensive search, they found her at headquarters, saluting furiously and struggling to remain calm. Later, as she left the building, she confided to the press, "Yes, the Committee has recommended me. Now I have to get the army really interested in a woman war artist. I have been before wonderful majors and lieutenants — all very sympathetic — (she gulped for breath) and they all seem to think I have the job in the bag — Wow!! Where's the champagne? ... You know," she said seriously, "if I get this — I'll be made for life."

AWFUL RESULTS OF THE VICTORIOUS NIGHT

"I did," said L/Cpl. Lamb, "at least want to look at ease and unafraid when they took my photograph with the Governor-General, the night I got the prize in the Army Art Show ... I even hoped I might have looked fiercely proud."

But the above proof — sent by Photographer friend, Al Erris — shows mild terror of Lamb.

— SALUTING FURIOUSLY ..

Detail from W110278, May 4, 1944 "MILD TERROR OF LAMB"

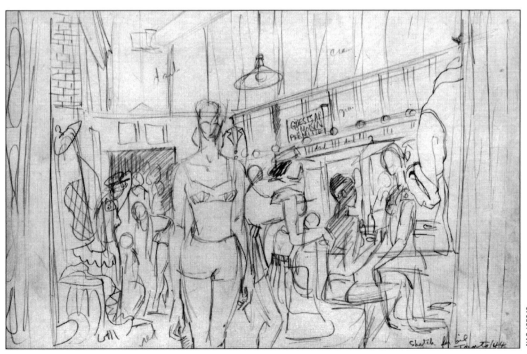

W110278

SEPTEMBER 1944.

CONFERENCE NUMBER QUEBEC SEPTEMBER

CHURCHILL, ROOSEVELT IN HISTORIC QUEBEC - LAMB ALSO.

September – In London this month, on the hush-hush, Prime minister Churchill told his wife Clementine, "Pack your suitcase tonight, my dear, if you want to accompany me to — — Quebec." In Washington, President Roosevelt asked his wife, Eleanor, to postpone any of her duties and accompany him to Quebec also. And in Toronto, Canada, L/Cpl. Lamb donned a huge battle jacket and paraded herself to Captain Wren in the hopes that a zany pleading act would win her a ticket to Quebec with the #1 Unit Show, which was leaving the next evening for that Historical city of Conferences. Prime Minister Churchill and President Roosevelt were all ready installed in the Chateau when L/Cpl. Lamb arrived with the Unit Show on a cold grey afternoon in September. For story of what happened see news photos in the issue.

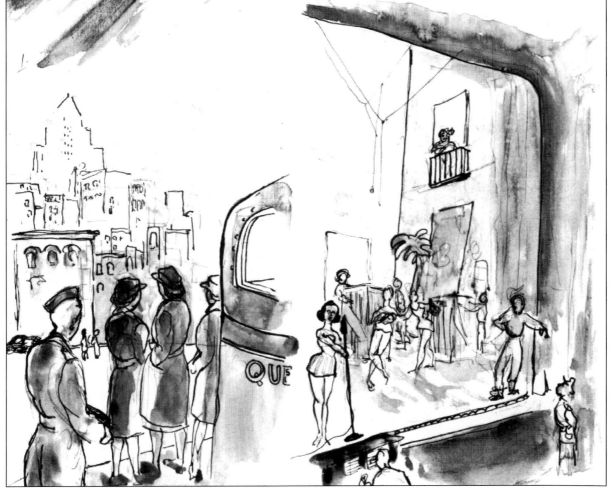

NAC 135847

121

W110278

OCTOBER 1944.

ARMY GIRL'S RETURN TO DISCIPLINE PROVES STRAIN.

W110278'S SPECIAL STAFF ARTIST PORTRAYS CWAC'S AGONY WITH AUTHENTIC PICTURES OF BASIC TRAINING KITCHENER

—L/CPL. LAMB SPENDS GHASTLY 24 HOURS TRYING TO DRAW BASIC TRAINING CENTRE FOR RECORDS PURPOSES, BUT SALUTING AND STRAIN PROVE TOO MUCH FOR POOR GIRL.

—MEAL TIME AT KITCHENER—CORPORAL BLOWS WHISTLE. ALL STAND. CORPORAL SAYS "FOR WHAT WE'RE ABOUT TO RECIEVE MAY LORD MAKE US TRULY THANKFUL TWEEET (WHISTLE). ALL SIT. "TWEET", ALL BEGIN TO EAT.

DISCIPLINE CORPORAL, WHO HAS NO TROUBLE THIS WAY HERSELF, TAKES LAMB ASIDE." CORPORAL LAMB, YOUR HAIR IS NOT ABOVE YOUR COLLAR, AND WITH ALL THESE BASIC TRAINEES ABOUT, YOU MUST BE NEAT AT ALL TIMES." "YES "SIGHS LAMB" BUT I LOOK SO AWFUL BALD."

IS P.T.S. (IN UNISON) "GET OFF THAT GRASS---"

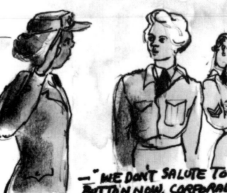

—"WE DON'T SALUTE TO THE CAP BUTTON NOW, CORPORAL.—

NAC 135849

122

PRINTED AT THE
CANADIAN ARMY
SHOW, TORONTO

THE MEDALS OF LAMB.

EVERYTHING BUT V. C.

1.

Pacific Command
patch - strictly for
show

2.

ten cents a day.

3. (T)

twenty five cents
a day - trades badge

4.

two year chevron

5.

non - zombie

6.

Mackenzie King's medal
for 18 months service.

Fashion authorities, together with
reporters from W110278 and Army
officials interviewed the celebrated
L/cpl. Lamb A.B.A.G. (as
bad as Goering) tonight
to get the latest news
on her medals, badges
and decorations.

They found the girl in the
act of ripping off her good
conduct stripe. (This stripe
is also known as the "Two years
of undetected crime" stripe and is
simply a lance-corporal stripe
upside down and worn under
the G.S. badge.

"Why are you ripping off
your good conduct?" queried
officials. "Ahh", sighed Lance-
corporal Lamb. "It limits one's
friendships — and also — I must
admit I don't really feel qualified.
"And these other decorations?" asked
the press. "All explained on the
left hand side of the news" con-
cluded the Lance-corporal.

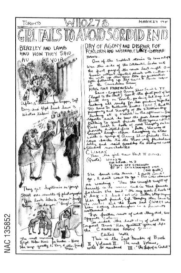

NAC 135852

GIRL FAILS TO AVOID SORDID END

DAY OF AGONY AND DESPAIR FOR FORLORN AND MISERABLE LANCE-CORPORAL

TORONTO —

One of the saddest stories to come out of the war this side of the Atlantic broke into the front page of the news last night. Our human interest reporters shook with emotion as they wrote up this grim tale for publication, after following up the saddest lance-corporal in the Canadian Army.

HAIL AND FAREWELL

Lance-Corporal Army Show Lamb L.T.T.L. (loyal to the last) spent the first part of her final day in Toronto, packing kit bags and making all ready for her pending trip to Ste. Anne de Bellevue, Quebec, (O.T.C.) — Officers Training Course . And the poignancy and tragedy of the situation began lurking at four o'clock in the afternoon. One reporter said he saw the poor lance-corporal talking to great friends Bill Speare and Art Price with a look of real tragedy on her horribly distorted face. Later, she was observed clown-laughing in a tavern with a group of Army Show friends. She came back to the Show very flushed and silly and said good-bye to everyone with a studied nonchalance.

CLIMAX

Then the girl saw Part II orders

(quote) W110278

 LCPL. LAMB, M.J.

 STRUCK OFF STRENGTH

 OF #1 ENTERTAINMENT UNIT

 (end quote)

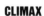

She burst into tears. "I don't want to go! I don't want to go!" she was observed as wailing. Then she caught sight of herself in the mirror and in true female fashion, she said, "Oh my gosh, I look like a bag! I had better (sob, sob) stop crying."

Her great friend Sgt. Beazley then came to the rescue and the two sad CWACs were seen eating hamburgers in a favourite restaurant.

For further news of what they did, see opposite column.

So ended the last day of what the lance-corporal terms "Her greatest year of life — the CANADIAN ARMY SHOW."

EDITOR'S NOTE:

This is the last number of Volume II, Book II. The next Volume will be numbered (Volume) III — "The Life of a Cadet."

W110278

NOTES FROM THE LAMB GALLERIES

"To our famous collection," stated Curator Lamb to Art Critics today, "comes this masterly piece of overstatement by an unknown soldier. It is simply called 'Relax!' to be interpreted as a command. The work depicts the feelings, I believe, of a candidate to the Officers' Training Course, when she is up before a board of officers."

For further explanation of this great canvas, our curator interviewed a typical officer candidate. "She told me that one polishes one's buttons, cap strap, shoes and face. One puts one's hair above one's collar, makes sure that one's powder is not on one's tie and with false courage, one rattles one's knuckles on the Board of Officers' door, enters, salutes, sits down like a poker and is immediately told to RELAX. Then comes the bombardment.

"One is asked if one wants to become an officer; if one understands one's responsibilities etc. etc. It is a very interesting policy known in some countries as the Third Degree. I believe this actual canvas shows a candidate who passed the questions successfully and for further adventures see the following pages."

NAC 135853

STE. ANNE DE
BELLEVUE
QUEBEC

W110278

MAY 20, 2I, 22
1945

LIFE BEGINS AS A SECOND-LIEUTENANT

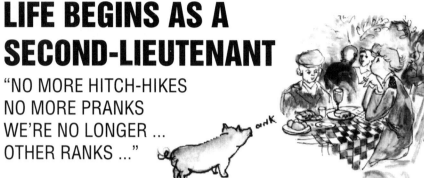

"NO MORE HITCH-HIKES
NO MORE PRANKS
WE'RE NO LONGER ...
OTHER RANKS ..."

MAY 19TH ... FLASH ...

Newspapermen who scooped the Graduation Story of earlier this afternoon followed confused 2nd Lieutenant Lamb and her good friend Mrs. Downes to Montreal on the 4:30 train. During the evening reporters followed the 2nd Lieutenant around and plied her with questions ... "Don't you feel elated?" asked one. "No," said 2nd Lieutenant Lamb (after friend Downes had left on the eight o'clock train for Ottawa), "I'm homesick, lonely, frustrated, confused, unhappy, restless ... and what's more, I can't believe it."

For more of girl's unhappiness see next issue ...

1) Lt. Lamb and great friend, Mrs. Downes, go to Montreal after graduation to celebrate new pips.

2) What should have been the first salute — 2nd Lt. Lamb forgets how to "Normalize the Situation."

3) Feeling very officery at the well-known restaurant "Au Lautin Qui Bouff" ... (pig was entirely unnecessary, but steak was the very best).

4) The first salute — 2nd Lt. Lamb, although it was 8 o'clock at night, shrieks "Good morning!"

5) Mrs. Downes leaves for Ottawa, so Lamb sends telegram to mother — with a happy Major's help. But Lamb is feeling far from gay.

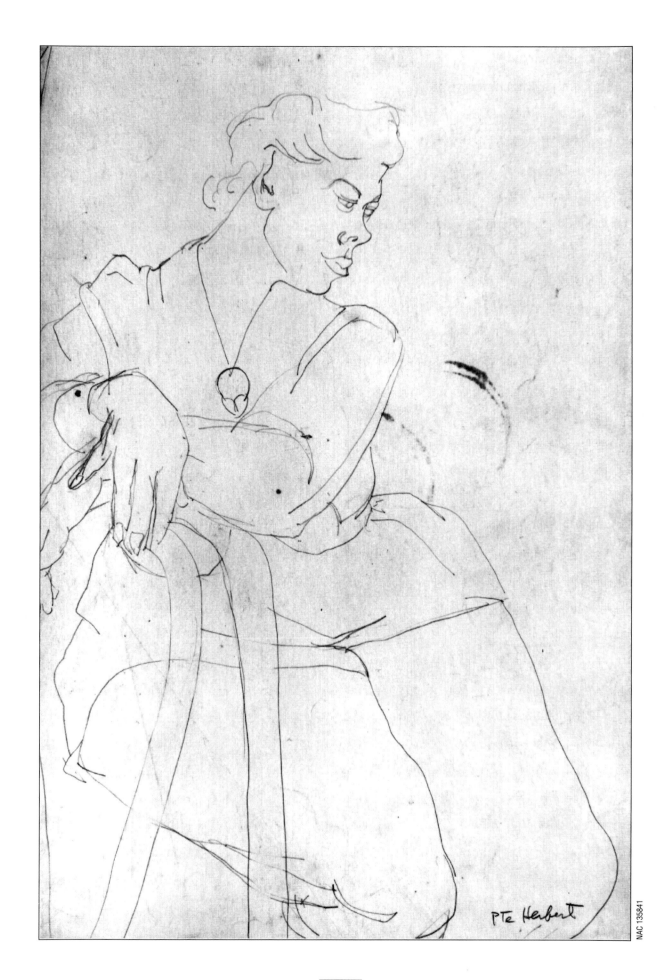

PTe Herbert

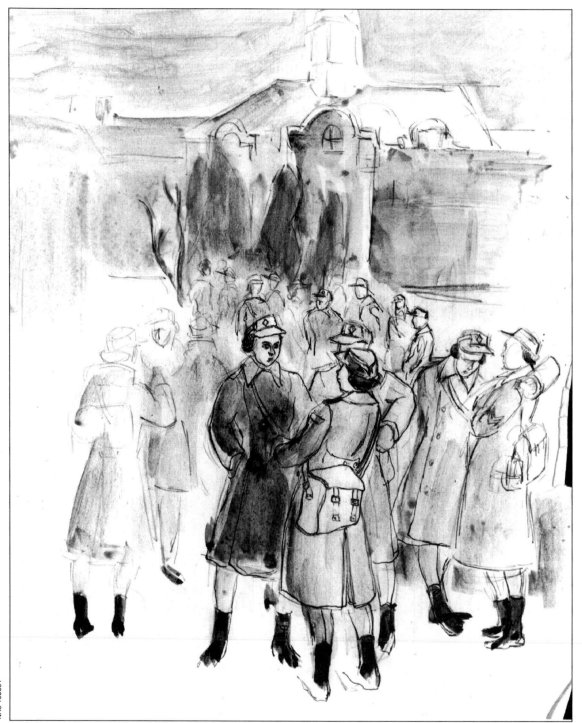

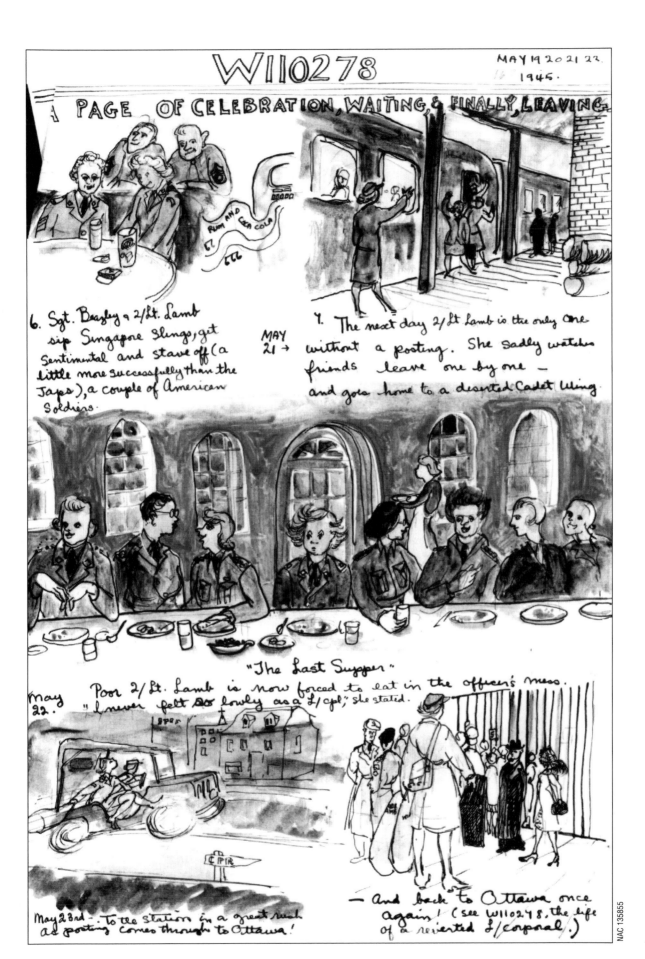

W110278

MAY 19 20 21 22.
1945.

A PAGE OF CELEBRATION, WAITING, & FINALLY, LEAVING.

6. Sgt. Beasley & 2/Lt. Lamb sip Singapore Slings, get sentimental and stave off (a little more successfully than the Japs), a couple of American Soldiers.

MAY 21 →

7. The next day 2/Lt Lamb is the only one without a posting. She sadly watches friends leave one by one — and goes home to a deserted Cadet Wing.

"The Last Supper"

May 22.

Poor 2/Lt. Lamb is now forced to eat in the officer's mess. "I never felt so lowly as a L/cpl", she stated.

May 23rd —. To the station in a great rush as posting comes through to Ottawa!

— and back to Ottawa once again! (see W110248, the life of a reverted L/corporal.)

NAC 135855

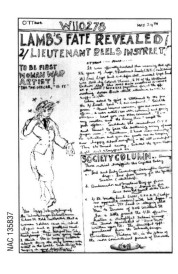

NAC 135837

LAMB'S FATE REVEALED!
2ND/LIEUTENANT REELS IN STREET!
TO BE FIRST WOMAN WAR ARTIST!
"THIS," SAYS OFFICER, "IS IT."

OTTAWA ... SCOOP ...

It was officially disclosed this morning that after two and a half years of hope, 2nd Lieutenant Lamb, C.B.I. (can't believe it) ... (nee L/Cpl. Lamb and before that, reverted L/Cpl. Lamb) was told by Colonel Thomas, second-in-command of the Historical Section, that SHE WAS GOING OVERSEAS WITHIN THREE OR FOUR WEEKS!

W110278 reporters found the officer reeling down Bank Street returning salutes to traffic lights.

When asked to give a statement to the press, the 2nd Lieutenant said, "I am confused."

Said the press, "Good heavens, woman! You are now an officer, a war artist and going overseas — have you no comment?"

"I want my mother and the Army Show," wept the poor officer. Suddenly she remembered O.T.C. and turned to face the battering army of newspapermen. "Gentlemen, I have now normalized the situation and you can quote me as saying I am happy about everything — It's all wonderful."

Then she turned away, saluted the green traffic light and staggered on.

SOCIETY COLUMN ... Among those noticed breezing into the Capital today were:
a) Lord and Lady Cavendrip-Ossington-Cavendrop — here from Surrey for the Sporting Season (elections).
b) Ambassador and Mrs. Bing-go from Peking breezed in for some sweet and sour at the Canton.
c) 2nd Lt. Molly Lamb, CWAC, S.F.N.A.R. (sad for no apparent reason) with kit bags and a vague look.
2nd Lt. Lamb is staying with Mrs. G. Downes of 305 Wilbrod St. For a little present, the 2nd Lt.
offered her hostess a delightful salami sausage with the Jewish equivalent of "Jesus Saves" written upon it. The beautiful gift was purchased from the Schmatzburger Delicatessen, Rideau St. in place of the more conventional present of chocolates.

SPECIAL ISSUE

EMBARKATION LEAVE
(INVOLVING A TERRIFIC TIME IN THE OFFICERS' MESS AT #5 DALE, HORSERACING; AND $50.00!)

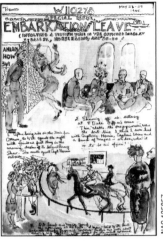

1) After a boring ride on the train from Ottawa, the 2nd Lt. spends the night with friends and, first thing in the morning, dashes off to the beloved Army Show. She meets great Capt. Harris outside.

2) Showing off in ecstasy at 5 Dale Officers' Mess. "This," states the one-pip wonder, "was the best time I think I ever had with Captain Harris, Captain Wren and a bunch of Majors — Oh dear, what it is to be an officer!"

3) 2nd Lt. Lamb and Major spend the afternoon at the races. "I now," said 2nd Lt. Lamb, "understand why Degas and Toulouse-Lautrec are nuts about drawing race tracks." She bet on the nicest coloured shirts of the jockeys and lost money.

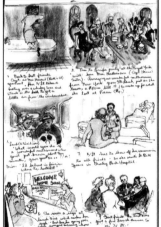

4) Back to best friends' Capt. and Mrs. Harris's (Ruth and Ed's) apartment. Poor 2nd Lt. Lamb takes a beating over a whiskey sour and stands in bath to get a little fresh air from the window above.

5) Then to a terrific party at the Royal York with keen Mrs. Nathanson (Capt. Harris's sister). Amazing and wonderful millionaire from New York gives 2nd Lt.Lamb — just as she leaves — a $50.00 bill!! (to make up for what she lost at the races ... $4.00).

6) Lamb (to taxi driver):
"What would you do if a wonderful millionaire, who you'd known about ten minutes, gave you $50.00? eh?"

Driver: "I'd believe in fairies ... Where to, Lootenant?"

7) 2nd Lt. has to show off her commission to all friends — so she visits Lt. Bill Speare in Chorley Park Hospital.

8) She reads a sign at lunch time which makes her sigh: "And here I'm going over, when everyone is coming home."

9) Great friends, the Andisons, give a fine French dinner to the 2nd. Lt.!

10) Farewell to A.Y. Jackson — who gives advice and a letter of introduction to Vincent Massey!

11 a) And so, after spending Sunday with the Harrises, 2nd Lt. Lamb goes back to Ottawa. On the train she has a big argument with Toronto ladies, who don't like anything very much except Anglo-Saxons. Said toothy lady, kindly, "Well, my dear, I think you're right being tolerant."

"I'm not being tolerant!" shrieks agitated 2nd Lt., "It's not a case of being tolerant etc.etc ... !" all the way to Ottawa.

11 b) "Pardon me," says half-Jewish girl, during the argument, "I couldn't help but overhear the lootenant and I just want to say that I agree with her. I'm from Chicago and believe me, Lootenant, you're right."

"Thank you, thank you," beams the 2nd Lt.

12) " ... And I went to the Officers' Mess and the races and a man gave me $50.00 and I had an argument ... and everything!" stated 2nd Lt. to Mrs. Downes and Gladys.

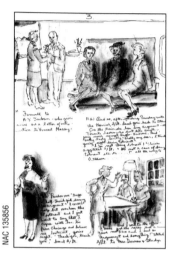

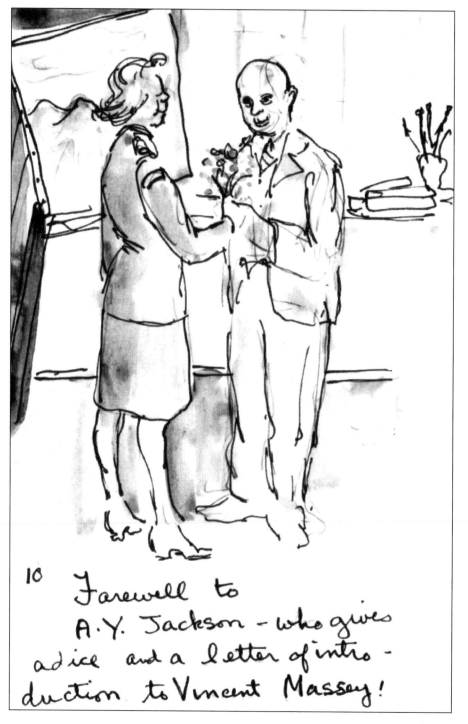

10 Farewell to A.Y. Jackson – who gives adice and a letter of introduction to Vincent Massey!

THE STORY OF AN OVERSEAS JOURNEY

W110278 begins today what they hope will be their best achievement in reporting to date. Here we begin to follow the life of our typical CWAC on her trip to Europe as a Canadian War Artist. Every part of the adventure will be set down with care by our reporters.

W110278 wishes its readers good reading and Bon Voyage!

1) 2nd Lt. Lamb gets X-rayed in Ottawa ... "What if I'm sick," thinks she, in fear ... "and me with my trunks all packed and everything ready!"

2) Final Chinese dinner in the Canton, Ottawa, with pals Bill Kinnis and Evan Boston.

3) And at last — the train at 11 o'clock ... 2nd Lt. with big help of Bill and Evan, ships two kit bags home and leaves on the train. Before she goes she meets and kisses good-bye Mac (see Volume II of W110278), old veteran guard pal of Ottawa.

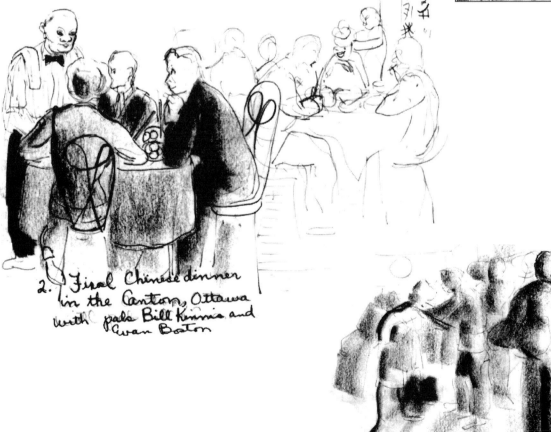

2. Final Chinese dinner in the Canton, Ottawa with pals Bill Kinnis and Evan Boston

EN ROUTE 2　　　**W110278**　　　JUNE 19, 1945

2nd Lt. Lamb, entitled to a lower berth, finds herself — as usual — surrounded by greatcoat, raincoat, drawings, haversack and suitcase in a stuffy old coach; for all the sleepers were in Halifax bringing home the Canadian Army.

All night long, returned prisoner-of-war behind her tells his experiences to airforce W O I. Lamb can't sleep for heat, dirt, excitement and interest.

From the Train in the Early Morning

In early dawn when mists
Lie close to earth
(I shall remember, wherever tread my feet)
These fields I pass as I now go away
I will remember that all these fields are sweet.

These are my eye ... to follow
The folding rolls of greenest land.
My ears ... to sense the silence of the mist
Planed in pockets of the loam.
This is my love ... to hold it all the way ...
To freshly hold for all it's worth
A mighty silent song
To sing me home.

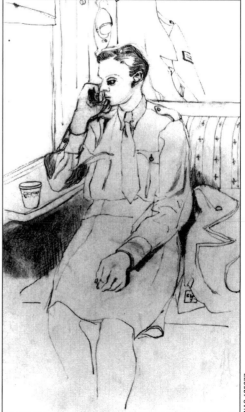

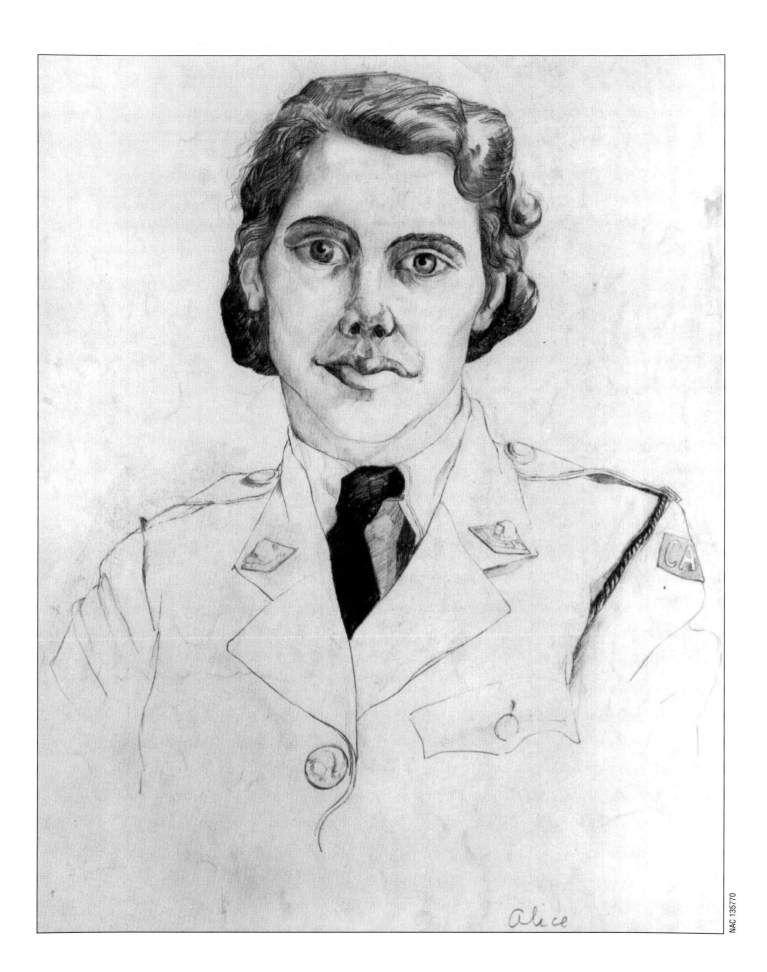

Alice

THE STORY OF A JOURNEY OVERSEAS ... CONTINUED

KITCHENER. TORONTO. TROOP TRAIN. HALIFAX AND ALL POINTS EAST ...

Two o'clock in the morning is the queerest time to get up. And we — a draft of 350 girls — were awakened at that time to leave for England. A hot wind rustled little poplars; the pale moon shone in a haze over the huts. We dressed and walked over quiet ground to the mess hall where a shift of rookies had prepared enamel jugs of coffee and enamel plates of bread and jam. Nobody talked or ate much and no one showed any excitement.

When the meal was over, the rookies began washing dishes and the night cooks threw strips of bacon into large black pans for tomorrow's breakfast. I sniffed the air and walked back to my hut by myself. "This is a good land," I thought dramatically, "I love my country — It's a terrific place."

I tried to think of what I was going to miss ... milk shakes (but I don't really drink much of those) ... juke boxes — yes, I'll miss those. What else? Oh, I didn't know.

I went into our hut and finished packing my toothbrush. A friend of mine woke up and came quietly to my room. "Is it time?" she whispered.

"Yes," I said, "Here we go ... Well, good-bye Nancy. I'll write. Thanks for waking up."

"It's about 2:30," she said, "Good-bye! I wish I was coming with you."

"I wish you were! I'll write ... Well, this is it, I guess, good-bye."

I went out into the moonlight again, laden down with a haversack, a suitcase, battle dress, sketch pads and oil paints and I joined a group of my friends.

Soon we climbed into an army truck and drove through the sleeping town to the station. The whole draft was massed along the platform in a thick, quiet group. Under the lights you could see their faces — chewing gum and nonchalant. A train shunted back and forth; a bit of dawn began to show. A crossing bell swung back and forth — dinging and donging.

We waited two hours. Then we boarded the train and the dawn came over the fields bright and fine. I walked through the carriages and saw the girls sleeping or smoking or talking sleepily to one another. They had mostly taken their tunics off and sat facing one another with their shirt sleeves rolled up.

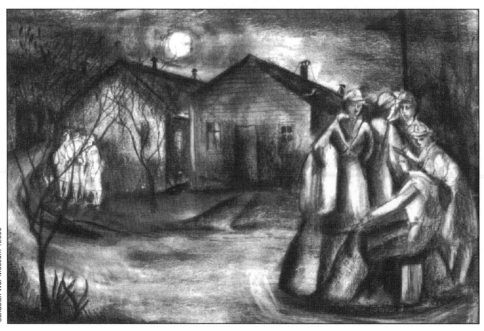

Canadian War Museum 12030

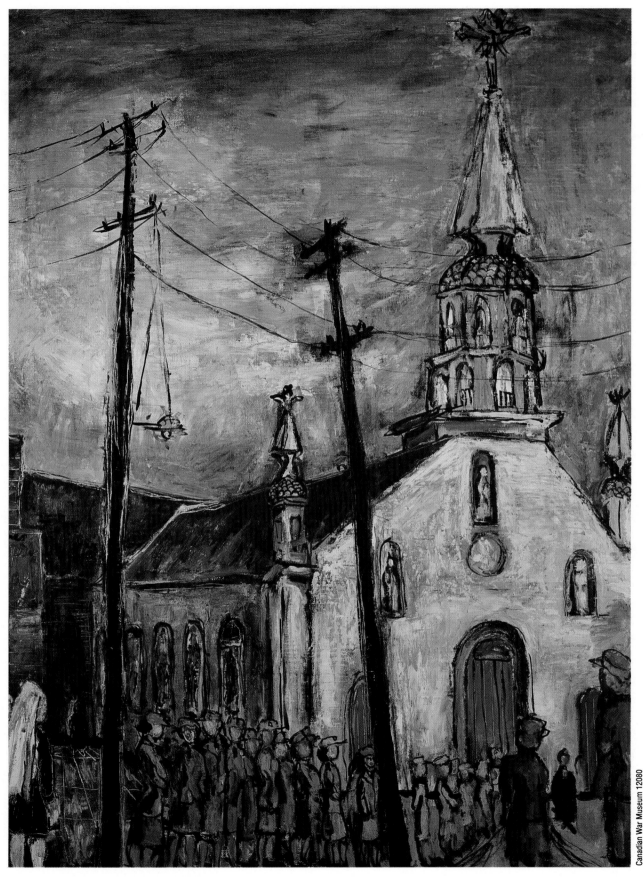

Roman Catholic Church Parade, Ottawa

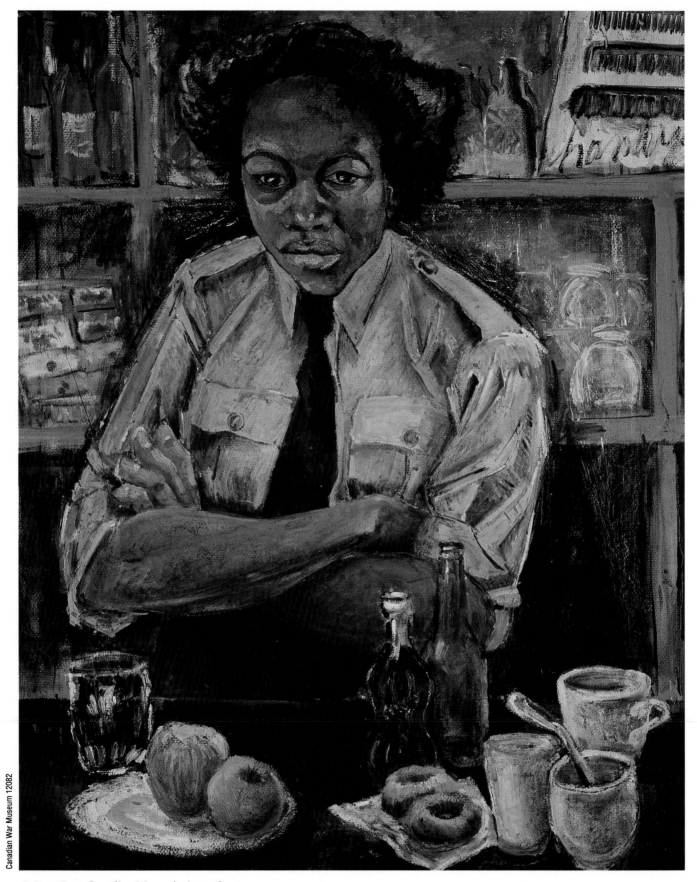

Private Roy; Canadian Women's Army Corps

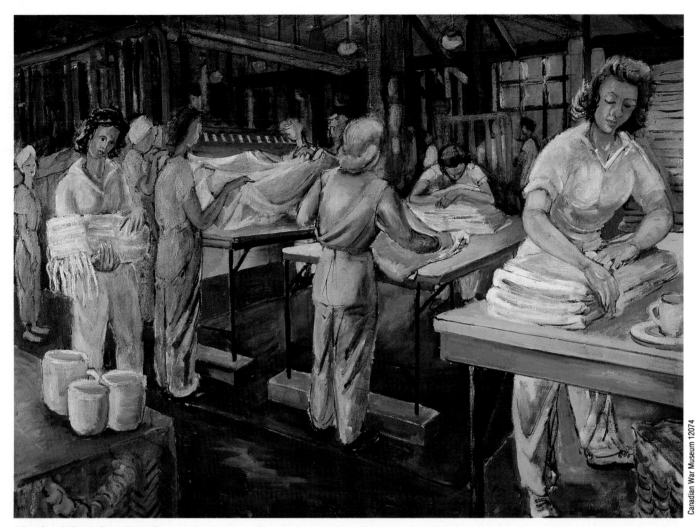

Canadian War Museum 12074

Number 1 Static Base Laundry

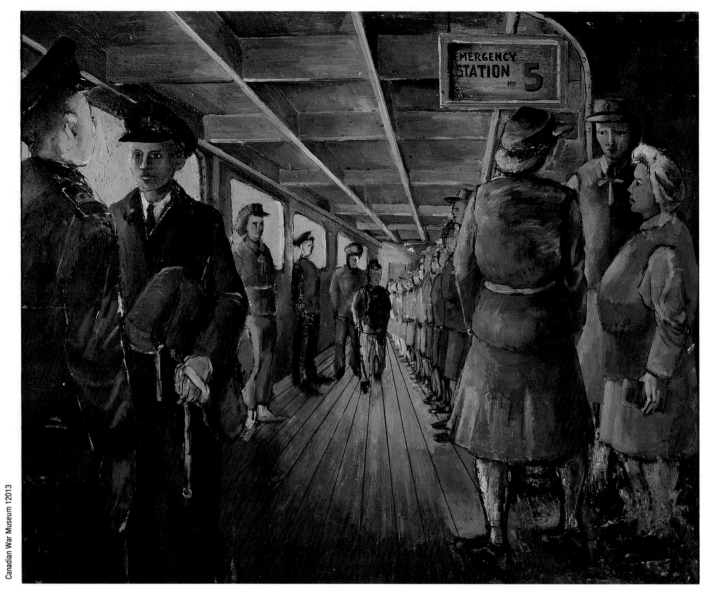

Boat Drill, Emergency Stations

AFTERWORD

◆

For me, this personal war diary speaks for itself and needs no epilogue or hindsight explanations. What followed after 1945 is another story.

The diaries are about a certain time, certain national convictions, certain places in Canada and Private Lamb's response to the experiences which Charles Comfort refers to as a "time out of time."

Now, after fifty years or so, "Private Lamb" remains an optimist and an enthusiast, though she gave up writing awful poetry years ago and contents herself with painting.

From time to time, she returns to the West — especially to Galiano Island, where the old people she once knew are long gone; but the smell of the briar roses, the sea and the cedars remain just as they were in 1942.

<div align="right">

Molly Lamb Bobak
Fredericton
August 24, 1992

</div>

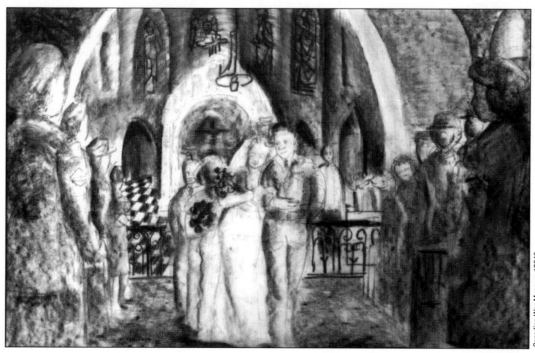

Canadian Women's Army Corps Wedding in the Seminary's Chapel
conte and pencil
30.5 x 45.8 cm

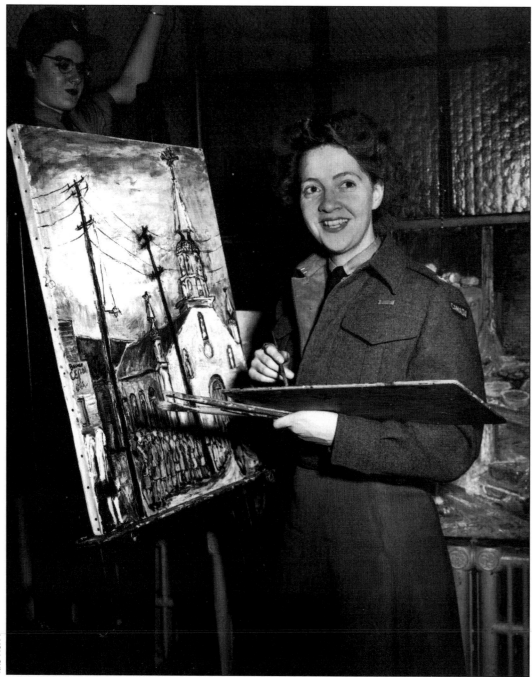

Molly Lamb Bobak

War Artist

◆

A PORTFOLIO

C A N A D A ' S W A R A R T :
A N A T I O N A L L E G A C Y

———————◆———————

Perhaps the most important and enduring legacy from both world wars is the art and literature produced, often under fire, by Canadians in the armed forces.

— Heather Robertson
A Terrible Beauty: The Art of Canada at War (1977)

While Canada has never regarded itself as a warlike nation, the visual record of its contribution and sacrifice in time of war has been preserved for posterity. The National War Museum's collection of war art and the material held by the National Archives of Canada and the Canadian Forces Photo Unit are testimony to our dedication to the concept of honouring and preserving what has become our collective military past.

Ironically, recognition of the need to assemble and preserve such a record came from an ex-patriot Canadian living in England during the dark days of World War I. The man responsible for initiating a program aimed at the creation of a permanent record of Canadians at war was New Brunswick's own Sir Max Aitken, who in 1917 became Lord Beaverbrook. The young self-made millionaire received his knighthood at the age of thirty-one within a year of his arrival in Britain in 1910, and he rapidly acquired a reputation as a force to be reckoned with. Yet inexplicably, when war broke out in 1914, no official appointment came his way. Exercising his own legendary initiative, Beaverbrook declared himself a self-appointed eyewitness to the activities of Canadian troops at the front. Two years later, in 1916 — the same year he acquired the first newspaper in his extensive publishing empire — he became the driving force behind the creation of the Canadian War Records Office in London, with the express purpose of amassing and preserving pictorial and documentary material.

The following year, in true entrepreneurial style, he initiated a charitable offshoot of this burgeoning collection of articles, photographs and films. The aim of the Canadian War Memorials Fund (CWMF), masterminded and overseen by Beaverbrook in 1917, was to assemble — in the interests of posterity — a collection of paintings and watercolours that would reflect something more than the grim statistics of the slaughter on the Western Front. Initially the artists of preference were British rather than Canadian, but by the war's end on November 11, 1918, increasing numbers of Canadian artists were being commissioned by Beaverbrook to participate in the program.

The British counterpart of Beaverbrook's collection of Canadian war art originated somewhat earlier, in the summer of 1916. Another of the dominions — Australia — had begun sending artists to record the gallantry of its troops in the trenches at Gallipoli as early as 1915. The official raison d'être for these war art programs was unquestionably noble, but in retrospect it seems clear that an underlying factor in their creation was something that had little to do with art for art's sake or even with the value placed on visual documentation. The wartime propaganda mills required additional grist, whatever the source. The war was by no means won, and the importance of artistic images as a

vehicle for bolstering both public and military morale was gaining recognition among the strategists. The efficacy of the printed word and of black and white photographs and films had long been accepted; now propagandists were coming to believe that if artists could be sent to the battlefields under official auspices, the visual evidence of what they had seen first hand might prove invaluable.

A substantial number of British artists on active service had been sending home the sketches they had made in their "spare" time at the front, but none had produced work at the request of the War Office. Yet, one way or another, a good many of these "unofficial" drawings had found their way into exhibitions and showings at private galleries throughout Britain. The considerable interest and acclaim these shows generated may well have been a factor in the subsequent decision in the spring of 1916 to send a lone British artist to the Western Front.

Muirhead Bone, a well-regarded Scottish etcher, was appointed a war artist on a more or less trial basis. If the results of this experimental foray proved useful for propaganda purposes — if it could be demonstrated that the effect on popular support for the war effort was indeed positive — then official recognition of the significance of war art might be forthcoming. In his zealous efforts to produce a sufficient body of work to satisfy the requirements of Wellington House, the newly created pictorial publications bureau, Bone was on the verge of collapse one year and 500 drawings later.

Shortly after Bone's appointment, a second artist, portrait painter Francis Dodd, was pressed into service, and in 1917 James McBey was dispatched to Egypt and from there to the Middle East, where he met and painted T.E. Lawrence as well as some of the Arab chiefs who had allied themselves with Lawrence and the British. At this point, the British war art program had demonstrably proven its worth. Increasing numbers of portrait painters, etchers and printmakers were commissioned to record the war effort both on the home front and in the war zones.

The establishment and growth of Canada's own war art program paralleled the British experience. Beaverbrook and the Canadian government worked in concert to finance the venture. Maurice Cullen and J.W. Beatty, both established painters whose artistic credentials were widely acknowledged in Canada, were among those invited to participate in Beaverbrook's campaign to create a military art bank. Originally Beaverbrook relied on the advice of London-based critic and art historian Paul Konody, but he later solicited the opinions of Sir Edmund Walker, then chair of the National Gallery of Canada, and those of its director, Eric Brown. As a result of their involvement and recommendations, the names of several painters who had yet to make their mark on a national scale were added to the list.

Four future members of the Group of Seven, which formed in 1920 — A.Y. Jackson, Fred Varley, Arthur Lismer and Franz Johnston — were in the forefront of younger Canadian artists commissioned to produce sketches that, subject to approval, would later be committed to canvas. David Milne, whose distinctive style set his work apart, was also among those singled out as painters of promise.

Women, too, were enlisted to make artistic contributions to the Canadian War Memorials Fund. The British Imperial War Museum appointed two noteworthy painters, Anna Airy and Victoria Monkhouse, to record assorted aspects of the war effort on the U.K. home front. Their two Canadian counterparts, Florence Carlyle and Caroline Armington, both happened to be living overseas and were therefore immediately accessible to Beaverbrook for participation in Canada's war art program. The selection of Carlyle as the portraitist who would immortalize Lady Julia Drummond, the much-admired London director of Canadian Red Cross operations, was especially appropriate in that a female artist would paint the portrait of the solitary woman among the distinguished Canadians whose likenesses were commissioned by the CWMF.

Caroline Armington spent the entire war in Paris. Both she and her husband, Frank, were respected printmakers, but it was Caroline's work — two etchings of Paris in wartime — that was commissioned and exhibited as part of the Canadian War Memorial Fund collection in 1919.

In marked contrast to these two officially appointed artists, whose work depicted only officially approved subject matter, are the astounding accomplishments of another Canadian artist, Mary Riter Hamilton. Hamilton's "unofficial" post-war records of the battlegrounds of France and Belgium stand as testimony to her artistic ability and determination. Undaunted by the rejection of numerous appeals for her consideration as a war artist overseas, Hamilton left Vancouver early in 1919 to proceed to France. Under conditions that can only be described as spiritually and physically devastating, she spent the next three years exploring and documenting the battlefields.

Mary Riter Hamilton's personal mission led her into a grotesque and forbidding landscape. She returned with over three hundred sketches, drawings and paintings that reproduced the horrors of war. There is a certain irony in the fact that some of the most starkly compelling images of World War I and its aftermath were created "unofficially" by a Canadian woman — a remarkable woman by any definition.

On Canada's home front, sculptors Frances Loring and Florence Wyle were given official access to subject matter deemed more suitable by male decision makers such as Walker and Brown, who in turn were responding as best they could to the requirements set out for them by the government. Loring and Wyle were commissioned to complete works in bronze such as *The Shell Finisher*, which would depict the unprecedented contribution of Canadian women working in munitions plants and industry. Meanwhile, printmaker Dorothy Stevens was requested to execute a wartime series based on her observations in factories and shipyards in the Toronto area. Montreal artist Mabel May accepted similar official commissions and found them "desperately interesting." The artistic output of these four women represents the female contribution to Canada's substantial collection of art relating to the Canadian home front during this period.

Gradually the concept of utilizing art to elicit public support for the war effort at home and abroad had gained a foothold. More and more artists, both British and Canadian, were commissioned to help fuel the fires of patriotism. These World War I collections of military art formed the basis of a permanent artistic legacy of inestimable worth in both countries. It was a legacy that would extend into World War II, into the lives of young Canadian painters like Molly Lamb and Bruno Bobak, and beyond into 1991 and the Gulf War.

The vast majority of Molly Bobak's official war art was executed overseas during the summer and autumn of 1945, before her return to Canada in early 1946. Although she expressed the intention of continuing to keep the readers of "W110278" informed of further developments, the process of sketching and recording the activities of the Canadian Women's Corps in England and newly liberated Europe precluded further entries.

The following "portfolio appendix" includes selected paintings and drawings from the 111 Molly Lamb Bobak works that now comprise part of the collection of the Canadian War Museum. They are representative of Molly Bobak's work as an officially designated war artist — the culmination of the long-awaited hopes and dreams recorded so vividly in the pages of " 'W110278' — The Diary of a C.W.A.C." from November 1942 until June 1945.

DRAWINGS
& PAINTINGS

In Night, Ottawa
conte and ink
44.9 x 30.3 cm

Canadian Women's Army Corps Laundry Workers Going to Dinner, Bordon, England
conte
30.5 x 45.8 cm

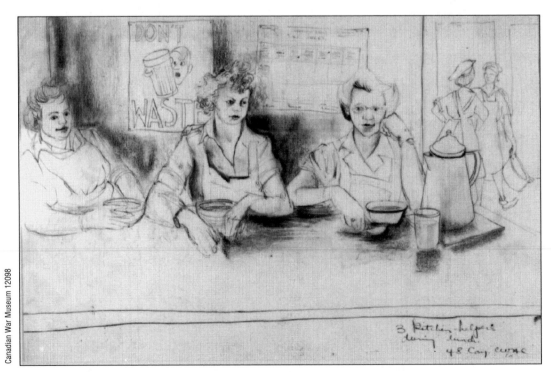

Three Kitchen Helpers During Lunch, Ottawa
conte
30.3 x 44.9 cm

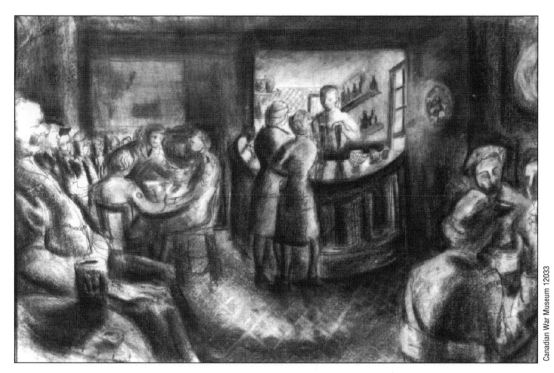

Canadian Women's Army Corps in an English Pub, Guildford
charcoal
30.5 x 45.7 cm

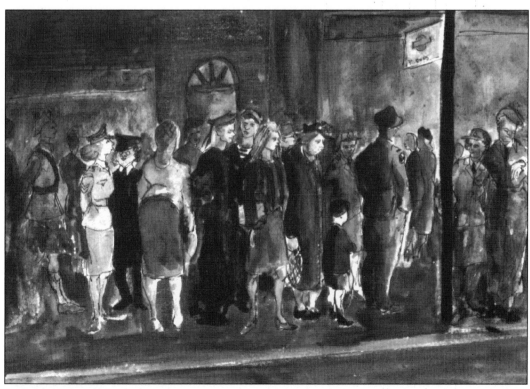

London Bus Queue
watercolour
25.3 x 35.5 cm

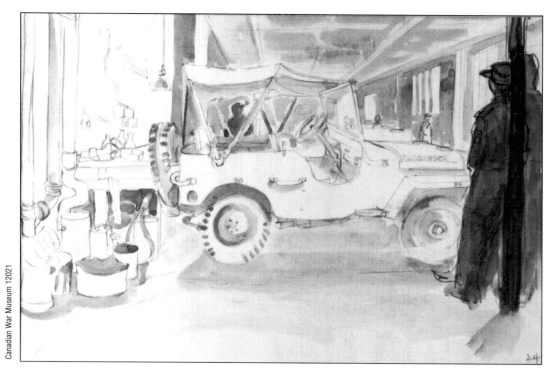

CMHQ Garage, Chelsea, London, England
wash
30.6 x 45.8 cm

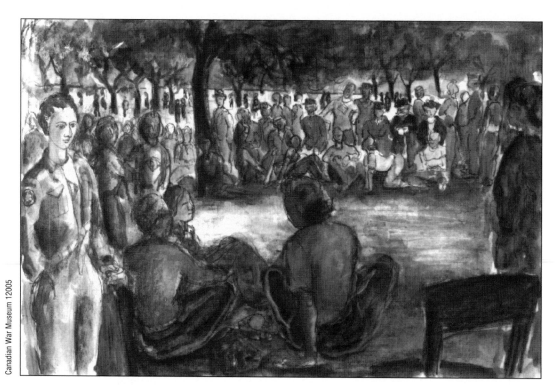

Baseball Game in Hyde Park, London
ink and watercolour
38.2 x 55.9 cm

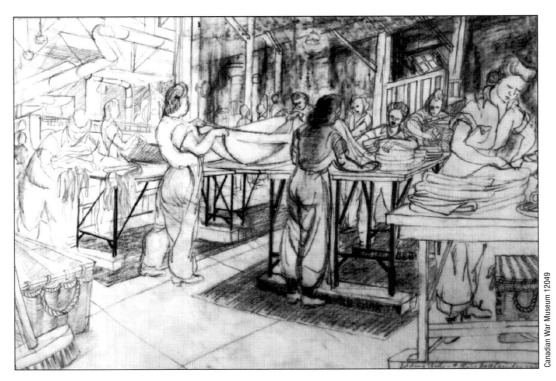

Canadian Women's Army Corps Folding Sheets
conte
30.5. x 45.7 cm

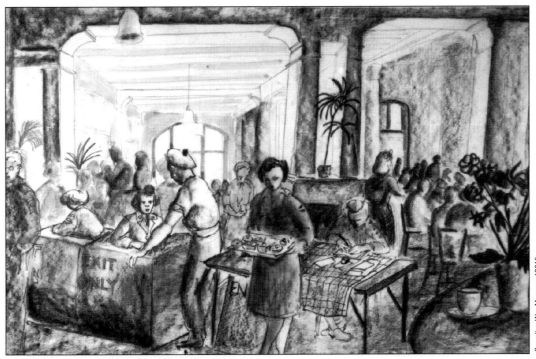

'Canada Club' Nijmegen, Holland
conte, ink and carbon pencil
30.5 x 45.7 cm

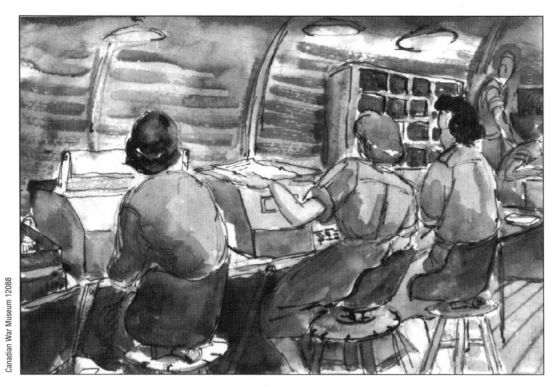

Signal Corps Teletypists on Night Duty, Apeldoorn, Holland
watercolour and ink
19.3 x 25.4 cm

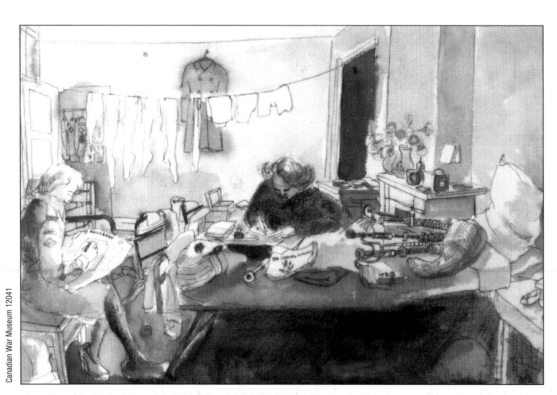

Canadian Women's Army Corps Pipe Band Writing Letters Home
wash
35.7 x 50.7 cm

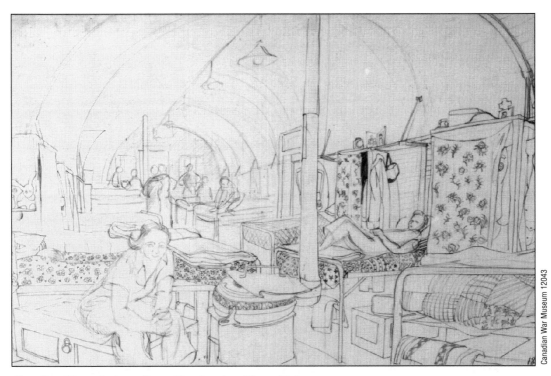

Canadian Women's Army Corps Quarters in a Nissen Hut
carbon pencil
35.6 x 50.8 cm

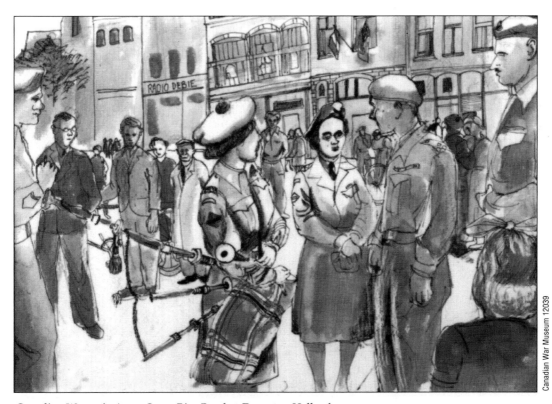

Canadian Women's Army Corps Pipe Band at Deventer, Holland
ink and wash
25.4 x 35.5 cm

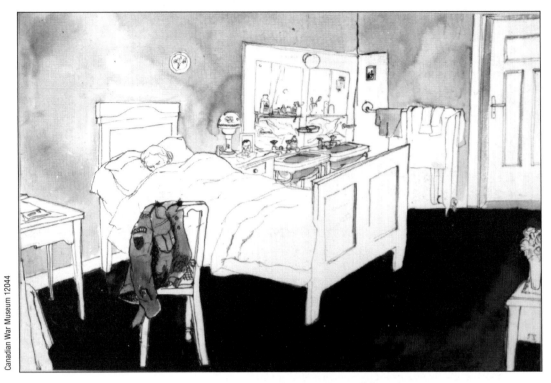

Canadian Women's Corps Sleeping Quarters in the Administrative Building, Germany
watercolour and ink
35.6 x 50.8 cm

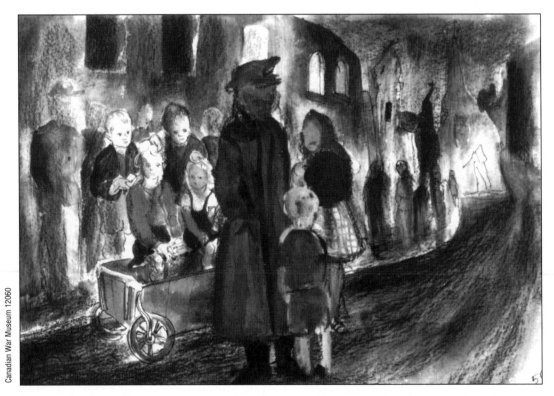

German Children in Bremen
watercolour
25.4 x 35.4 cm

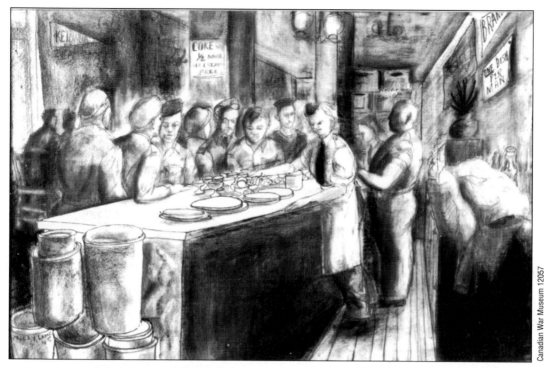

The Eskimo Inn, Oldenburg, Germany
conte on paper
30.6 x 45.8 cm

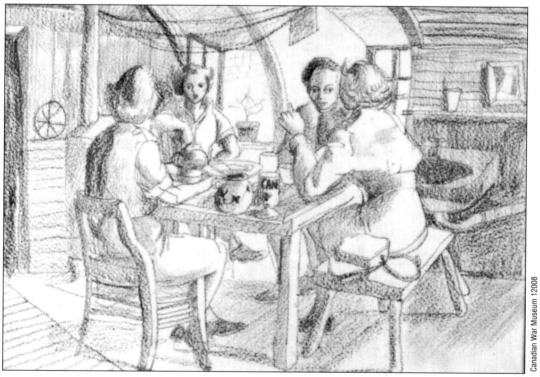

The Base Post Office, Lot, Belgium
conte
25.6 x 35.7 cm

BIBLIOGRAPHY

Bissell, Claude. *The Imperial Canadian: Vincent Massey in Office.* Toronto: University of Toronto Press, 1986.

Bobak, Molly Lamb. *Wildflowers of Canada: Impressions and Sketches of a Field Artist.* Toronto: Pagurian Press, 1983.

———. "'W110278' — The Personal War Records of Private Lamb, M." National Archives of Canada (1942–1945), #135857.

Boyanoski, Christine. *The 1940's: A Decade of Painting in Ontario.* Toronto: Art Gallery of Ontario, 1987.

Bruce, Jean. *Back the Attack! Canadian Women During the Second World War — At Home and Abroad.* Toronto: Macmillan, 1985.

Byers, A.R., ed. *Canadians at War 1939–1945.* Montreal: R.D. Publications, 1986.

Conrod, W. Hugh. *Athene, Goddess of War: The CWAC — Their Story.* Dartmouth, N.S.: Writing and Editorial Services, 1984.

Davis, Angela, and Sarah McKinnon. *The Battlefield Paintings of Mary Riter Hamilton (1919–1922).* Winnipeg: University of Manitoba Art Gallery, 1989.

Fetherling, Doug, ed. *Documents in Canadian Art.* Peterborough: Broadview Press, 1987.

Foot, M.R.D. *Art and War: 20th Century Warfare as Depicted by War Artists.* London: Headline Book Publishing with the Imperial War Museum, 1990.

Herries, Meirion, and Susie Herries. *The War Artists.* London: Michael Joseph Press with the Imperial War Museum and the Tate Gallery, 1983.

Konody, P.G. *Art and War: Canadian War Memorials.* London, Canadian War Records Office, 1919.

Luckyj, Natalie. *Visions and Victories: Ten Canadian Women Artists (1914–1945).* London, Ont.: London Regional Gallery, 1983.

McCormick, Ken, and H.D. Perry. *Images of War: The Artist's Vision of WW II.* New York: Orion Books, 1990.

MacDonald, Colin S. *Dictionary of Canadian Artists.* Toronto: Canadian Paperbacks, 1967.

McIntosh, Terresa. *Other Images of War: Canadian Women War Artists of the First and Second World Wars.* Ottawa: Carleton University, 1990.

Murray, Joan. *Daffodils in Winter: The Life and Letters of Pegi Nicol MacLeod.* Moonbeam, Ont.: Penumbra Press, 1984.

Robertson, Heather. *A Terrible Beauty: The Art of Canadians at War.* Toronto: James Lorimer, 1977.

Sisler, Rebecca. *The Girls: A Biography of Frances Loring and Florence Wyle.* Toronto: Clarke, Irwin , 1972.

Tippet, Maria. *Art at the Service of War: Canadian Art and the Great War.* Toronto: University of Toronto Press, 1984.

INTERVIEW TRANSCRIPTIONS

CBC RADIO

#1305-1500 (D120-13) February 2, 1991,Vancouver. Molly and Bruno Bobak, "The Vicki Gabereau Show."

#660416 — April 16, 1966, Fredericton, N.B. Molly Bobak on "Saturday A.M." with Stuart Smith.

#630706-2D — July 6, 1963, London, England. Molly Bobak on "Trans-Canada Matinee" with Pat Patterson.